SCHAPIRO'S HEROES

PHOTOGRAPHS BY

STEVE SCHAPIRO

For Maura

Introduction

David Friend

The term "hero" has evolved over time. For centuries, heroes were the central characters in myths: individuals, chiefly male, who embodied humanity's grandest ideals. They were born in mysterious settings, operated in a loftier realm than men and women, strove for immortality, struggled through a gauntlet of perilous tasks, died spectacular deaths and, quite often, experienced miraculous rebirths. They were rare creatures of providence who were regarded with respect by both the gods above and mere mortals below.

In contemporary times, we still consider these mythic figures as heroic. We think of Oedipus or Robin Hood, Romulus or Paris (not Ms. Hilton, of course, but Paris of Troy, who was nursed by a she-bear, raised as Alexander, and later brought calamity to his city). But we also apply the word hero to two other types. First, heroes are ordinary people who, confronted with extraordinary circumstances or challenges, end up saving lives, leading struggles, or reaffirming humanity's best principles through their acts of will, sacrifice, conviction, or daring. Many of them we know by deed, though not by name or face; others go unnoticed altogether by the mass of men and women, having committed what Wordsworth called "nameless, unremembered acts of kindness and love."

A second form of hero is the almost larger-than-life personality in our culture, someone who epitomizes extraordinary achievement in one or more areas of endeavor: entertainment or sports, business or philanthropy, public service or world affairs, academia or theology, the arts or the sciences. These individuals, renowned and celebrated by society at large, serve to inspire the common man and woman. They represent our Best Selves, writ large.

Photographer Steve Schapiro has spent much of his career focusing on these latter, public heroes. Unlike most of us, he has been granted access to their charmed lives. He has visited their homes and offices, spent time with their

FAMILIES, AND BEEN ALLOWED TO REMAIN FOR EXTENDED PERIODS AS A TRUSTED OBSERVER. HIS CAMERA LENS, IN TURN, HAS SERVED AS THE CONDUIT THROUGH WHICH THEIR HEROISM HAS BEEN CONVEYED TO THE REST OF US.

IN THE PAST, HEROES' LIVES WERE BEST RENDERED IN WORDS—IN FIRESIDE STORIES PASSED ALONG BY WORD OF MOUTH, IN SONG, IN EPIC POETRY. BUT IN THE MODERN ERA, IT IS OFTEN PICTURES THAT BEST CAPTURE, EDIFY, AND MAGNIFY OUR HEROES. PHOTOGRAPHS GRANT THEIR SUBJECTS STATURE, PERMANENCE, UBIQUITY. AND A GREAT PHOTOGRAPHIC PORTRAIT—THINK MARGARET BOURKE-WHITE'S STUDY OF MAHATMA GANDHI SEATED AT HIS SPINNING WHEEL OR YOUSUF KARSH'S WINSTON CHURCHILL GLOWERING DIRECTLY INTO THE CAMERA—OFFERS A DEFINITIVE PORTRAYAL OF THAT FLESH-AND-BLOOD HERO, A VISUAL ICON FOR HUMANITY'S ENDURING ADORATION.

ONE OF STEVE SCHAPIRO'S CHIEF TALENTS OVER THE YEARS HAS BEEN HIS ABILITY TO MAKE BOTH INTIMATE AND CLASSIC IMAGES OF SO MANY VAUNTED PERSONALITIES: MARTIN LUTHER KING JR. AND ROBERT F. KENNEDY, MUHAMMAD ALI AND ANDY WARHOL, JAMES BALDWIN AND SAMUEL BECKETT, JACQUELINE KENNEDY AND TRUMAN CAPOTE, BARBRA STREISAND AND RAY CHARLES, ALL OF WHOM HE CONSIDERS HIS PERSONAL HEROES. SHOOTING ON ASSIGNMENT FOR SOME OF THE GREAT PICTURE JOURNALS—LIFE AND LOOK AND THE NEW YORK TIMES MAGAZINE—FOR MOVIE COMPANIES, OR ON HIS OWN INITIATIVE, HE SUCCEEDED IN GETTING CLOSE TO HIS SUBJECTS BY RELYING ON HIS RESOURCEFULNESS, HIS KINDHEARTED SPIRIT, HIS PERSUASIVE WILES. HIS PHOTOGRAPHY HAS ALSO BENEFITED FROM HIS REMARKABLE SENSE OF HUMANITY AND EMPATHY—AND A NETWORK OF TRUSTING CONTACTS— THROUGH HIS LONG-TERM COMMITMENT TO COVERING THE CIVIL RIGHTS MOVEMENT THROUGHOUT THE 1960s.

ON THESE PAGES ARE SCHAPIRO'S HEROES. HIS IMAGES, IN THE WORDS OF PHOTOGRAPHER FRANK WARD OF AMHERST COLLEGE, "COMBINE NEW YORK GRIT AND L.A. GLAMOUR"—ALONG WITH A PRETERNATURAL PERCEPTIVENESS AND NO SMALL MEASURE OF COMPASSION AND TENDERNESS.

SCHAPIRO'S

HEROES

PHOTOGRAPHS BY

STEVE SCHAPIRO

INTRODUCTION BY

DAVID FRIEND

pH powerHouse Books Brooklyn, New York

HERO Frame: The best image in a group of similar photographic images.

Looking at a contact sheet of photographs, an editor would write "hero" next to the one picture he or she particularly liked. The hero frame, or "hero" as it was simply called, would then become the lead picture or perhaps the magazine cover.

This book includes my "hero frames" of Robert Kennedy, Muhammad Ali, Martin Luther King, James Baldwin, Truman Capote, Andy Warhol, Barbra Streisand, Ray Charles, Samuel Beckett, and Jacqueline Kennedy Onassis.

As a young photographer on assignment for *Life*, my only ambition was that the pictures I took each day would be published in the following week's magazine; I never thought beyond that. I could not imagine that 40 years later, so many of my subjects would remain strong, iconic figures in the world. However, as I photographed each of these ten individuals, I was aware of the life-changing effect they were having on me.

Playing Monopoly with a 21-year-old boxer named Cassius Clay at his home, I might have guessed at, but could not have foreseen, his emergence as the great Muhammad Ali. Robert Kennedy and Martin Luther King Jr., who both offered us so much hope in a troubled world and were shot down in their prime, remain today as inspirations to us all. Ray Charles and Truman Capote could not have imagined the impact they would have on the worlds of music and literature, or known that the incidents of their lives would one day be molded into insightful films.

The sixties were a defining era in America. In 1964, *Esquire* magazine wrote that the equivalent of a whole decade's events had already occurred. The Kennedy era had brought a sense of unlimited opportunity and optimism in all fields.

In the early years of that decade, people would get their 30 minutes of news every night from the growing influence of television, but still looked to their favorite magazines to linger on the weekly events of the world. When President Kennedy was shot, everyone stayed glued to their TV sets for three days, but then ran out to buy their special copy of the *Life* magazine memorial issue, so they could "own" a piece of history and hold on to those sad yet poignant memories.

During *Life*'s heyday, long photo-essays were laid out for twelve pages. However, when the magazine was ready to print it had frequently become unrealistic to find that many advertising-free pages available. Stories that had been designed to have a strong emotional flow and a continuous point of view from one spread to the next were collapsed into half their original number of pages. Often, the most dynamic images from each spread were bundled together, which sometimes worked and sometimes did not.

As a photojournalist in the sixties, you could spend anywhere from four days to six months doing a story on a particular personality, witnessing important moments in his or her life. You developed a sense of the person's inner drives and expectations. You got into a rhythm that gave your story a visual and emotional continuity.

The editor's contribution was important as well. Alfred Eisenstaedt, the great *Life* photographer, once told me about how he photographed Hitler's aide and minister of propaganda Joseph Goebbels. In one shot, Goebbels appears sitting stiffly in a straight-backed chair, peering up with a sinister look of evil. But Eisenstaedt had also photographed Goebbels a few minutes before, smiling and in a much friendlier mood. It was Henry Luce, the editor and publisher of *Time* and *Life*, whose choice it was which image to show. He picked the sinister photograph, which influenced millions of readers to fear an emerging Nazi regime. Choosing the relaxed photograph could easily have swayed the public in the other direction. A picture, it turns out, really is worth a thousand words.

The sixties were a time of change for photojournalism in general. When Robert Kennedy started his cross-country bid for the presidency, reporters and still photographers traveled in the first car, right behind the candidate, to be close to the action. Gradually, as television came more and more into the fore, photographers were edged out of the prime spots by big TV cameras and their crews.

America loved television. People in the streets began wearing larger and larger buttons and carrying bigger and bigger signs, because they knew if they were clever enough, they had a chance of seeing themselves pictured on the six o'clock news. The practically instant turnaround that television provided was appealing to the public, and magazines soon began to feel its impact.

Life magazine would spend six months doing an exposé on a subject, such as the Mafia. The editors would close the issue on a Friday night. By Saturday, radio had gotten wind of it. By Sunday, it was in all the newspapers. On Monday, the TV news shows were not only telling the story, but had already done follow-up interviews. Printing presses were slow and the magazine depended on the postal system. Most people had to wait until Thursday to receive their copy of *Life*, and by then the exposé had become old news. The weaning away of advertising dollars from the printed page to television helped cause the collapse of the great photo magazines. By the eighties, *Life*, *Look*, and *The Saturday Evening Post* were all gone.

I shot the very first *People* magazine cover: Mia Farrow in *The Great Gatsby*. Working for *People* magazine in the eighties was very different from my experiences in the sixties. You now were often given only two hours to do a story, and had to ask your subject to change clothes every 15 minutes, creating the illusion on the page that you had been with them for days. There was no hanging around waiting for those great emotional moments. You had barely gotten to know your subject before you were out the door. We had come, full swing, into an age of quickened "media journalism."

Now, the six- and eight-page photojournalistic stories in major magazines have disappeared, except for the occasional war or political essay in *Time* or *Newsweek*. For the most part, the photojournalistic tradition has been replaced by single "point" photographs, which primarily provide information, and with luck, perhaps some degree of emotion and design.

For the young photojournalist today, the opportunities are no longer there. Talented photographers lack the outlets once readily available to reach people with their work. The best hope for the future may lie in the Internet and the development of Internet magazines, which could again give the necessary space to tell a full story in a series of photographs with a flow and a viewpoint.

I was given many opportunities in my photography career. My first photo-essay was unassigned, and simply a project I cared about. I went to Arkansas and documented the hardships in a migrant worker's camp. A small Catholic magazine, *Jubilee*, ran the story as an eight-page spread. *The New York Times Magazine* picked up the same photographs and made them into a cover story. As a result, electricity was brought into that migrant camp, where before there had only had kerosene lamps. The photographs made a real change in the living conditions of those workers.

Young photojournalists need an outlet for their pictures. They need the opportunity to help make the world a better place. At the time of this writing, I am planning to launch an Internet photo magazine, to put the emotional and socially conscious photo-essays of our youth back into society. It is my way of giving back the gift that all those picture editors gave me.

<div style="text-align: right;">

STEVE SCHAPIRO
JUNE 2007

</div>

MUHAMMAD ALI

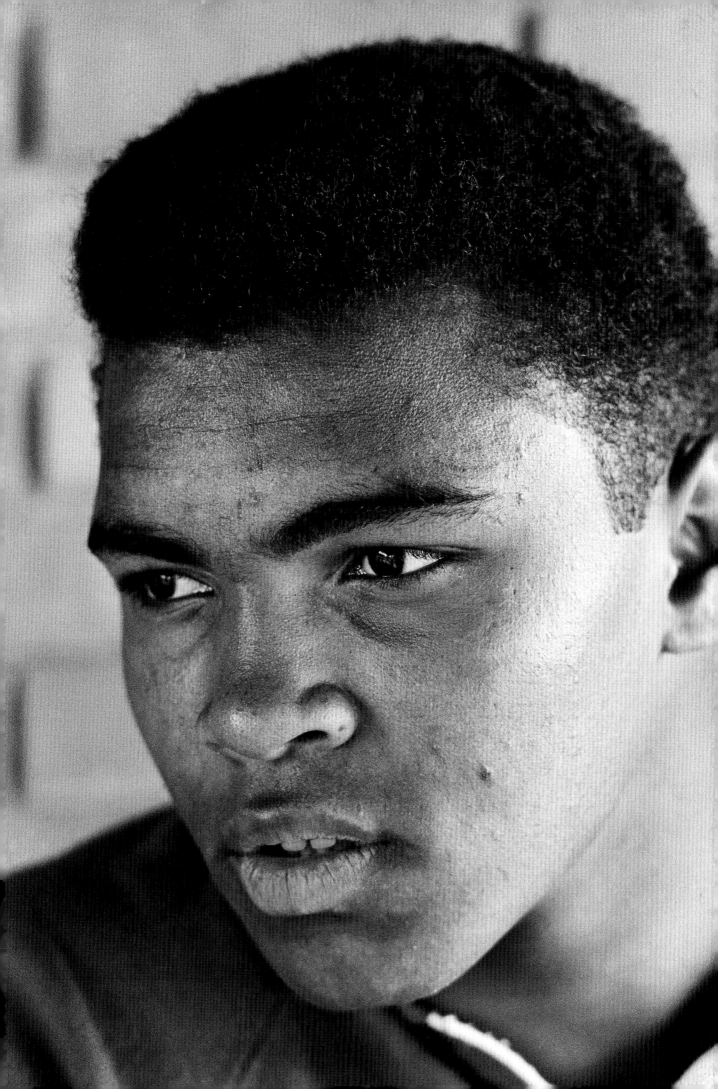

I met Odessa Clay in Louisville, Kentucky in 1963. She was making lunch for her son, Cassius.

The energetic, well-mannered 21-year-old was in the living room of his parents' red brick home, struggling over a game of Monopoly with some neighborhood children. Having already won the Olympic gold boxing medal and amassed a professional record of 18 wins, 15 of them knockouts, his biggest concern now was winning at the Parker Brothers board game. But winning wasn't enough: he needed to break the bank, and you had to lose all your money and property to *him*. He would loan you money to keep you in the game long enough to win absolutely everything on the board. Nothing would ever go back to the bank.

Even as a 21-year-old, he talked about socialized grocery stores, run by the people instead of by big chains, and of other methods to give people more voice in the economics of their own lives. He probably already had thoughts about Elijah Muhammad. Soon thereafter, he would change his name to Muhammad Ali and become known throughout the world for jabs of his fists as well as his tongue.

Ali took a break from the board game and gave me a glimpse of his life in his home and neighborhood. Hanging around the family house, he casually jabbed his left fist into the air, kissed his doting mother, and admired his own good looks in the living room mirror. It was a quiet, easygoing environment, a pause in the pages of boxing drama. In a few days, Ali was to leave for a major bout with Henry Cooper in London, which would lead to a chance at the heavyweight championship.

As I walked around the neighborhood with Ali, his Monopoly game under his arm, the local kids flocked to him. They genuinely loved him. They sparred with him, rode their bikes with him, told stories, visited the corner store, and, of course, played Monopoly.

I drove with Ali from Kentucky to New York, where he would catch his plane to London. All along the highway, his head was stuck out the window, proclaiming to anyone who could hear:

"Look at me! Look at me!"

"Ain't I pretty?"

"I am the greatest. I am the greatest."

Supposedly, Ali learned to be so boastful from watching the wrestling star "Gorgeous George" Wagner on television. Gorgeous George taunted his opponents so much that huge crowds in the thousands came to every arena match, with the hopes that he would lose and someone would shut him up.

Ali had an idol. It was Sugar Ray Robinson. Our first stop in New York was to be a meeting between the two of them, arranged to take place at Sugar Ray's gym in Harlem. I was to photograph the meeting at Ali's request. When we arrived at the gym, Robinson was nowhere in sight. We waited and waited…still, no Sugar Ray.

Finally, we got back in the car and drove down 125th Street. As we drove through Harlem, by sheer coincidence, we saw Sugar Ray, walking from his club on the corner to his nearby office.

Ali had been stood up by his idol.

For the first time on the trip, he was very silent.

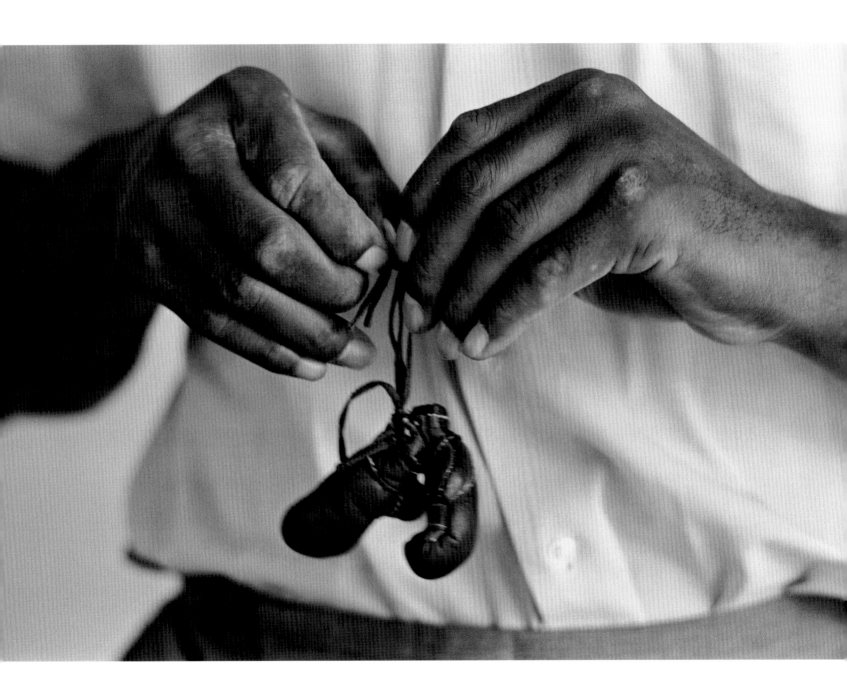

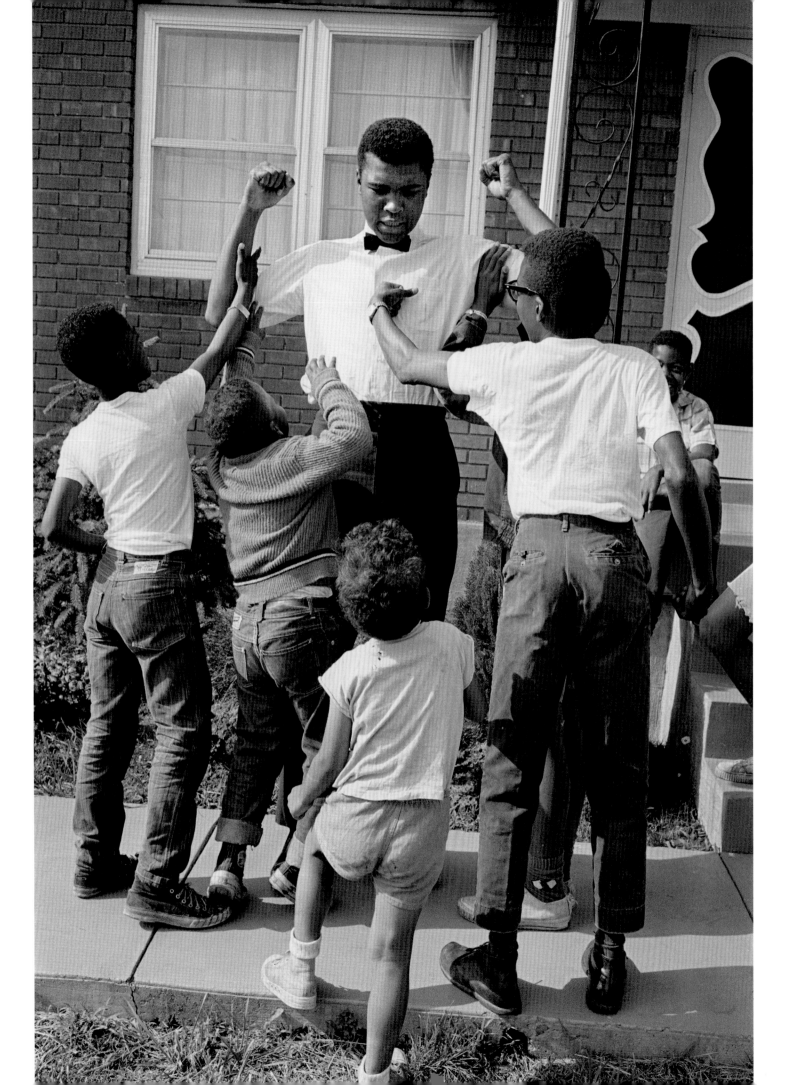

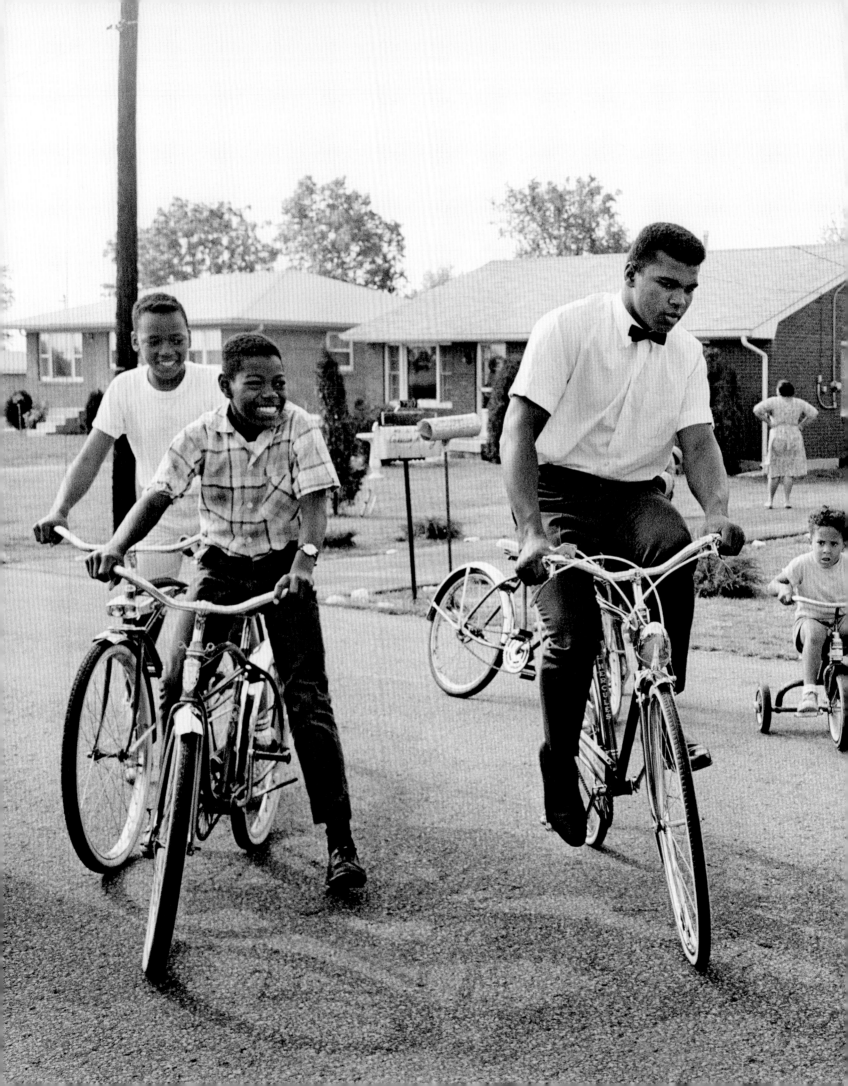

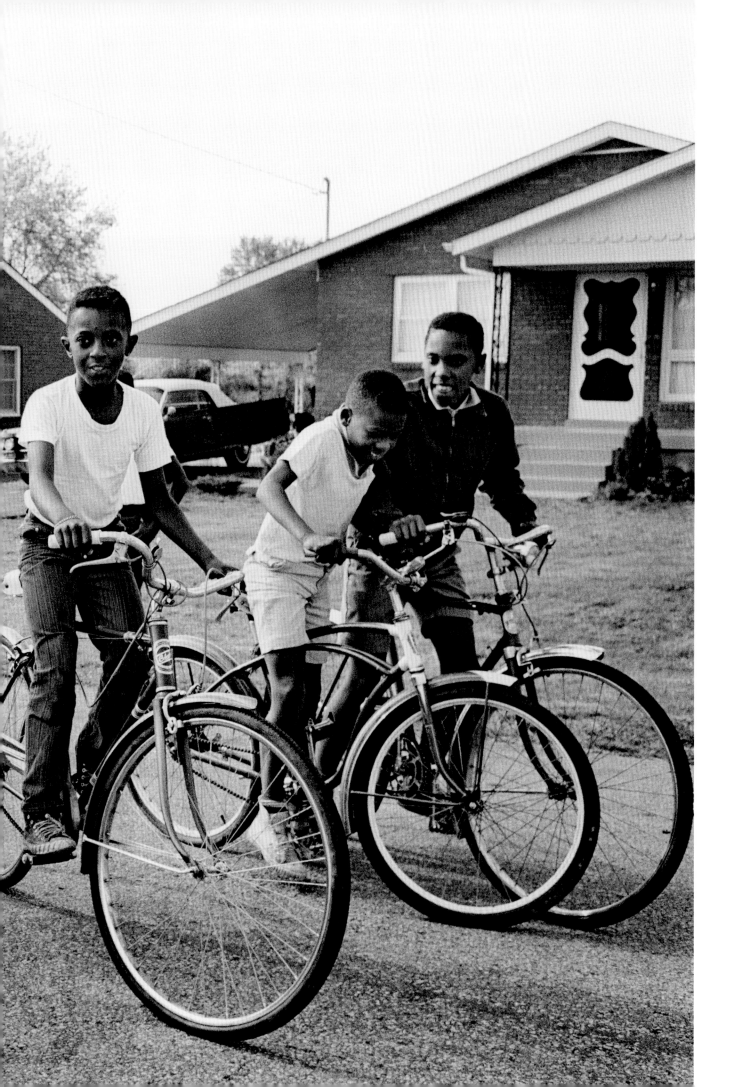

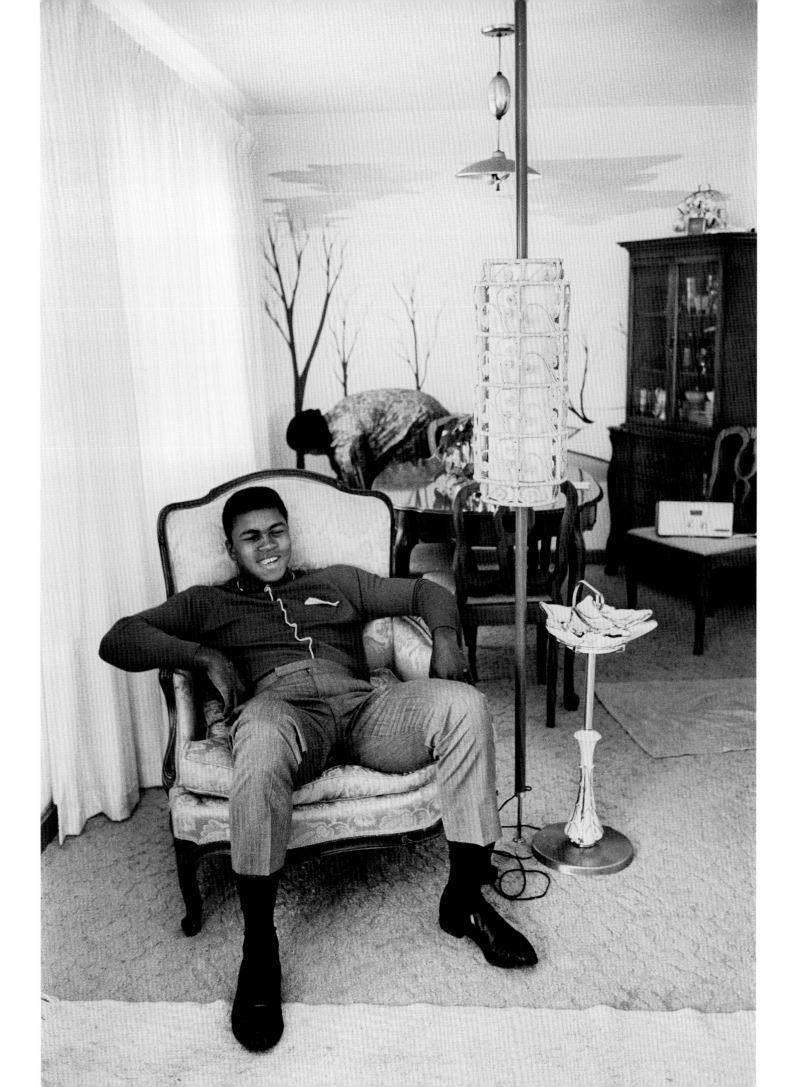

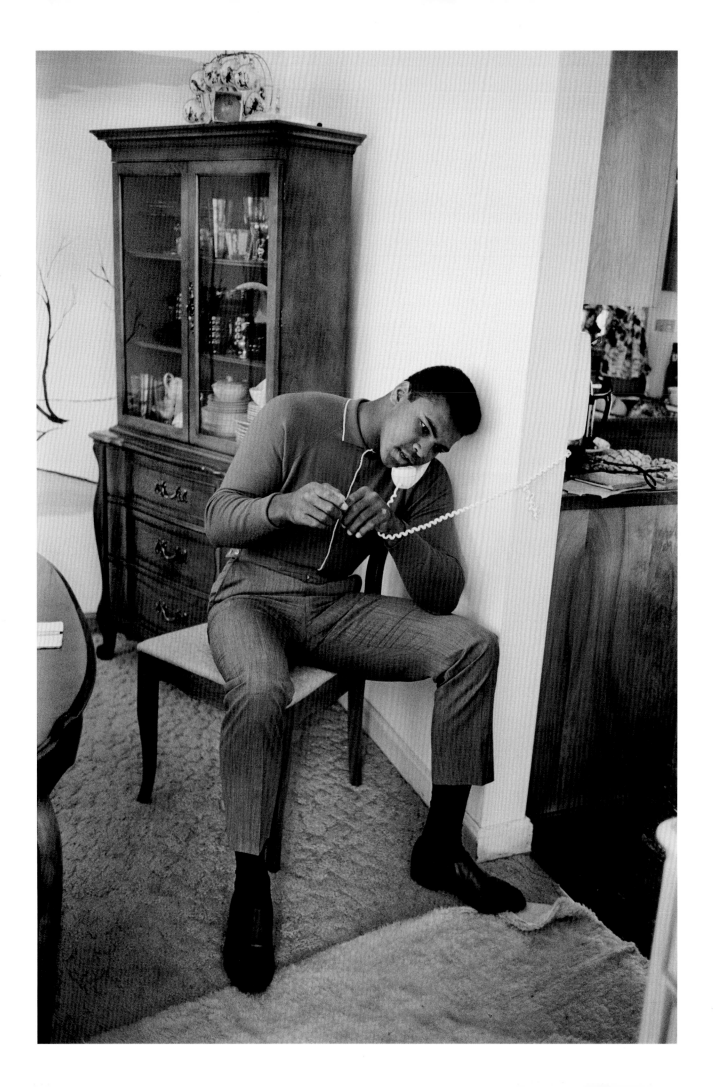

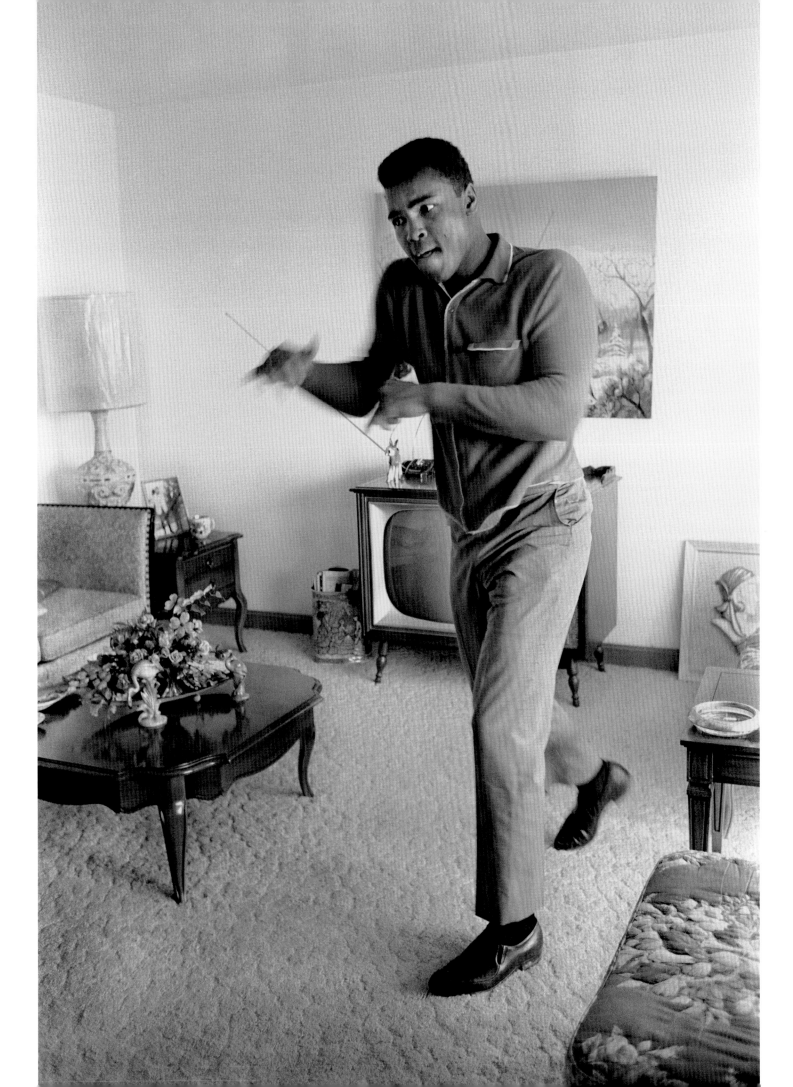

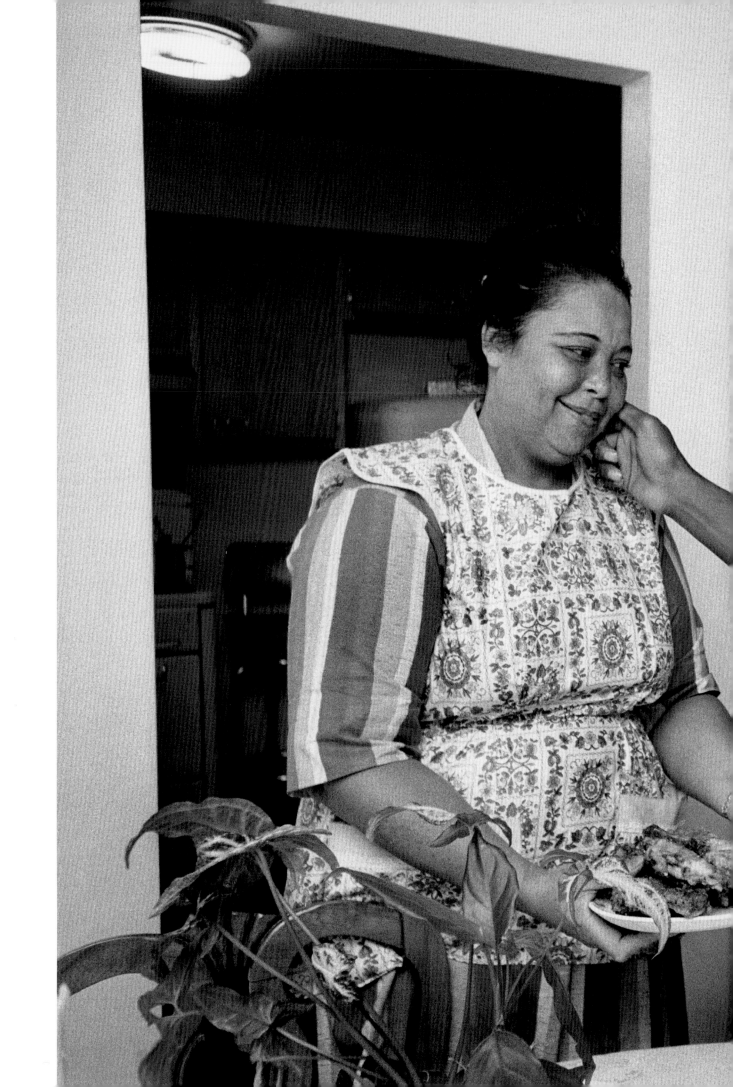

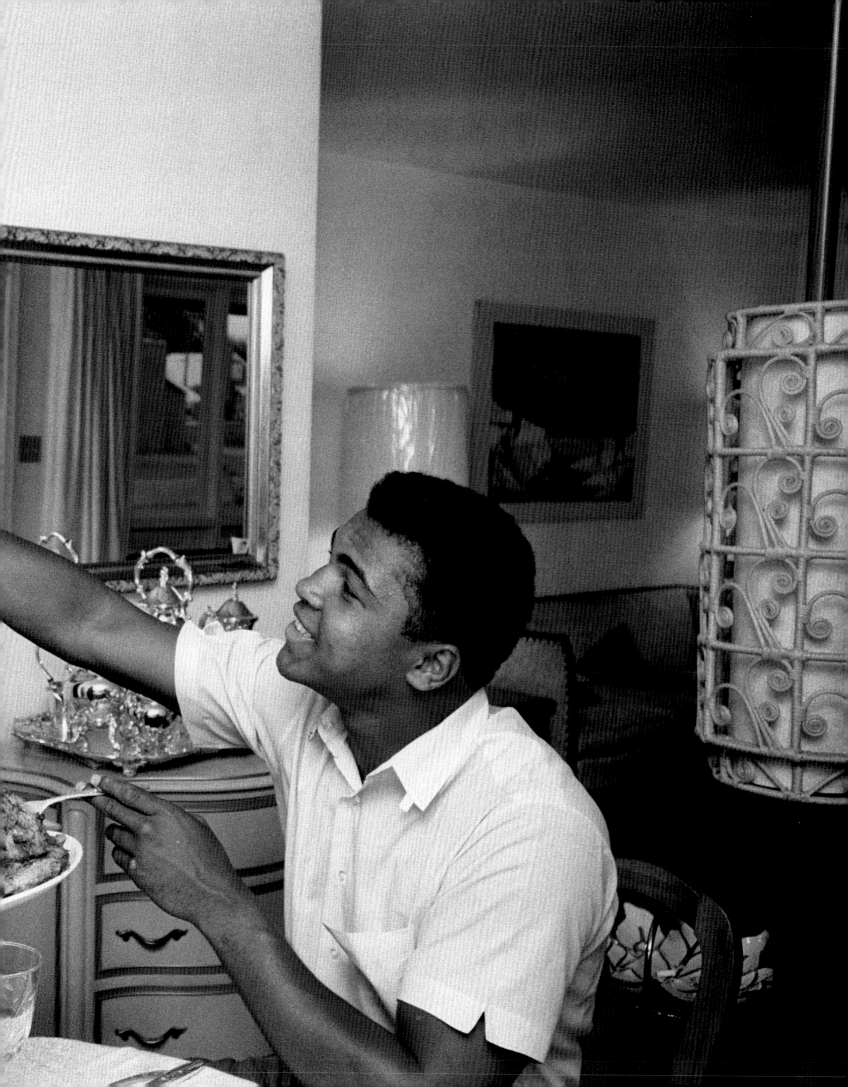

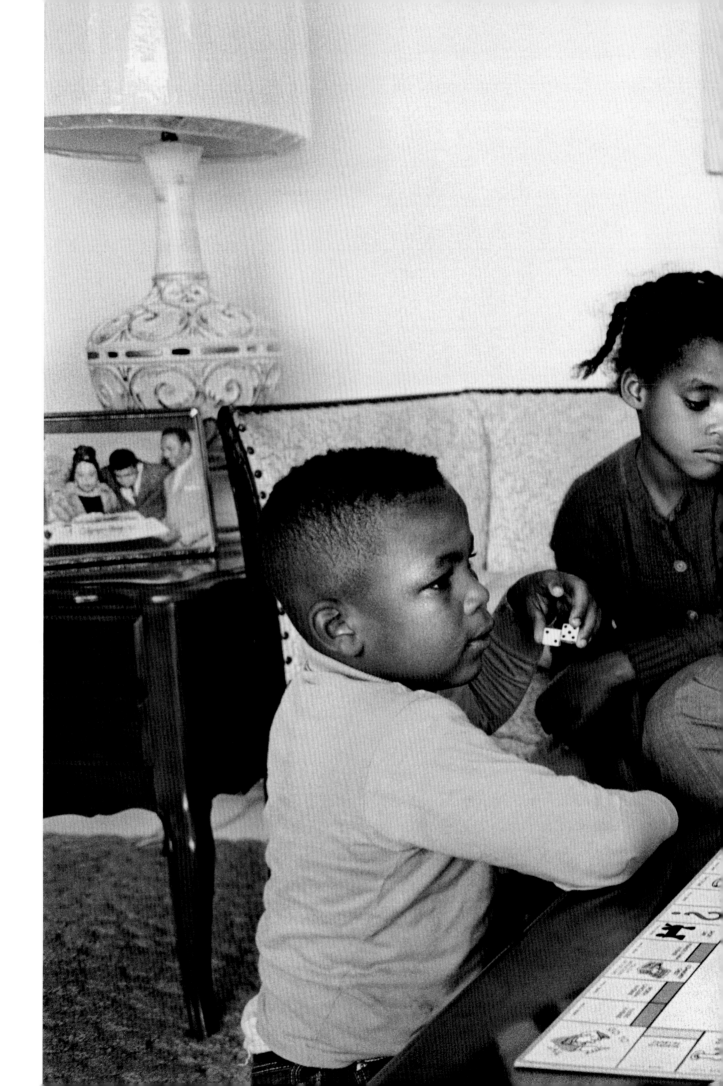

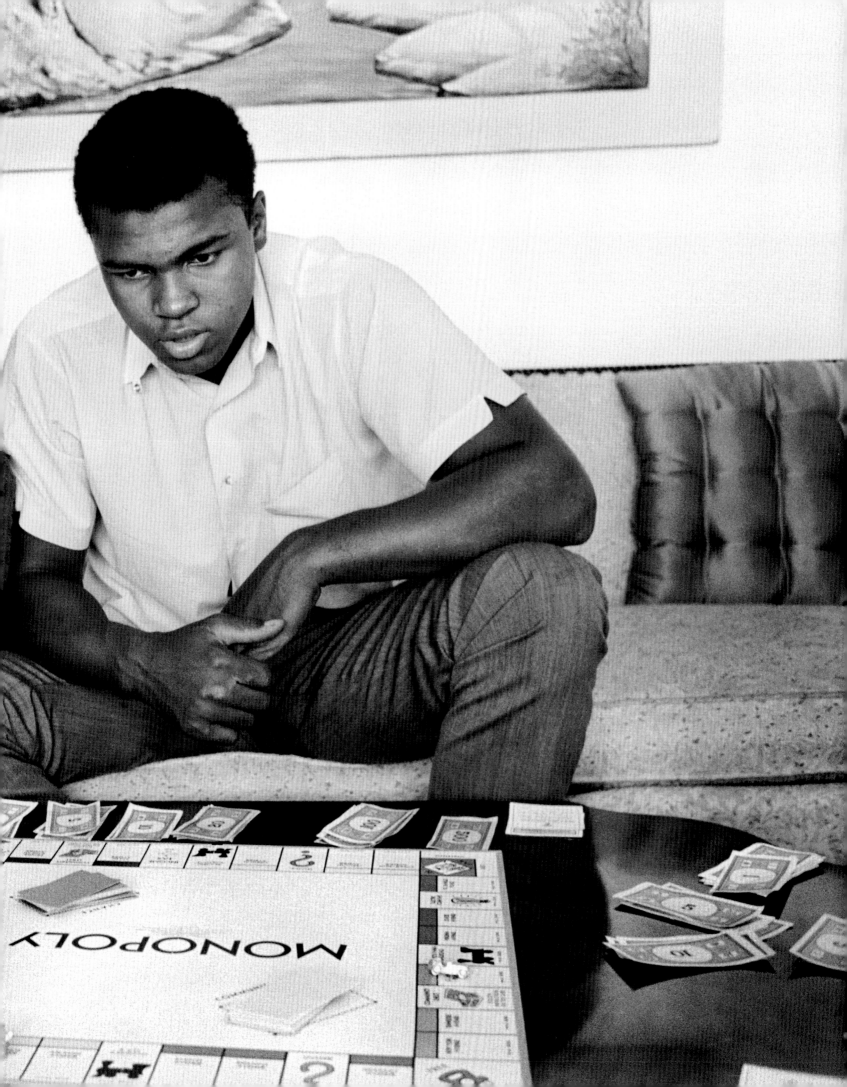

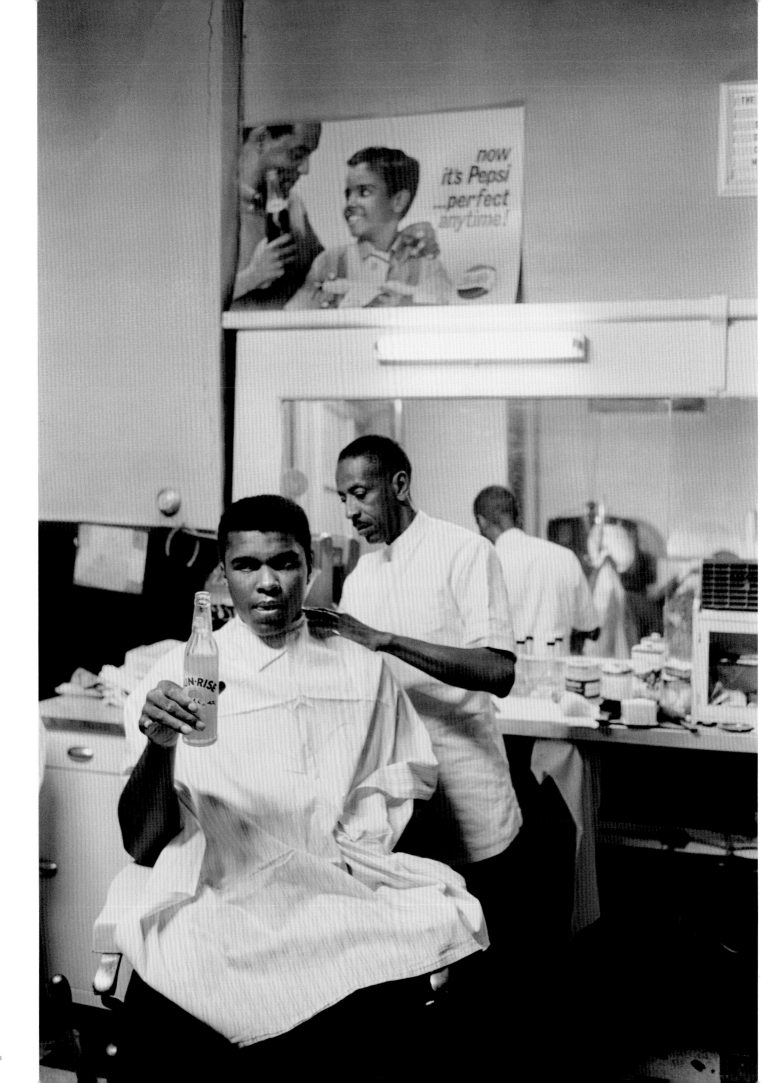

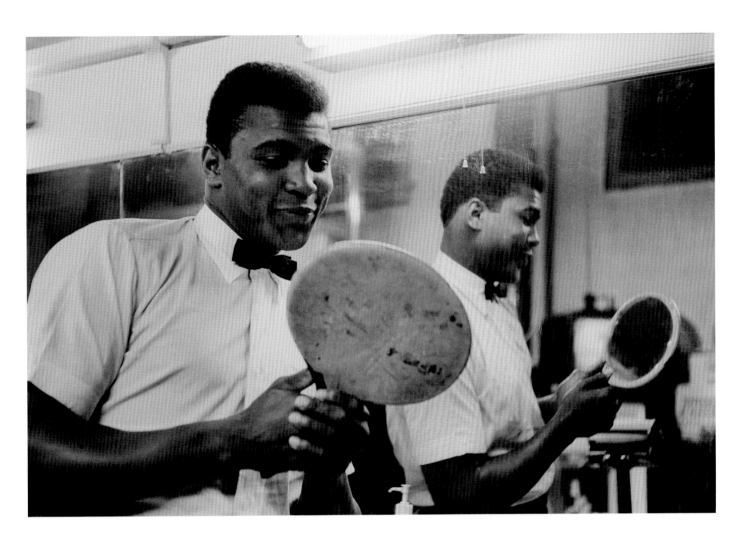
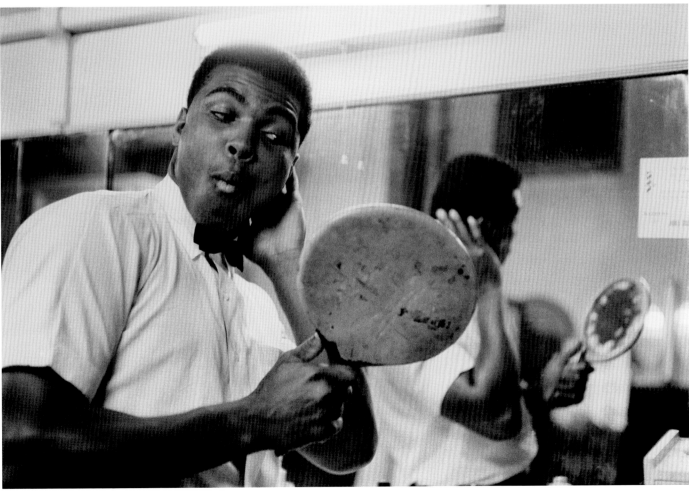

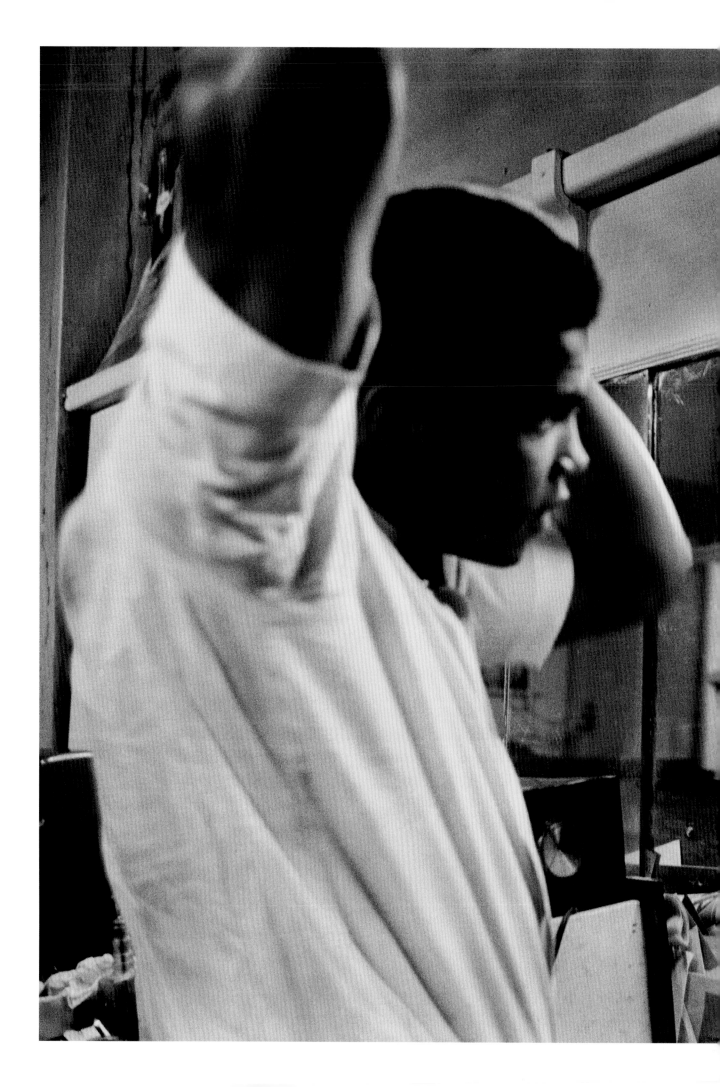

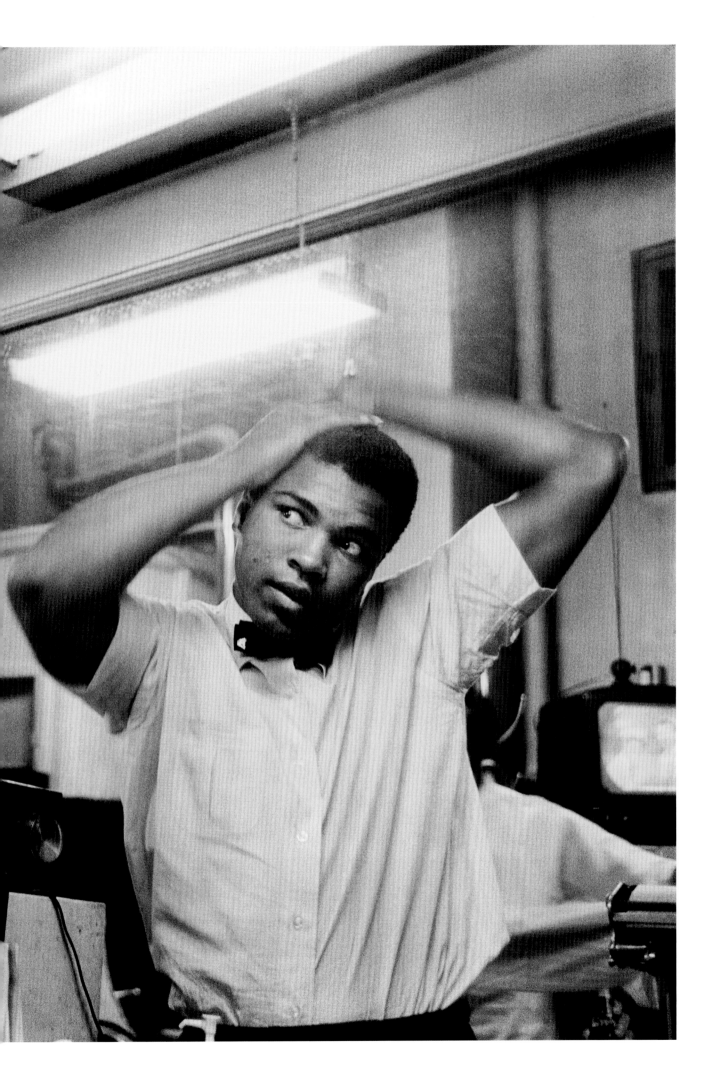

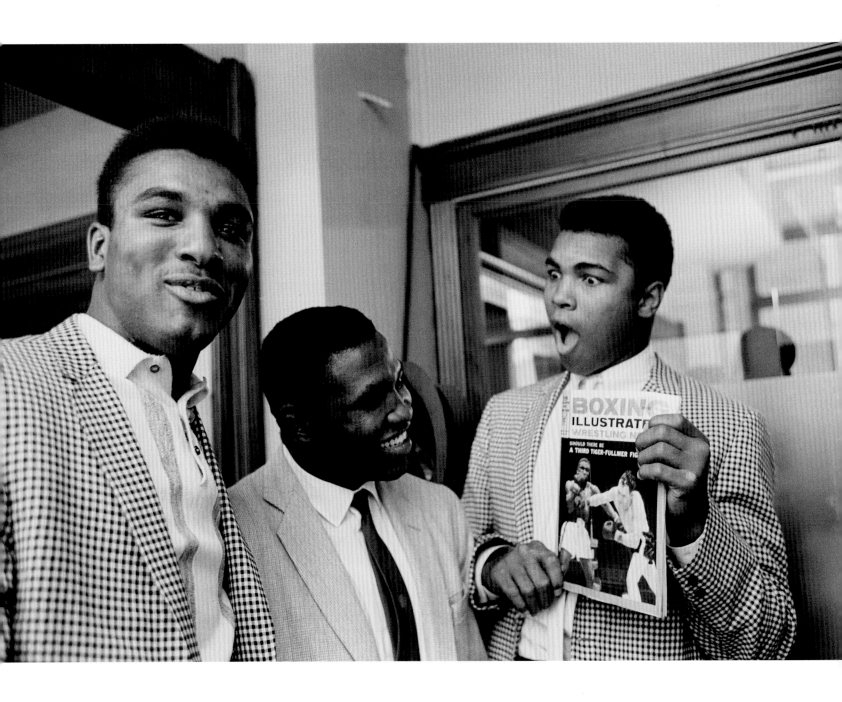

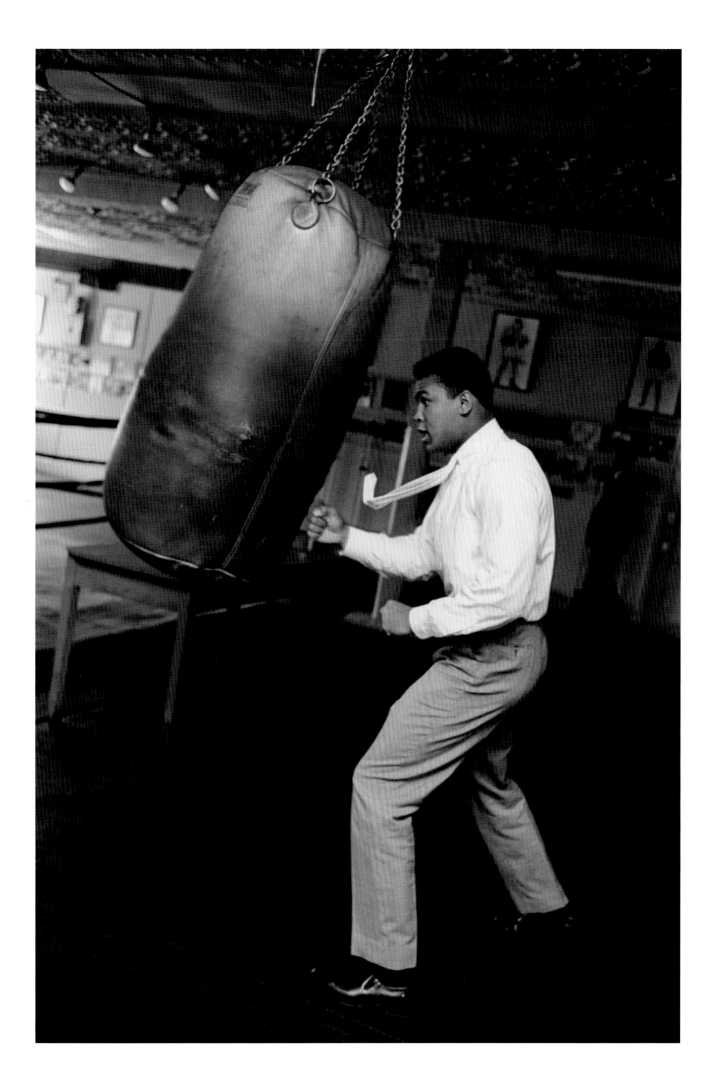

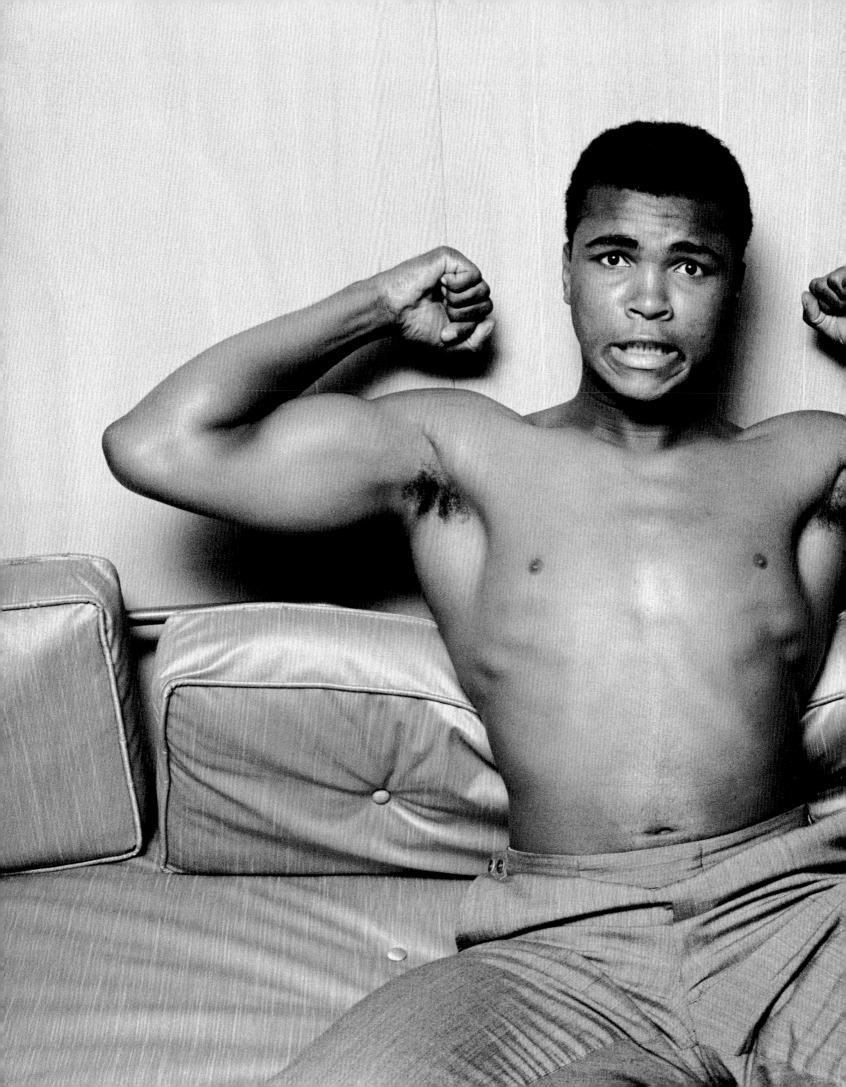

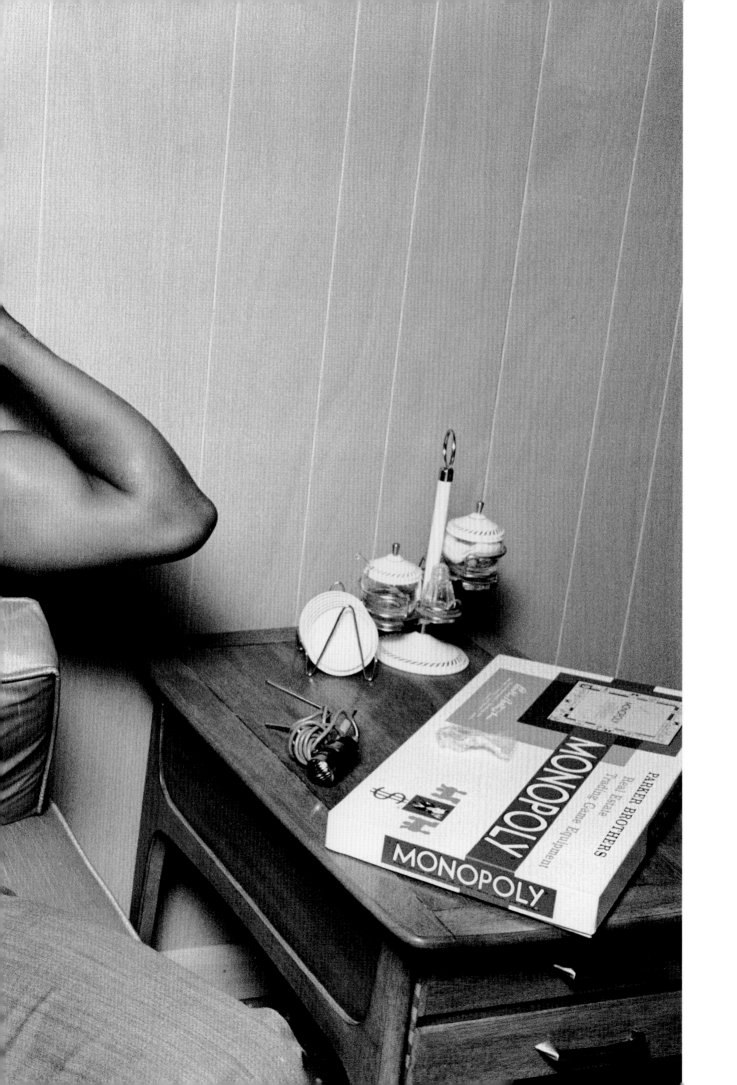

ANDY WARHOL

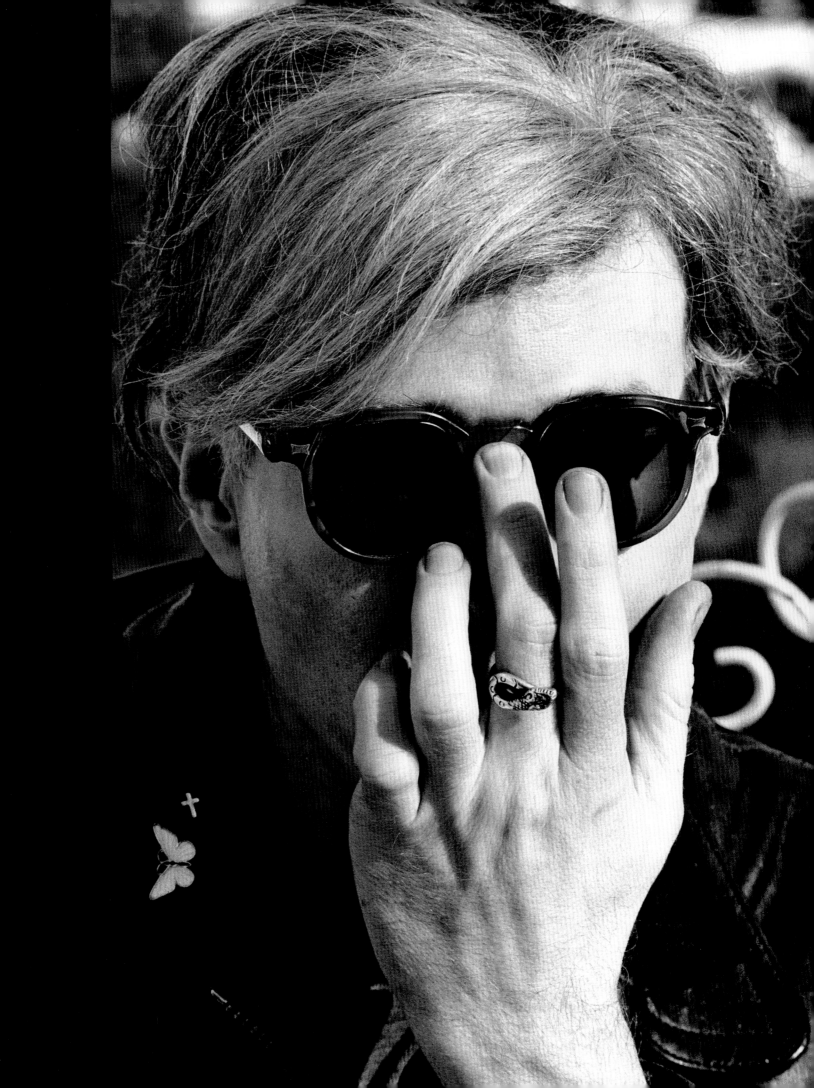

Andy Warhol went from drawing shoe sketches for department stores to becoming one of the most influential artists of the 20th century through his silk screen paintings, his movies, and his words. Incredibly shy, but with an unquenchable thirst for gossip and merchandising, he gradually learned how to project a special charisma, which the whole world fawned upon.

Henry Geldzahler, then the curator of Contemporary Art at the Metropolitan Museum and major tastemaker of the Pop Art revolution, introduced me to Andy in 1964. Gathering material for a *Life* story that never ran, I photographed Andy in New York and Los Angeles over a period of several years.

Every pop culture star wanted to visit the Factory, the legendary aluminum foil and silver-painted loft where Warhol's paintings and early movies were made. Endless stories of sex and drugs were reported in the gossip columns. At one party I attended, Tennessee Williams, Judy Garland, and Rudolf Nureyev all arrived. Dennis Hopper came to the Factory, Bob Dylan was photographed there, and Lou Reed, Nico, and the Velvet Underground emerged from its sliding doors.

Andy would sometimes be invited to dinner parties at the posh homes of New York art collectors who wanted to show him off as their special confidant. For a substantial fee, he would gladly paint a silk screen of any of them. At those socialite parties, Andy rarely talked. He stayed close to his entourage, and as they whispered hushed comments amongst themselves, the rest of the room would look on in bewildered wonderment.

In public, Andy hid behind a posed, emotionless mask, which allowed him to watch everything happening around him without showing any sign of a reaction. In photographs, he generally struck an inexpressive pose, one finger to the side of his mouth. In conversation, he would give the impression of being hopelessly naïve, but he used his calculated intelligence to perfection, often answering questions from interviewers with a soft-spoken "Gee, I don't know. Why don't you just answer it for me?" He even occasionally sent pretend Andys to give talks in his place.

I believe I did see the real Andy once, when I photographed him and Edie Sedgwick at a party in Los Angeles. Andy seemed so totally enthralled with Edie's charm that night, and his face lit up into a warm, human smile that I had never seen before and never would again.

Andy is famous for saying that everybody will be famous for fifteen minutes. But Andy himself will be famous for many, many years to come.

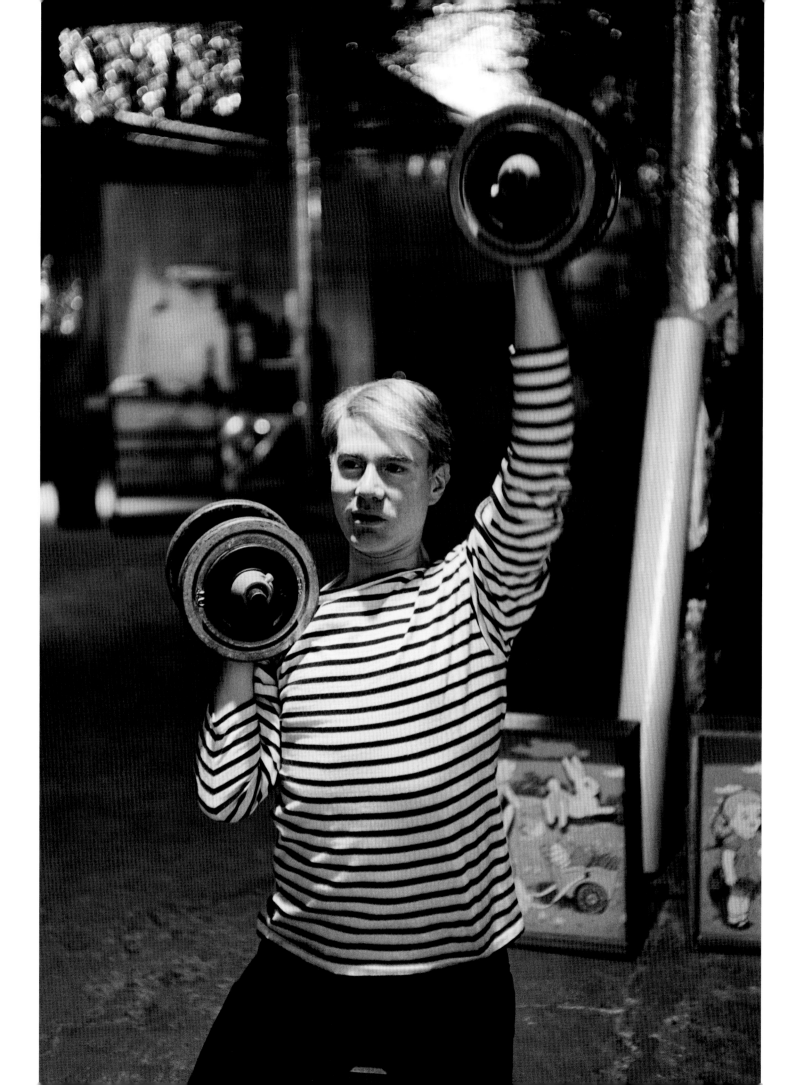

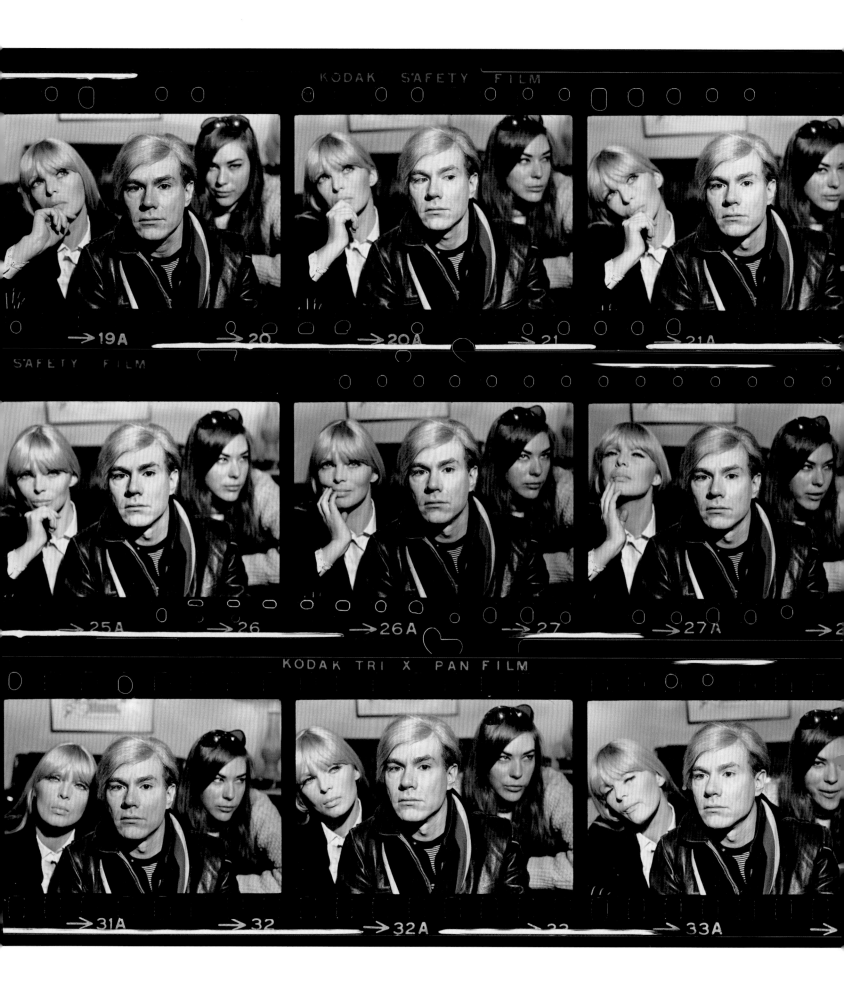

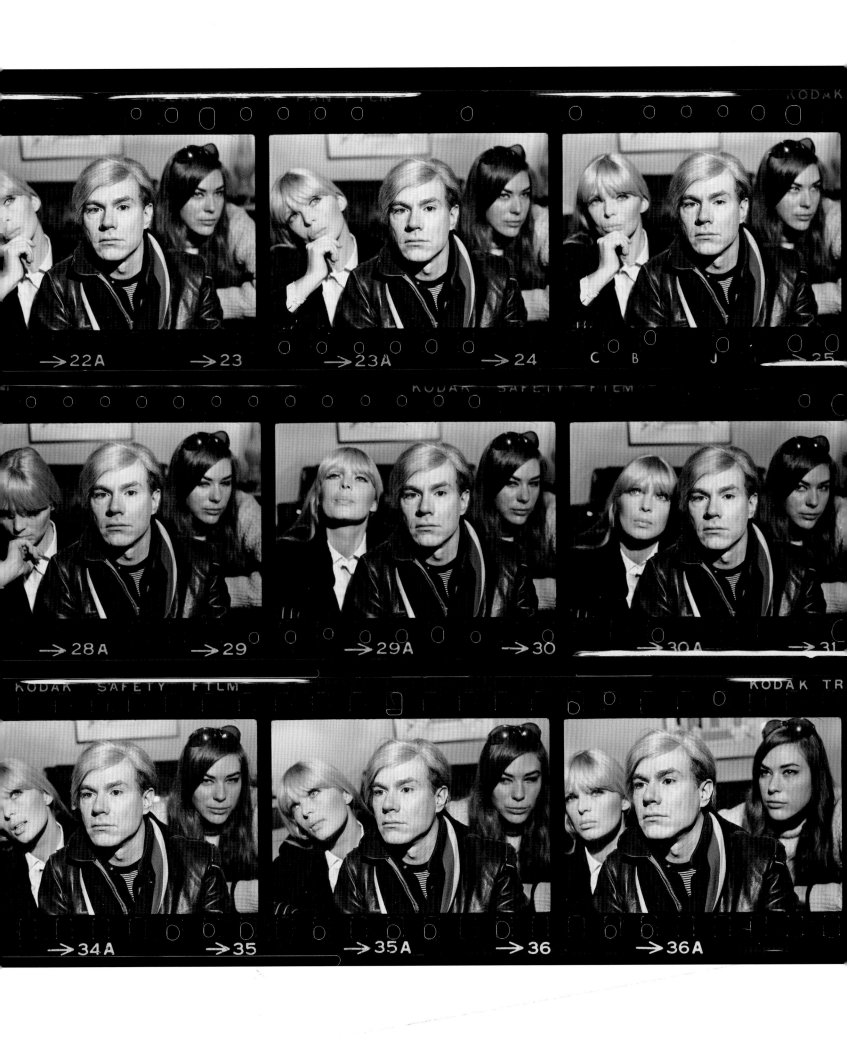

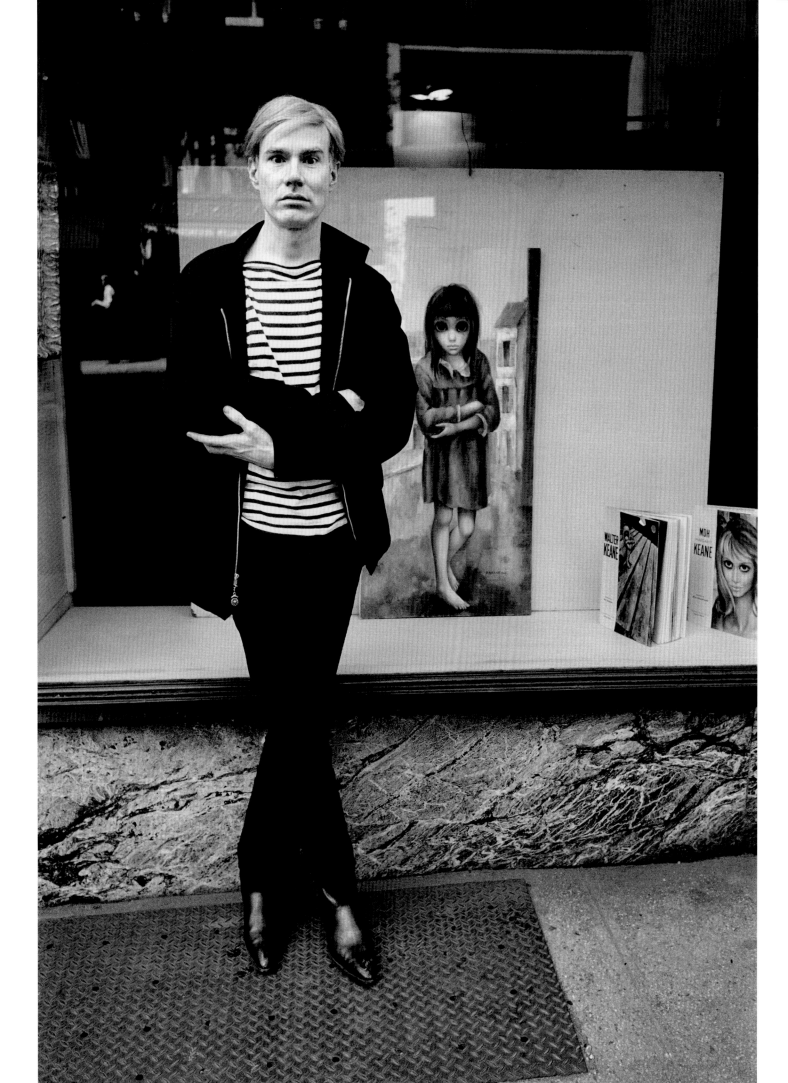

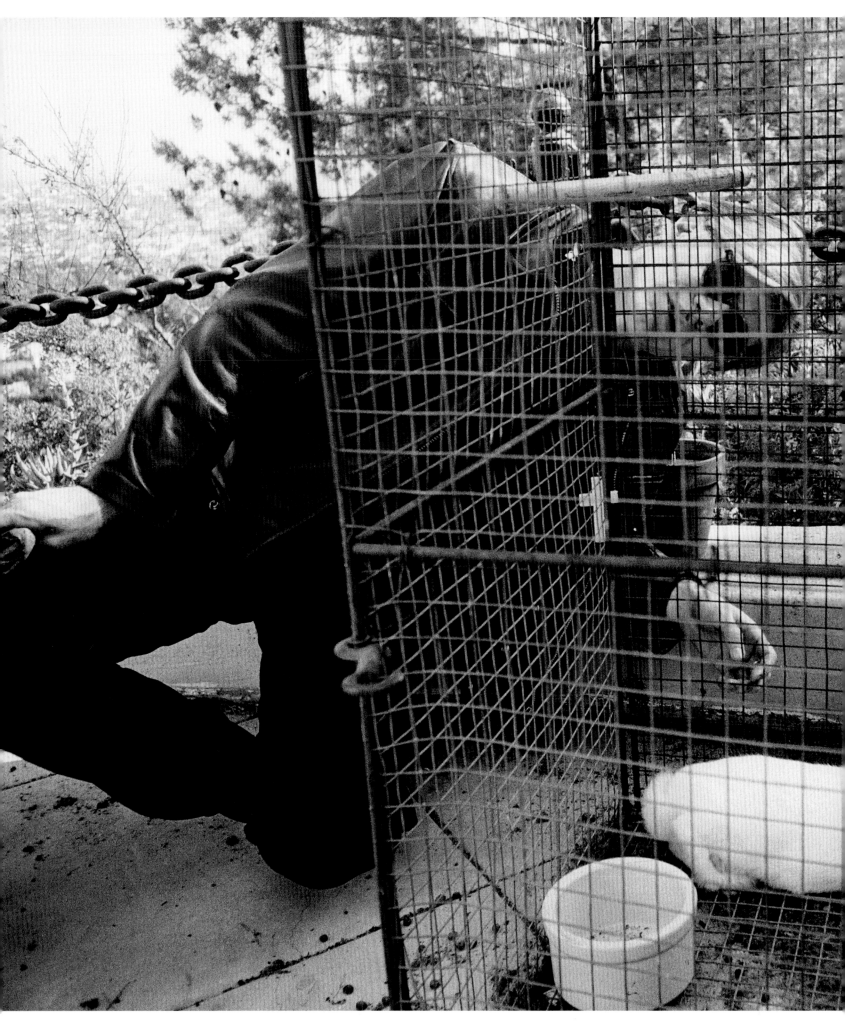

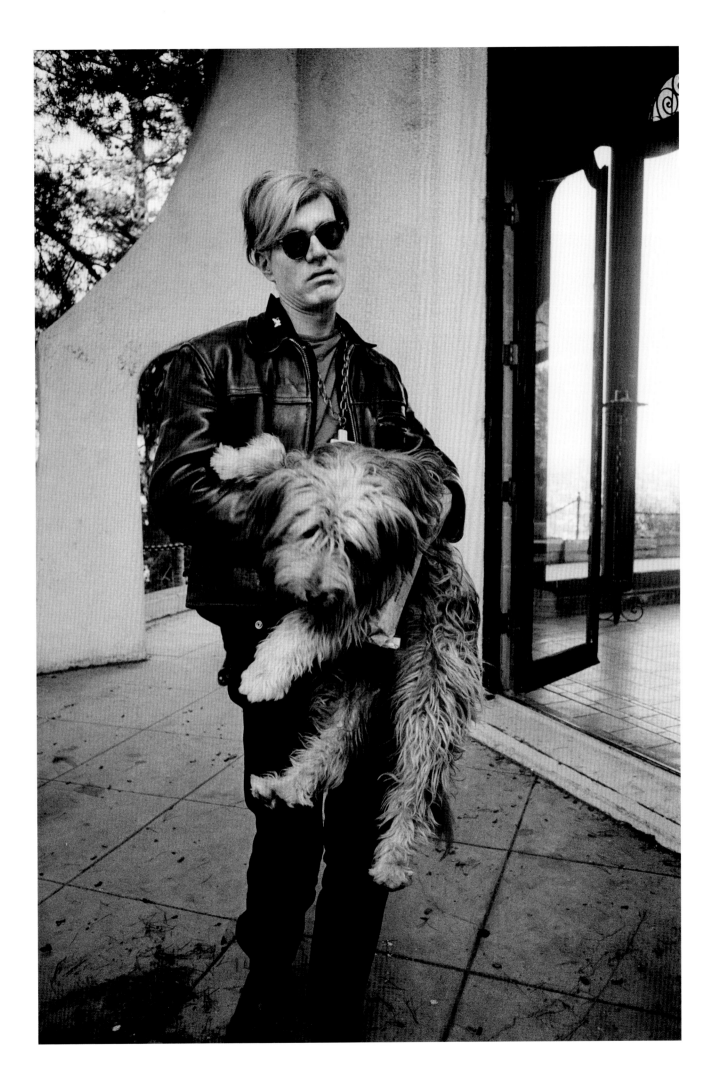

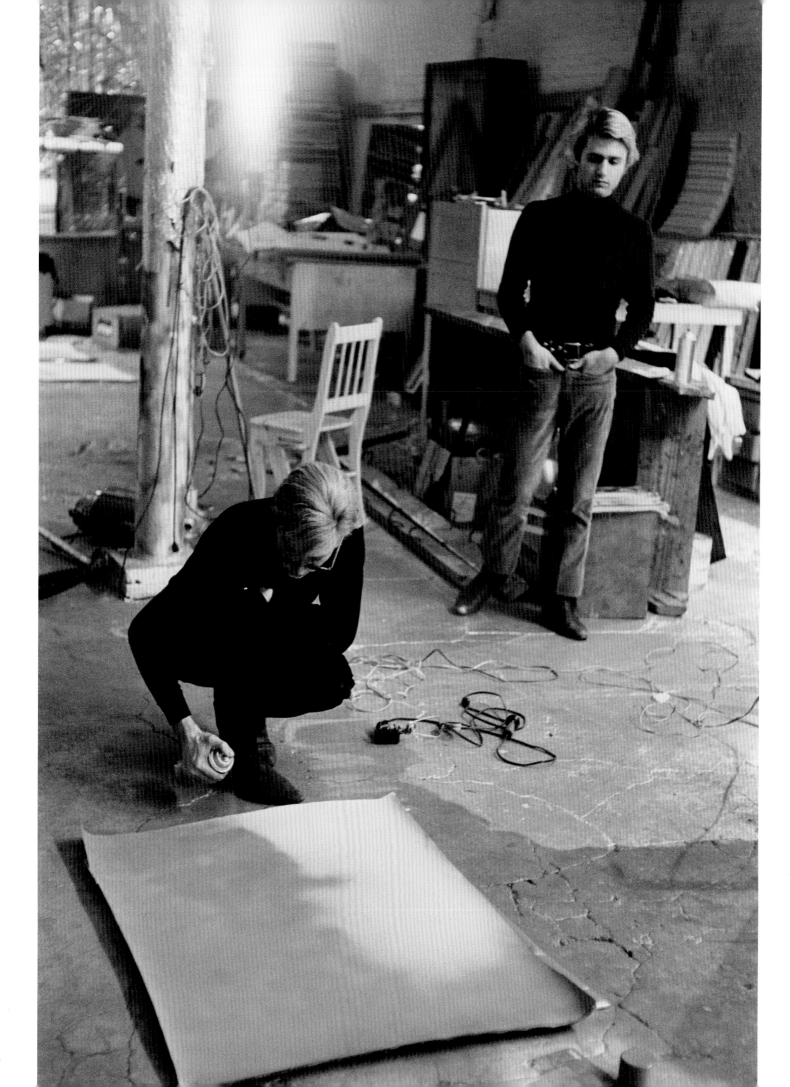

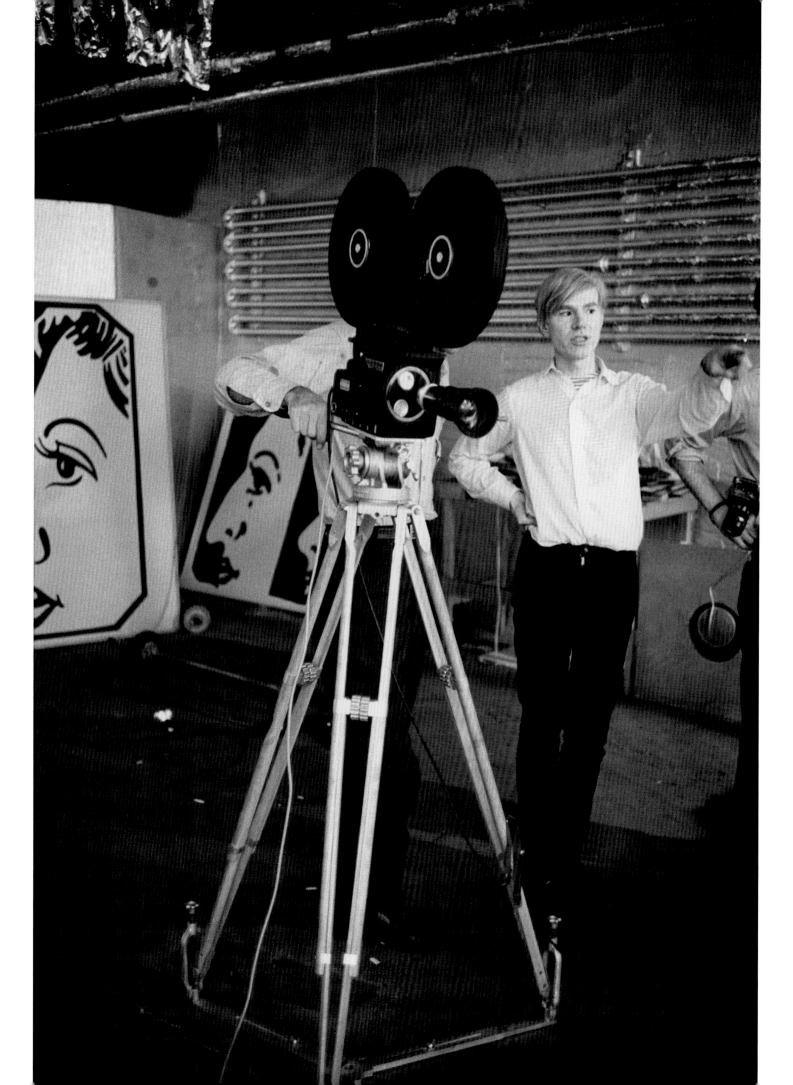

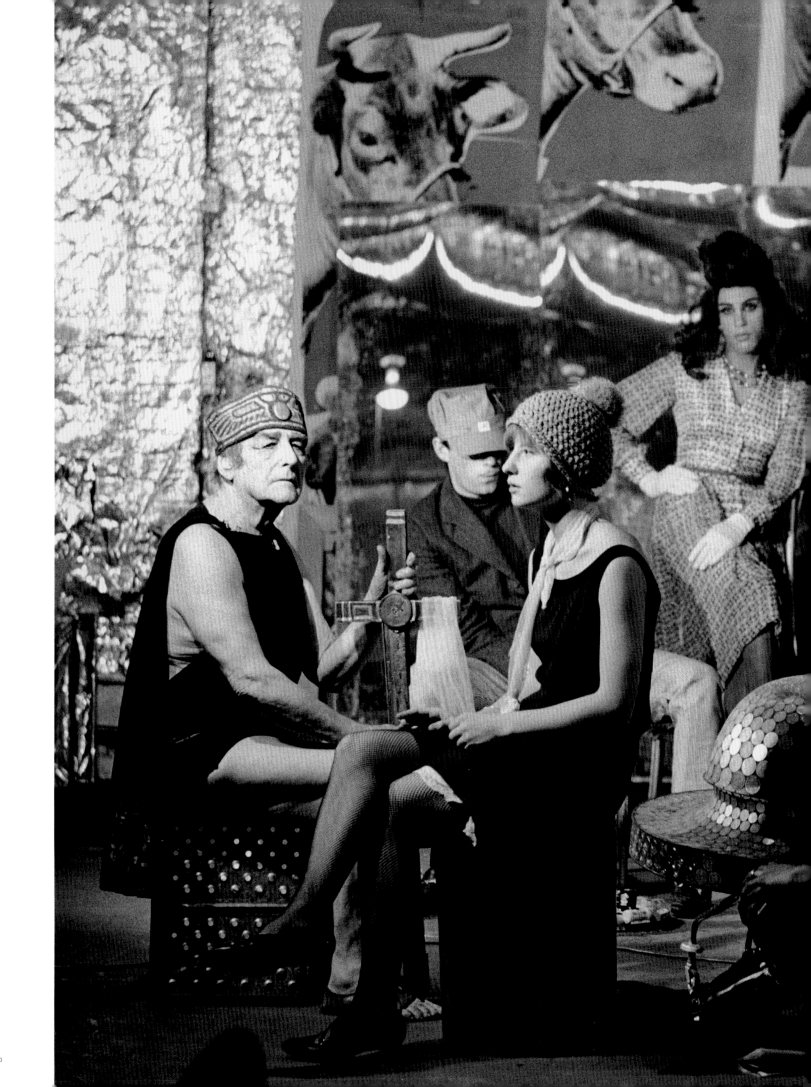

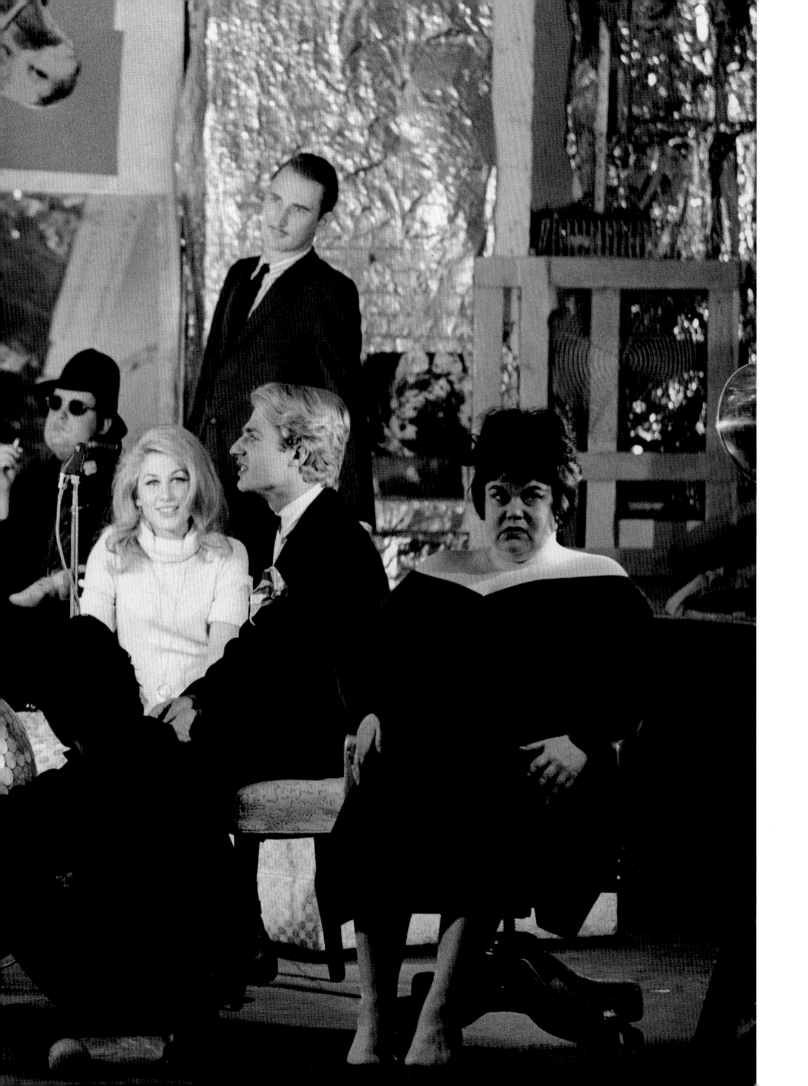

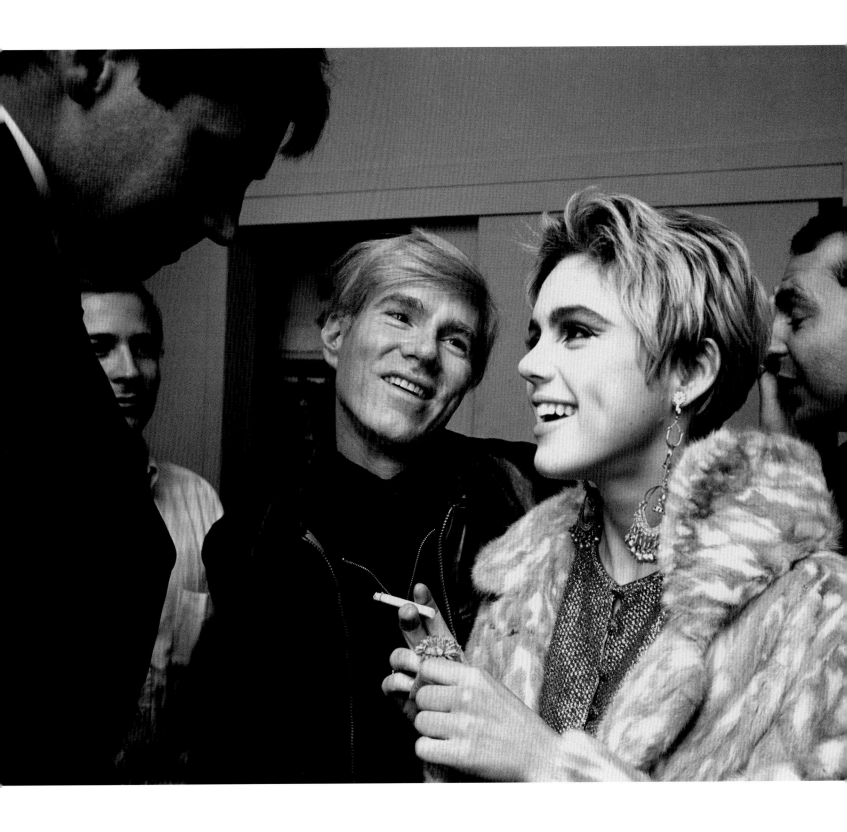

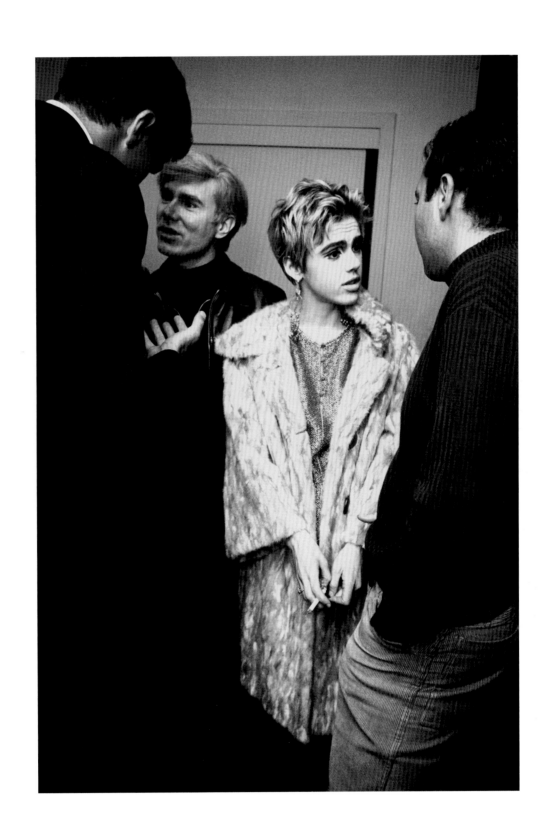

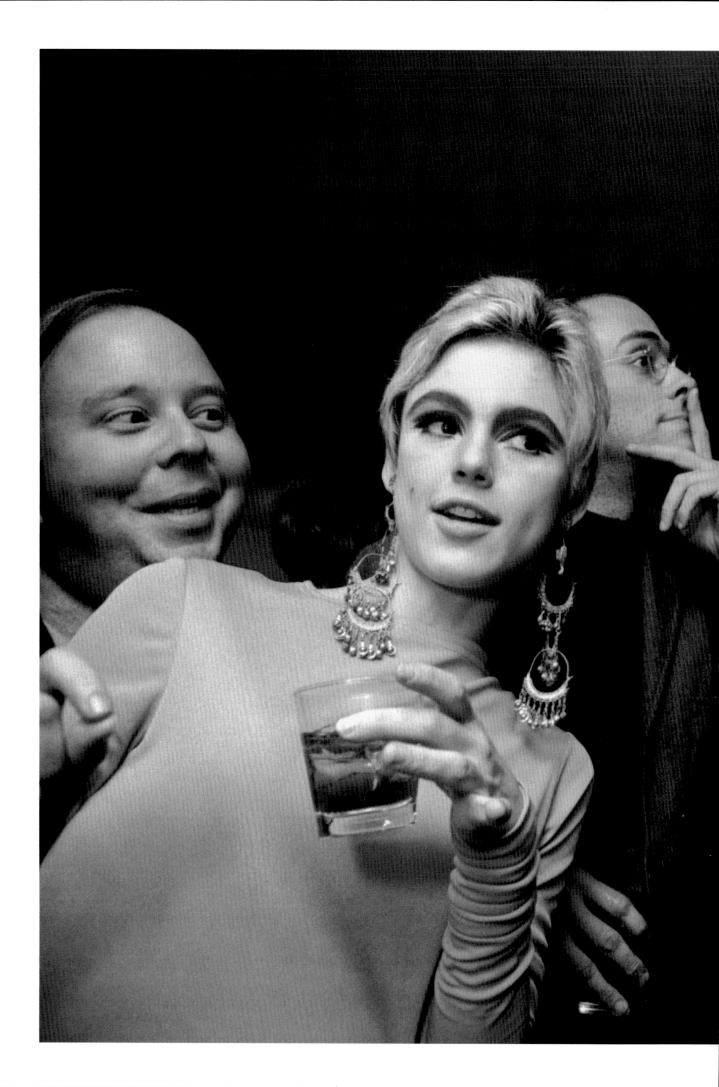

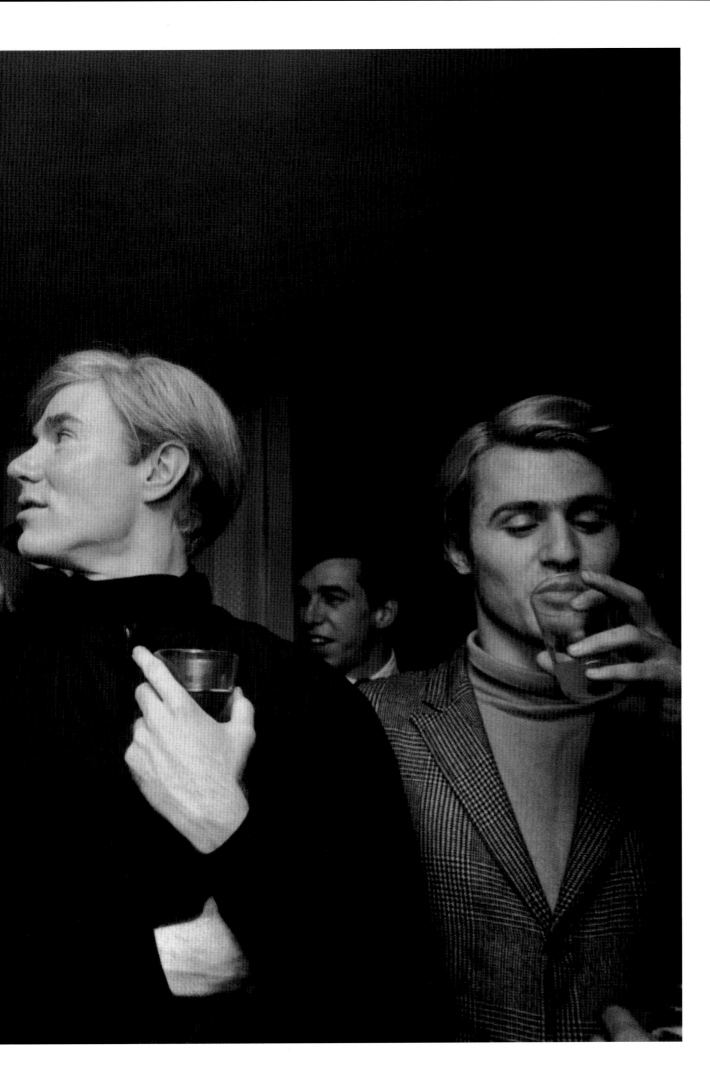

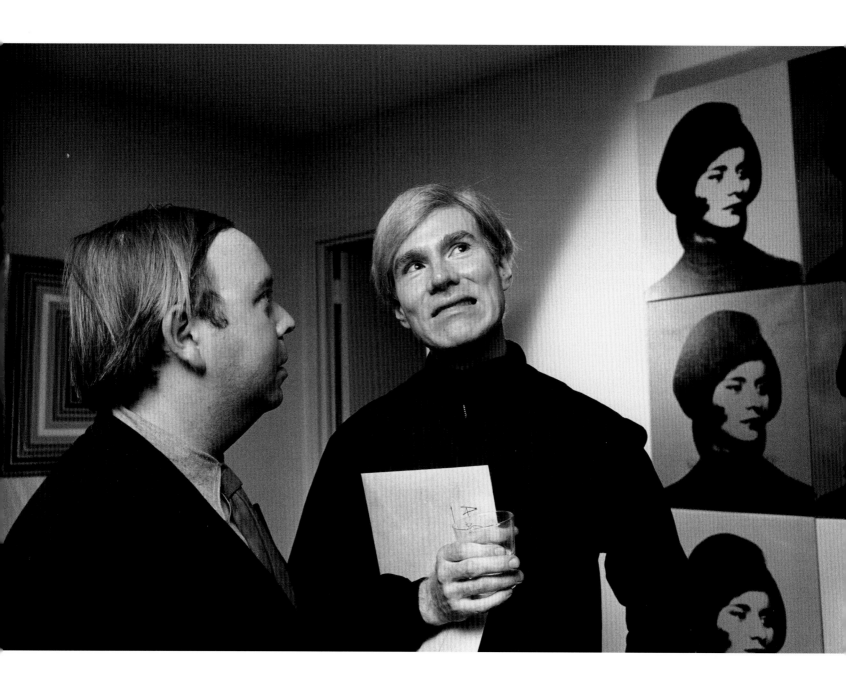

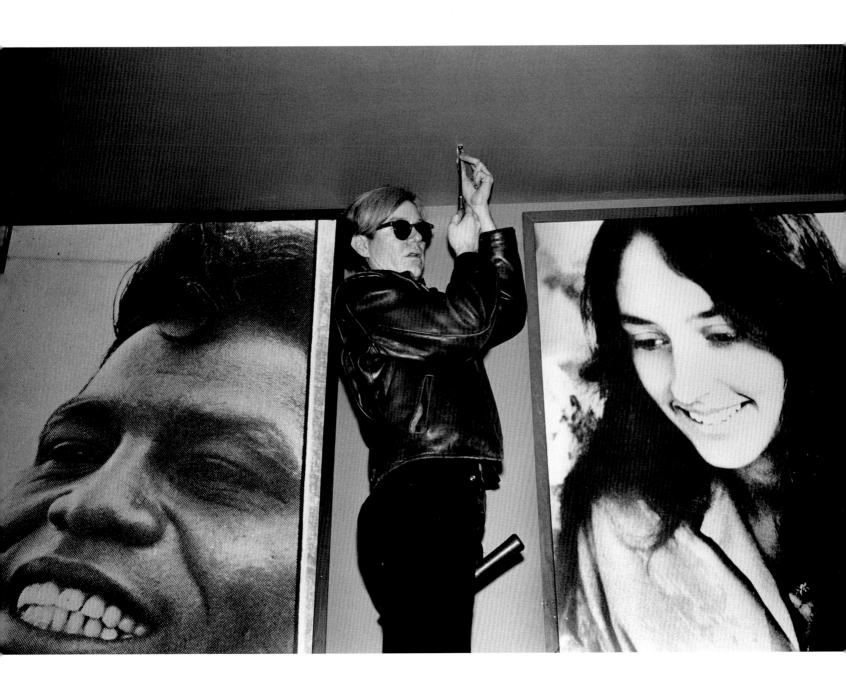

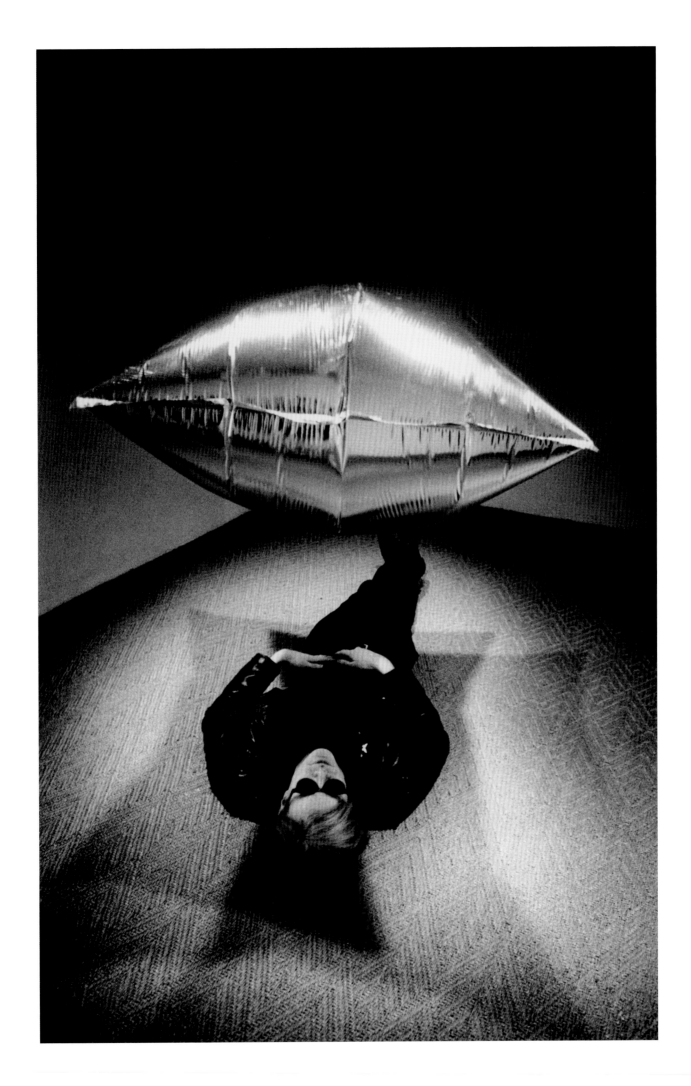

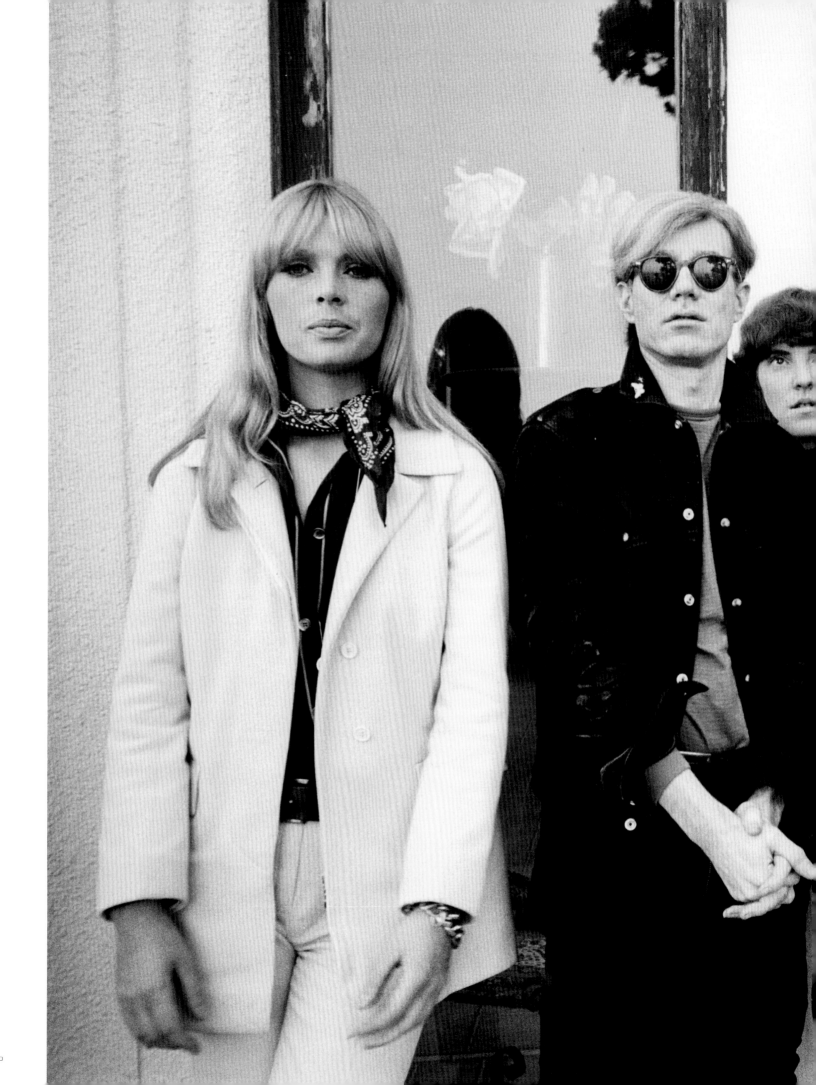

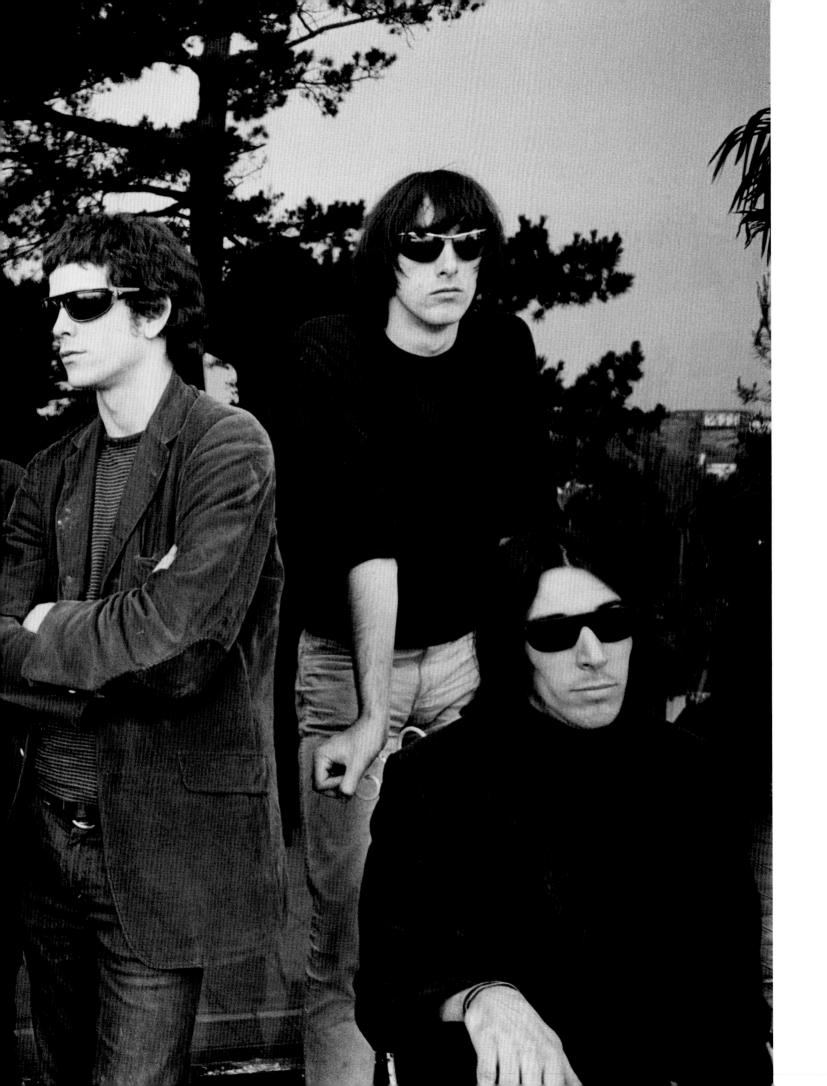

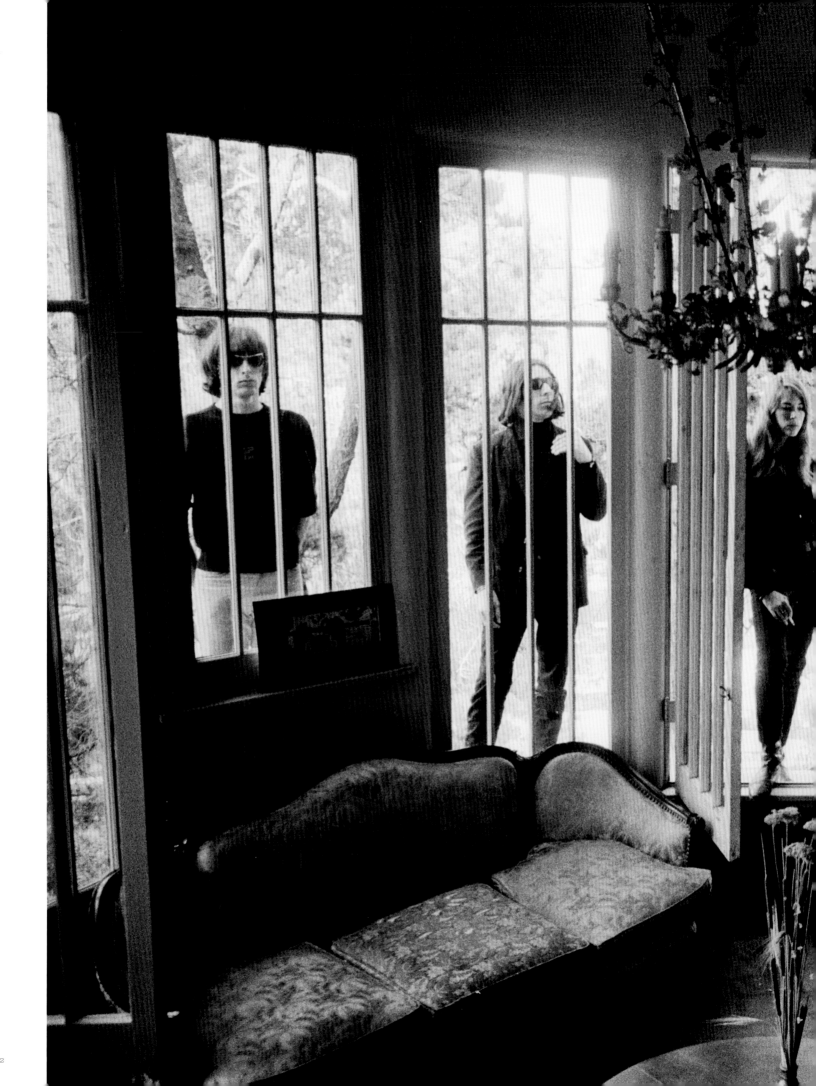

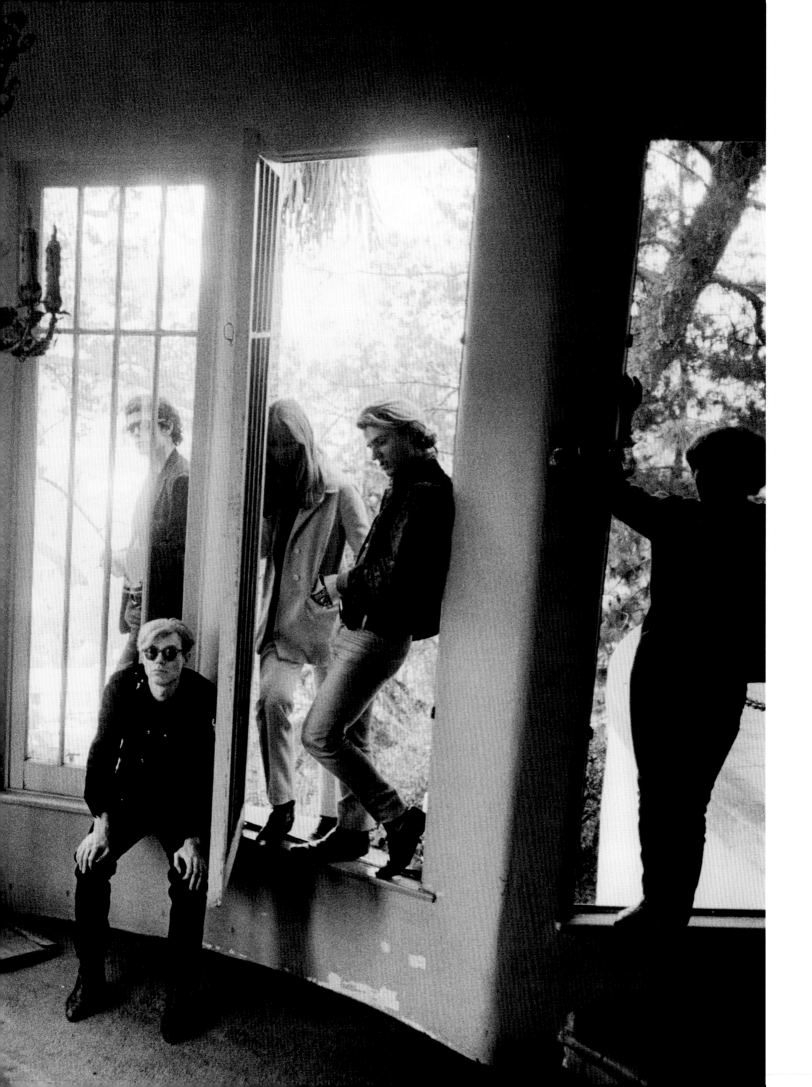

RAY CHARLES

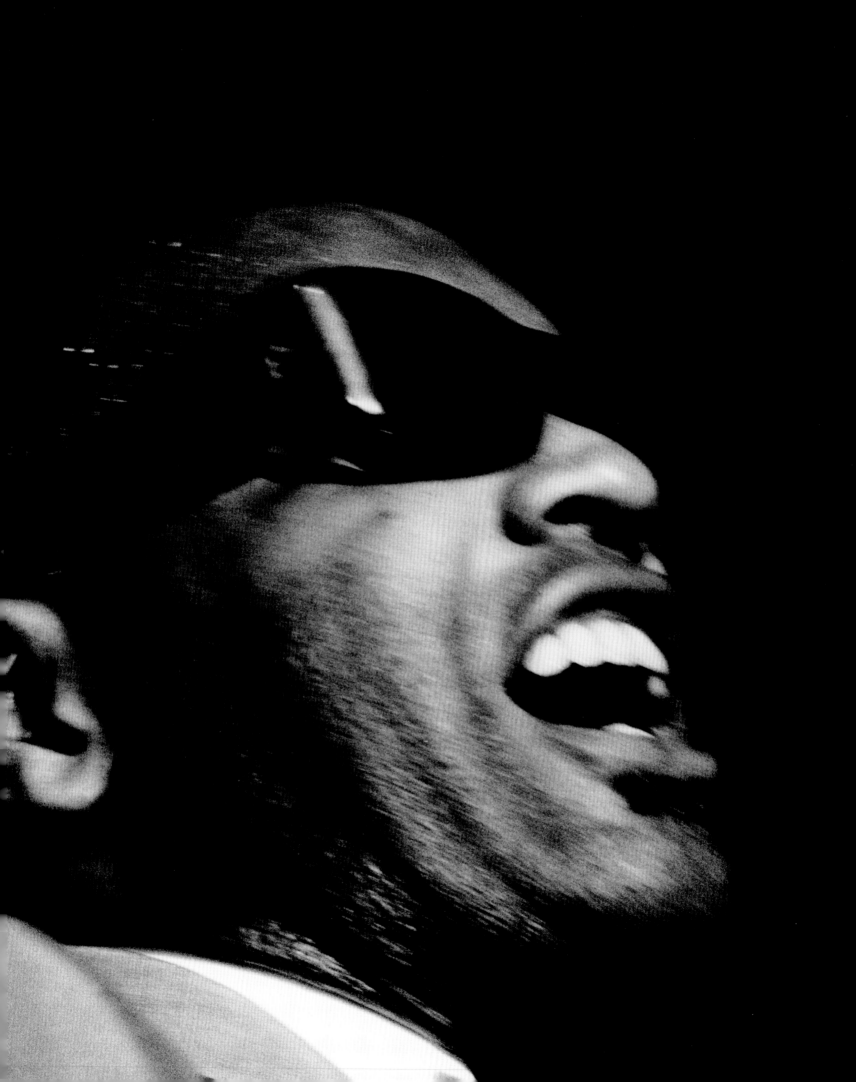

Henry Luce, the founder of *Life* magazine, would go through the make-ready pages each week before the magazine went to press. Looking at the pages, he would point his finger at a war photograph and mutter, "That's history! That's history!" Coming to a portrait of the new British Prime Minister, he would proclaim again, "That's history!" Next would be a double-page entertainment story featuring Elizabeth Taylor, Clark Gable, or perhaps Sammy Davis Jr. "Freaks! Freaks!" he would cry out, and quickly turn the page to find more history.

Yet history is cemented not only by the George Pattons and Dwight D. Eisenhowers, but by our cultural heroes as well.

So many great personalities I've met and photographed started out with one kind of disadvantage or another, which only added to their determination. Ray Charles is no exception: he became blind at the age of seven. He once said, "What you are inside is what you are inside."

Ray was raised in the church, but hung around the blues. He would listen to the musicians on jukeboxes, then go to revival meetings on Sundays. He heard all sorts of music. Many in the church community thought it was sacrilegious to listen to pop music, but Ray absorbed it all.

I photographed Ray with the Raelettes at a New Jersey nightclub. The large hall was brimming with an excited audience, sardined into rows of packed tables. What I loved best about Ray's performance was the moment when stood up from the piano. To see him in the center of the stage, shaking and shimmying, was a unique experience. He clearly had fused together all of his childhood musical influences, from gospel to blues to rock.

Another time, I followed Ray to ABC Records' offices in Manhattan for a meeting about his album *Together Again*. The meeting took place in a boardroom, with twelve executives sitting at a long, polished table. Ray's blindness may have helped him curb any feelings of intimidation circulating through that windowless room, but as usual, he was his own boss and they all knew it.

Ray Charles said, "I've never written or arranged anything I was unhappy with later." He added, "It's like Duke Ellington said; there are only two kinds of music—good and bad. And you can tell when something's good."

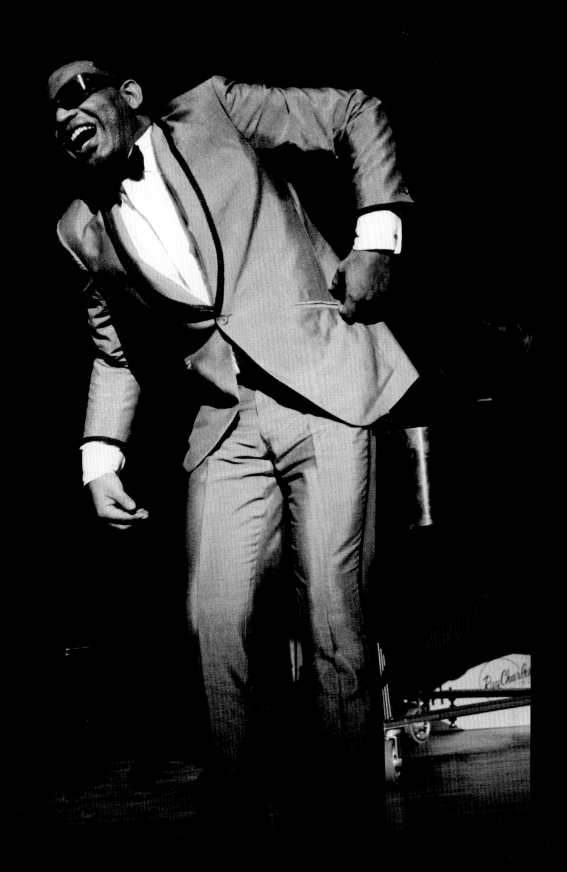

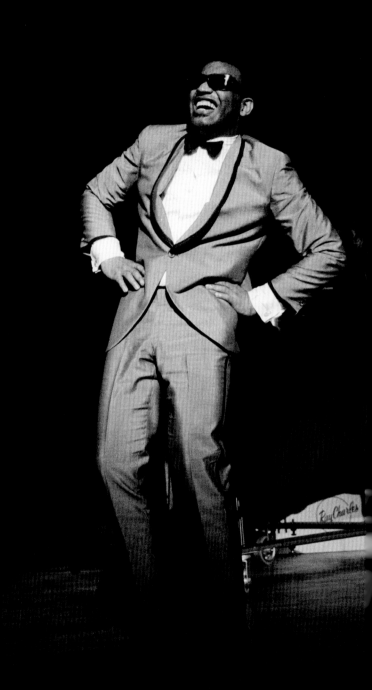

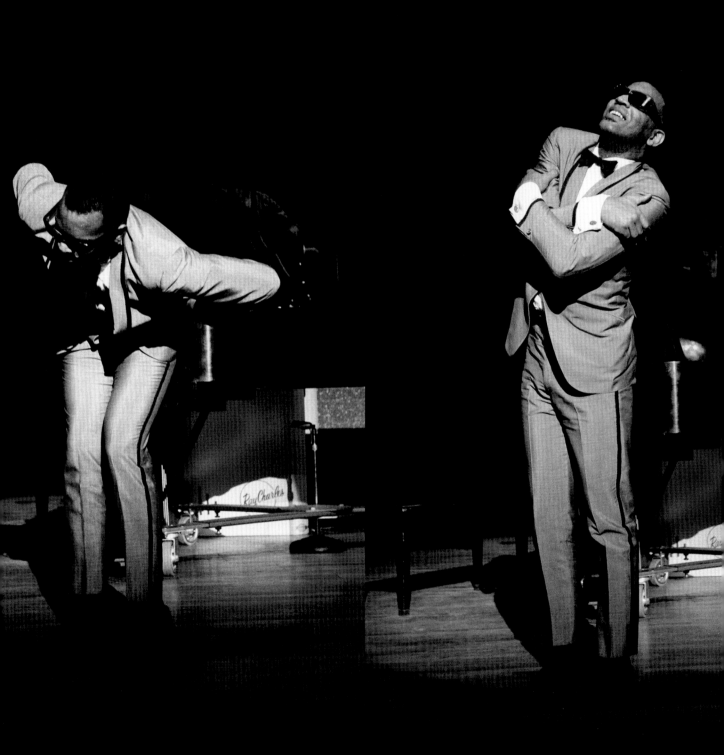

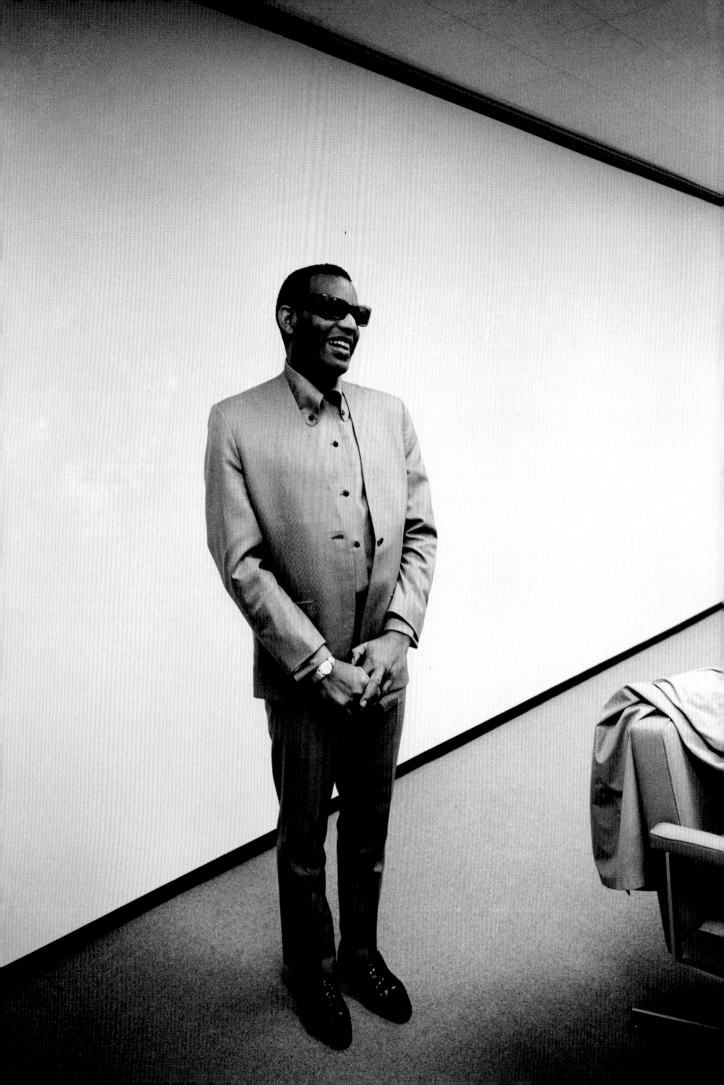

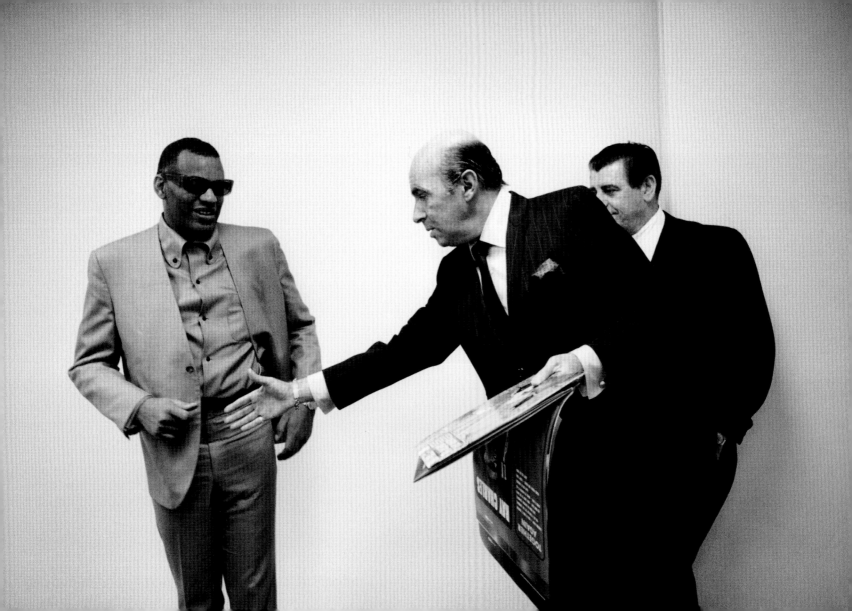

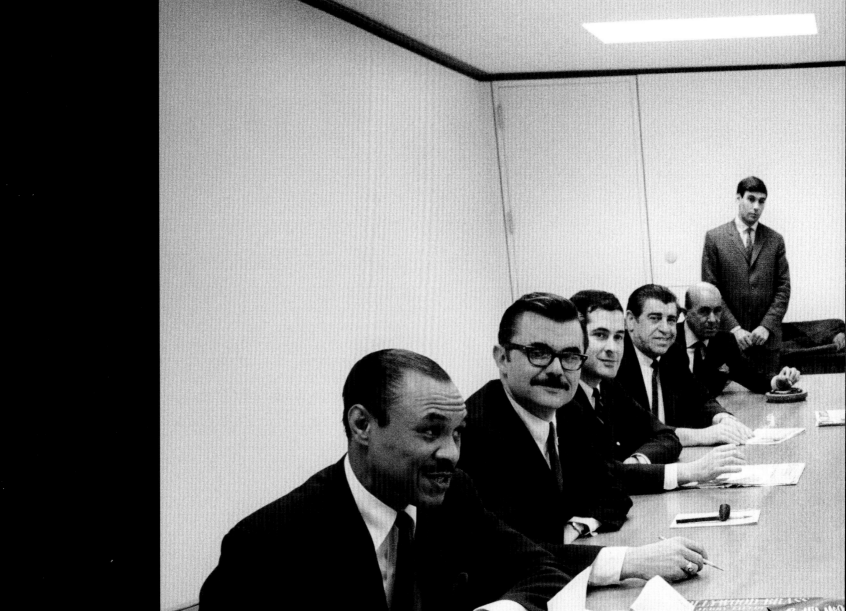

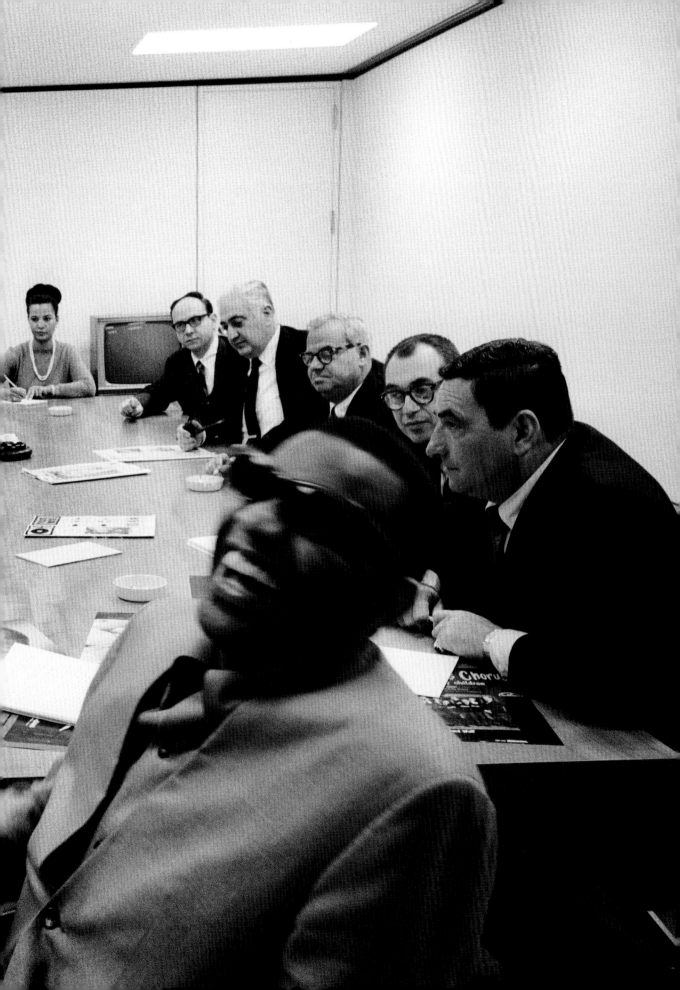

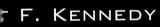
F. KENNEDY

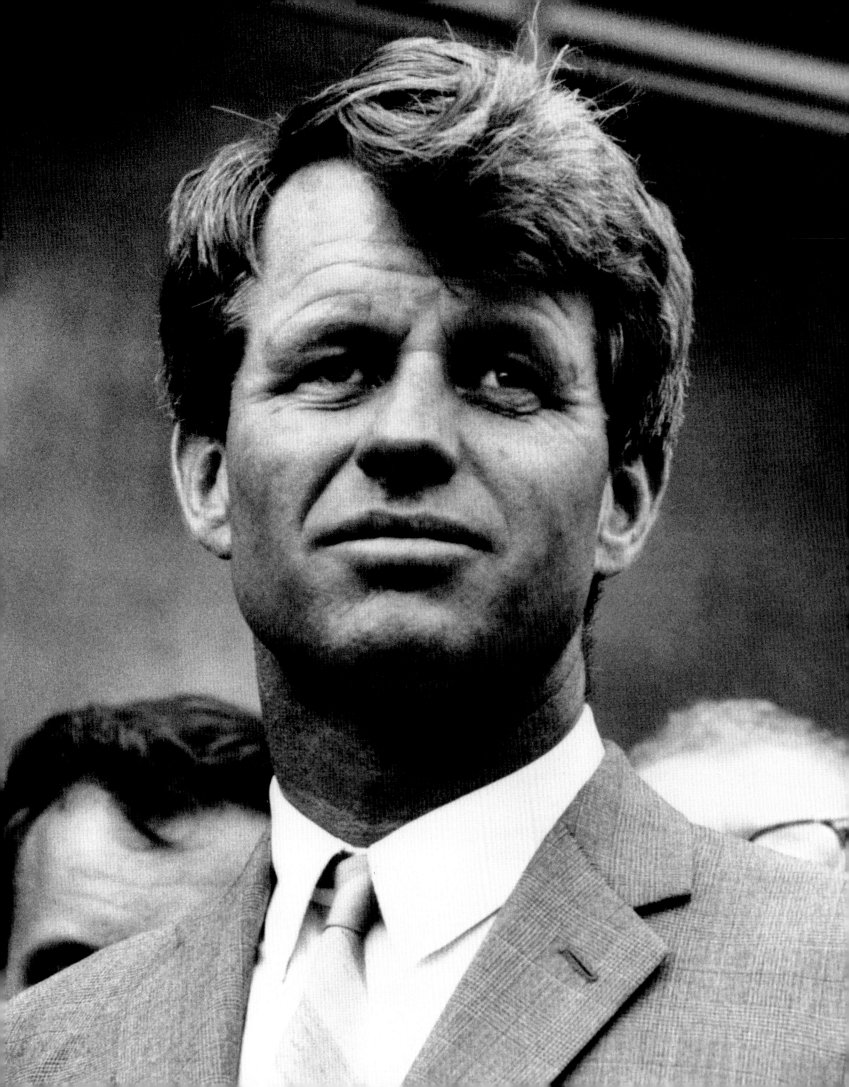

Robert F. Kennedy was considered the runt of the Kennedy litter. There is no question that he was a complicated man who lived life to the fullest. No sequence of pictures will ever tell his full story.

I first photographed Bobby Kennedy at the Democratic National Convention in 1964, where a film of his brother John F. Kennedy's life was screened. The picture I took was of Bobby at the podium with a tear in his eye. Pat Carbine, then the editor of *Look* magazine, took that photo and kept it in her desk drawer.

I followed Bobby while he was running for the Senate in New York. Everywhere he went, he was mobbed by people who just wanted to touch him and shake his hand. Thomas Hoving was also running for office in New York, and had been seen in the daily papers throwing a football in Bedford-Stuyvesant. Bobby had me deliver a personal message to Hoving that he was making some very important enemies, and should quickly learn that football was a Kennedy thing.

When I accompanied Bobby and his wife Ethel to South America for a three-week tour, it seemed Bobby felt more at home in the slums than with dignitaries. Public speechmaking had not been his natural talent, but the trip to South America gave him the opportunity to give speeches several times a day in preparation for a run at the American presidency. In the villages we drove through, the people spoke a different language, but Bobby's charisma and sincerity translated well. The Kennedys were dearly loved. In Rio de Janeiro at the statue of Christ the Redeemer, a man blessed Bobby by sprinkling rose petals over his head.

I photographed Bobby for his campaign poster; he was an easy subject. His commitment to making the world a better place shone through his eyes. There is no doubt in my mind that the country would have changed for the better if Bobby had become president. He seemed to have an unspoken mandate to accomplish the changes his brother Jack had set out to make. Politically, Bobby had the three qualities necessary for leadership—intelligence, a strong sense of compassion, and the ability to play politics. But his charisma was his most valuable gift.

For the presidential campaign, Bobby picked halls and auditoriums that were too small, thereby making the crowds always at overflowing capacity. In order to cover a speech, I found I had to walk right behind Bill Barry, his bodyguard, as he pushed his way into the auditorium through the crowds, otherwise I would never make it inside the venue.

In Berkeley, California, Bobby delivered a speech to an immense horde of press and supporters. After the speech, Bobby got wind that the press had latched onto a different issue than the one he had wanted to stress. He invited the entire press corps to his private rooms, and while they drank and enjoyed the hospitality, Bobby and his staff were in the bedroom calling the reporters' editors to correct the message. He wanted to be assured that the right aspects of his speech would be highlighted.

He was kind to all those he met in his travels, and was loved dearly by the people who followed his trail to the White House. More than that, he was a family man with a deep sense of values. In 1967, I spent Christmas with the Kennedys in their Hickory Hill home, and tried to capture his love of family in my pictures; whether I captured it or not, I felt it. That was Bobby's last Christmas.

When Bobby was shot, Pat Carbine took out my photo of him shedding a tear and used it as the cover of the *Look* memorial issue. I have yet to meet a person in politics whom I could respect more than Robert Kennedy.

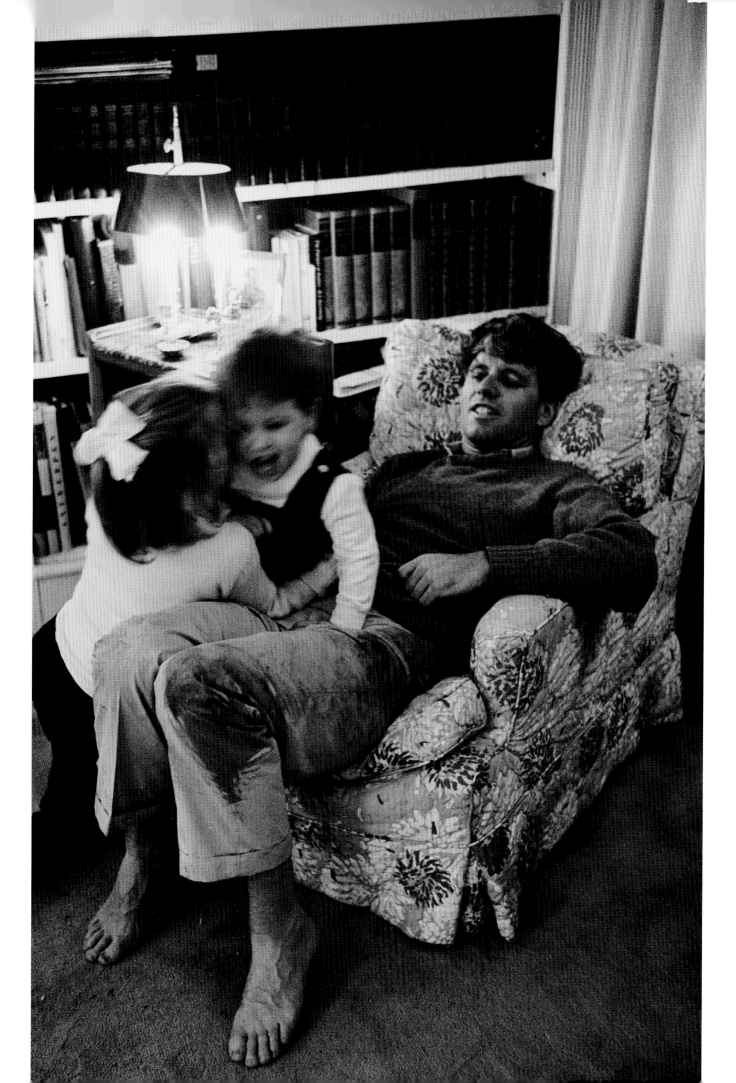

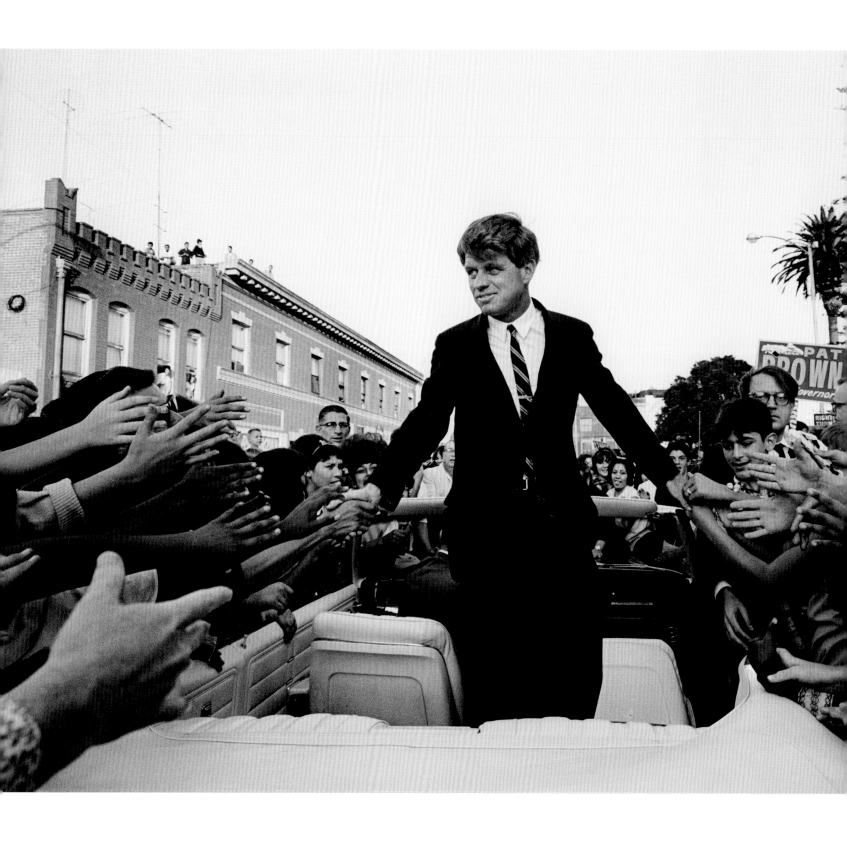

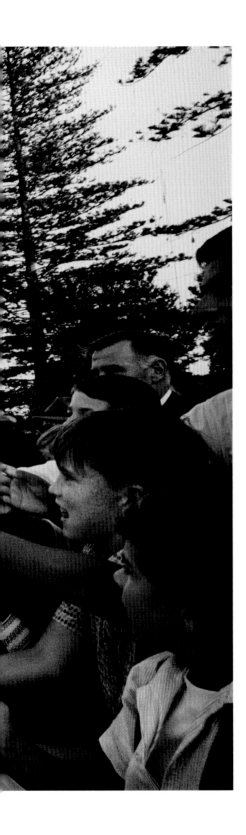

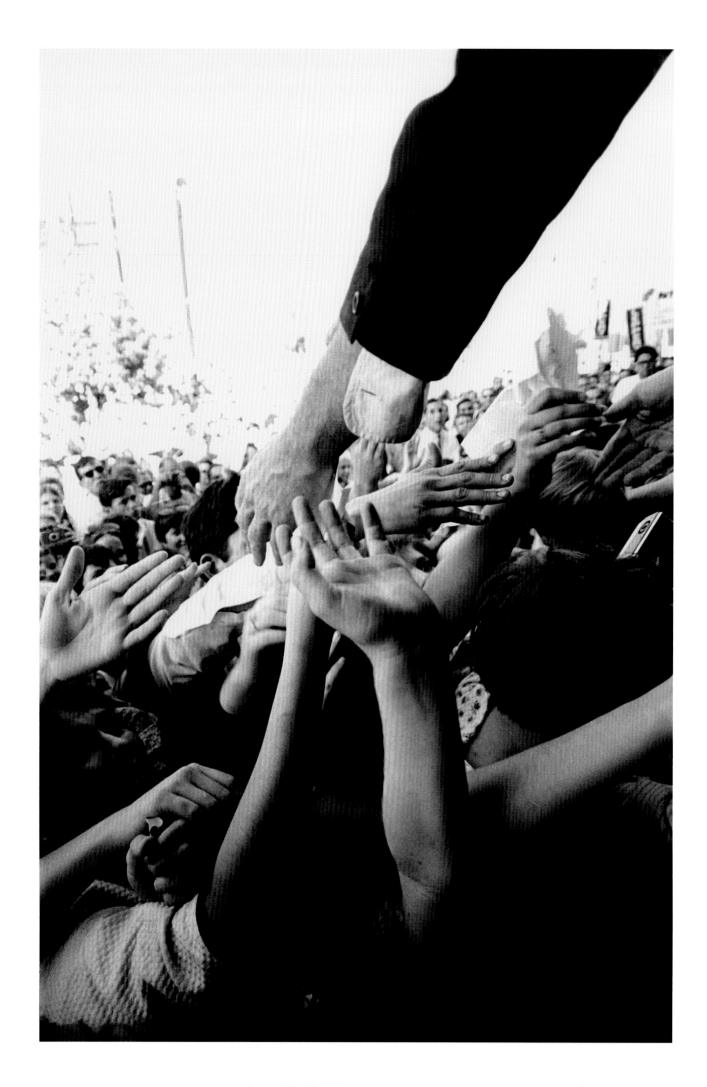

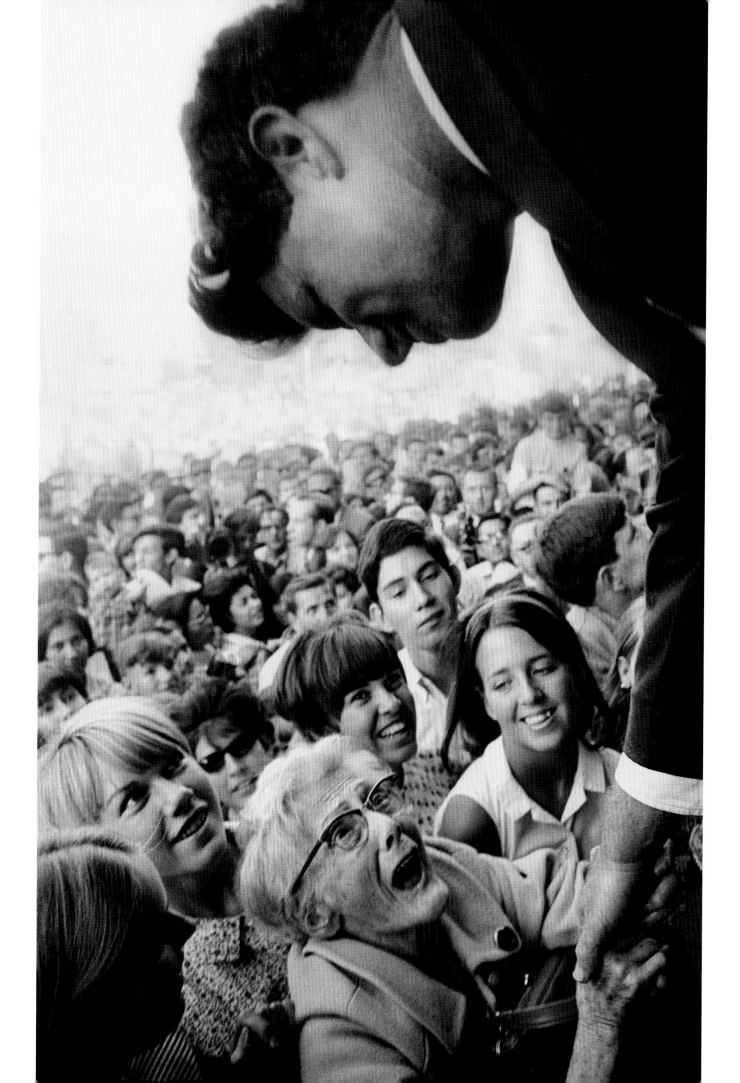

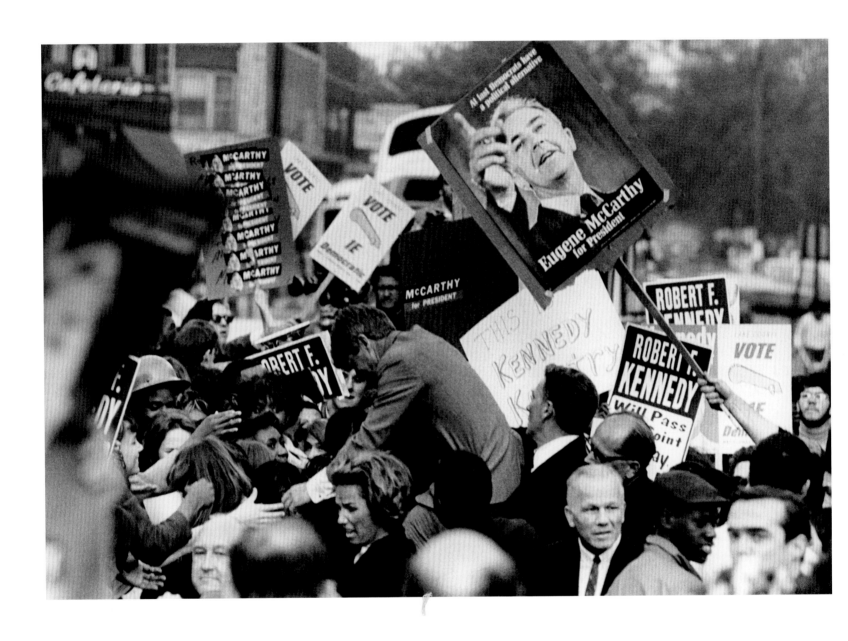

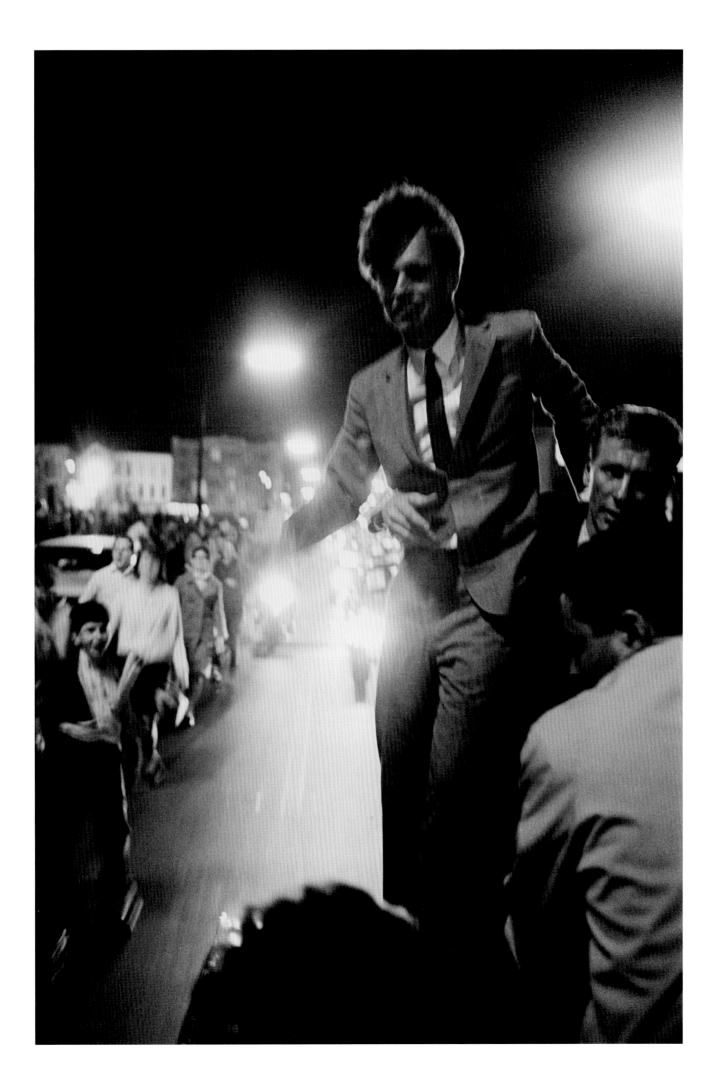

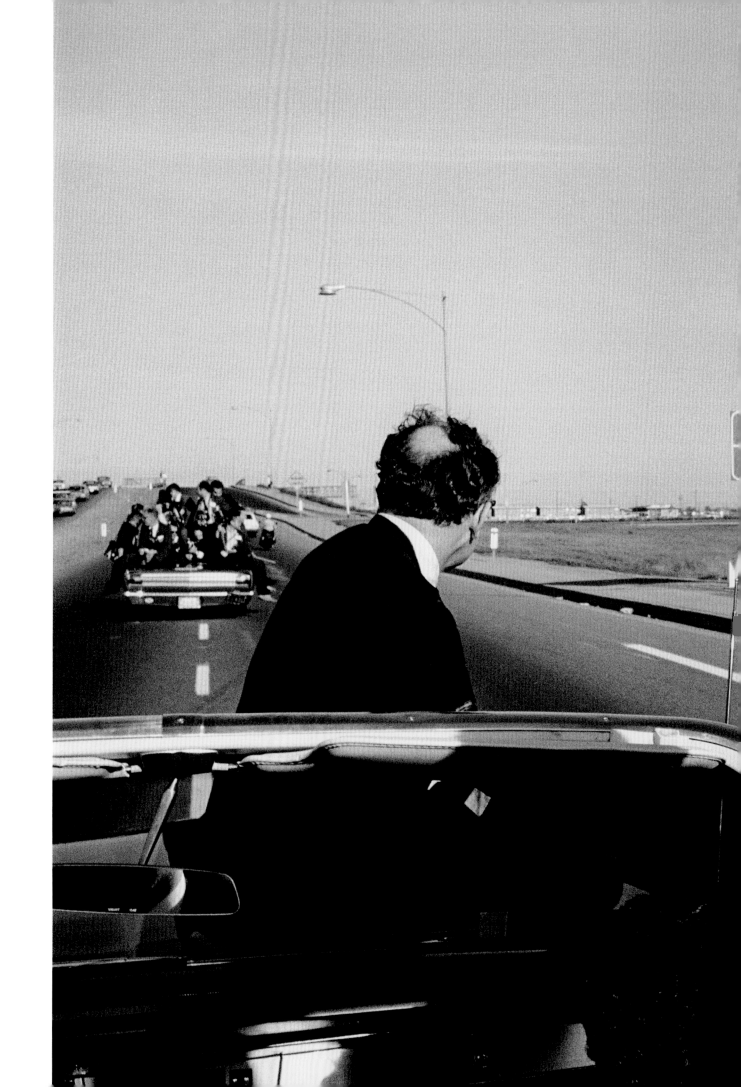

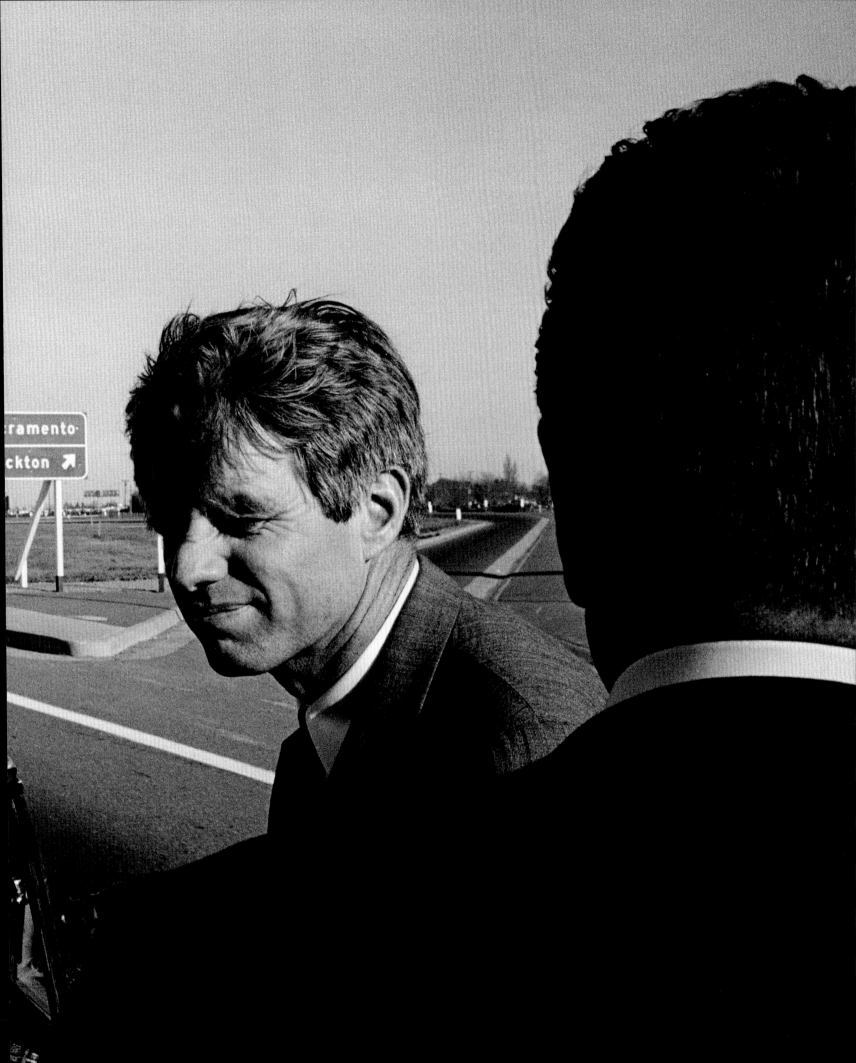

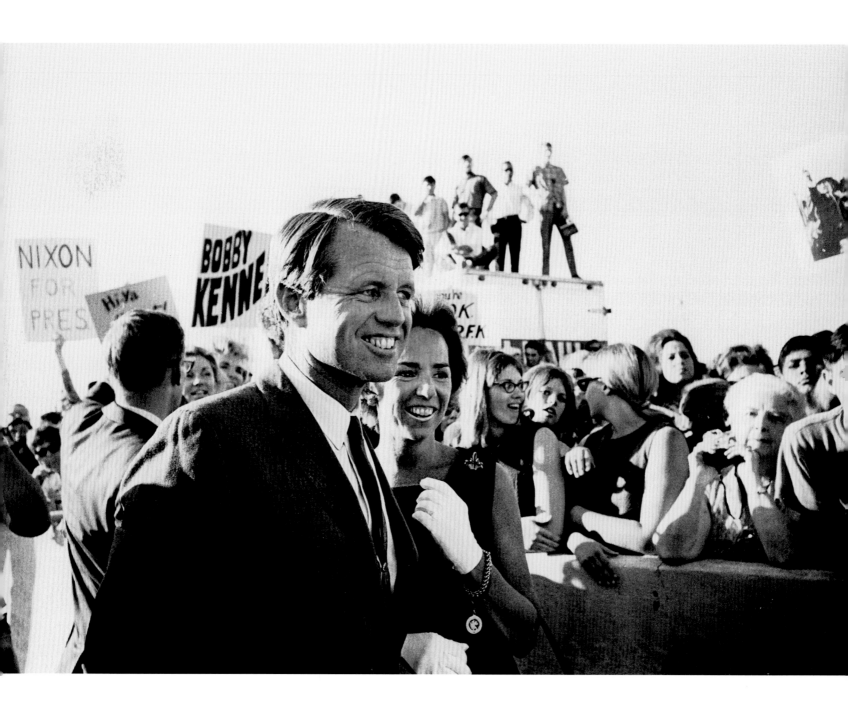

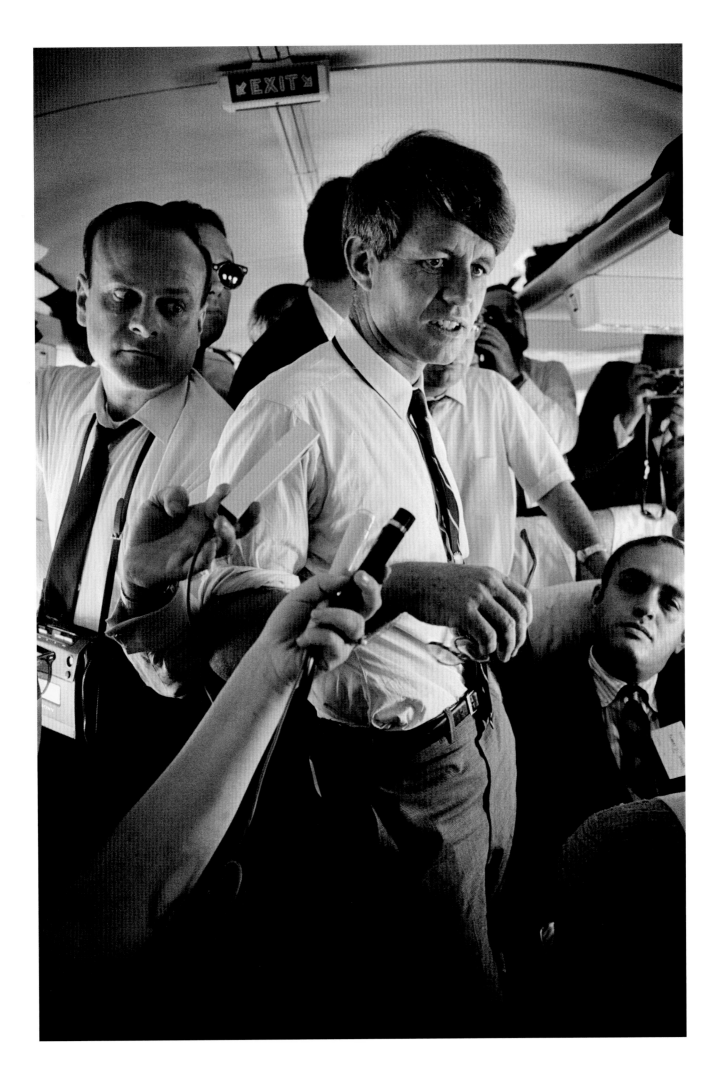

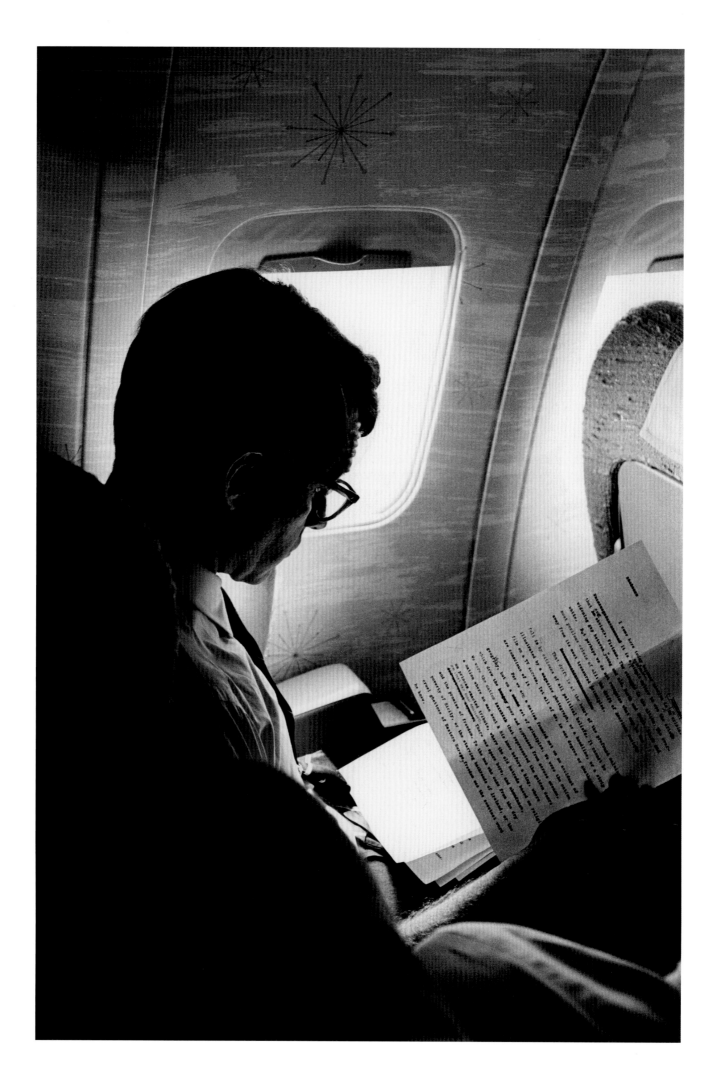

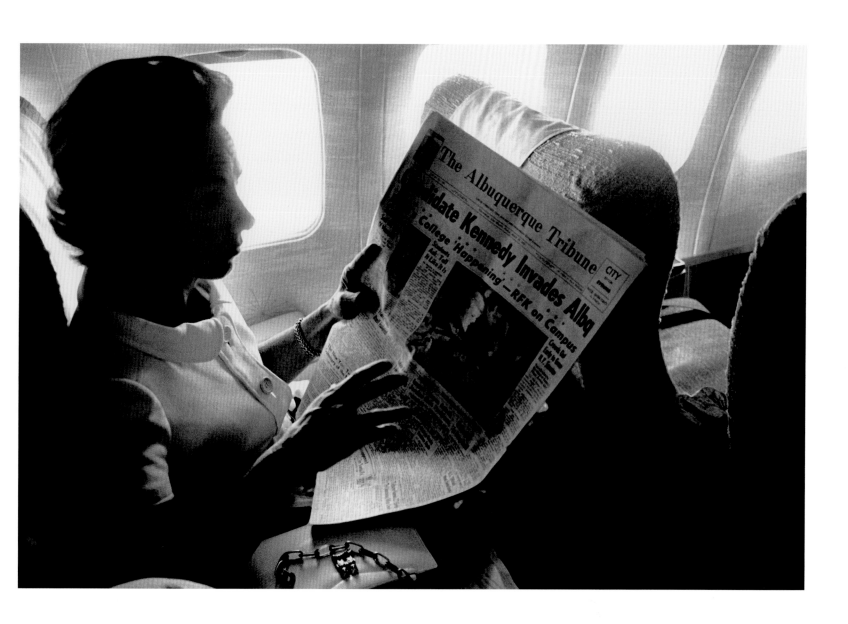

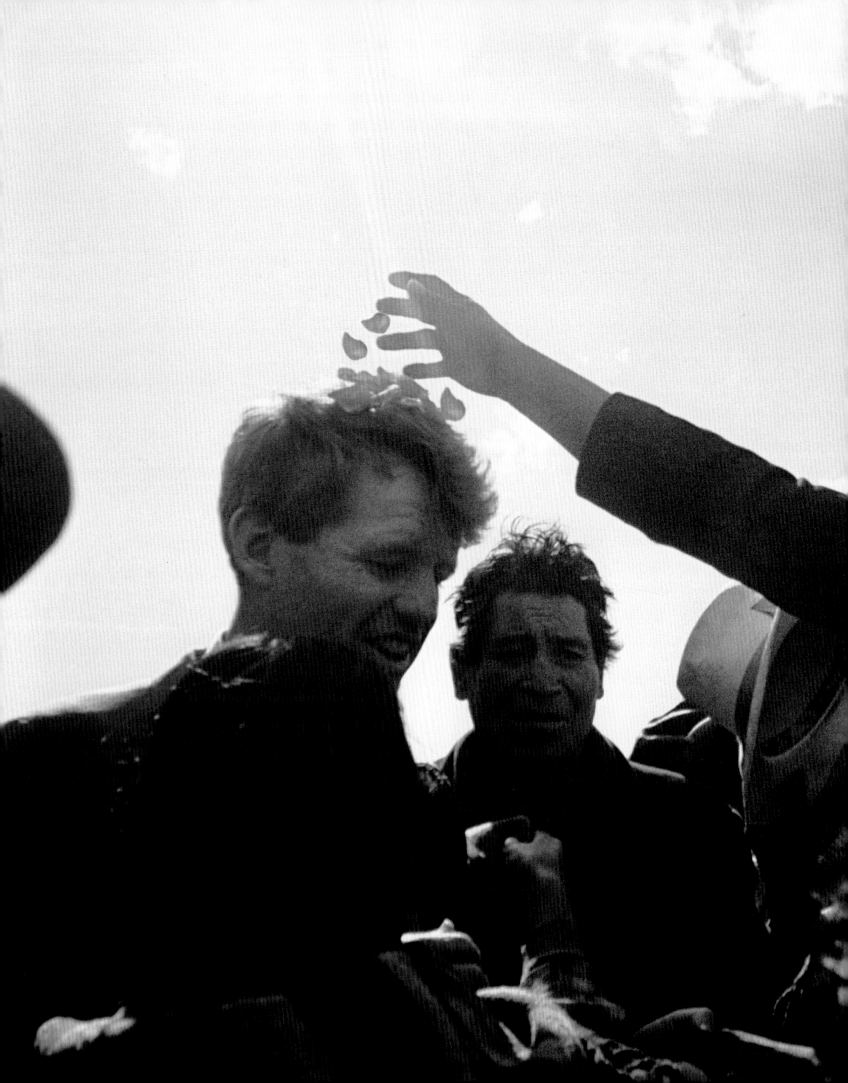

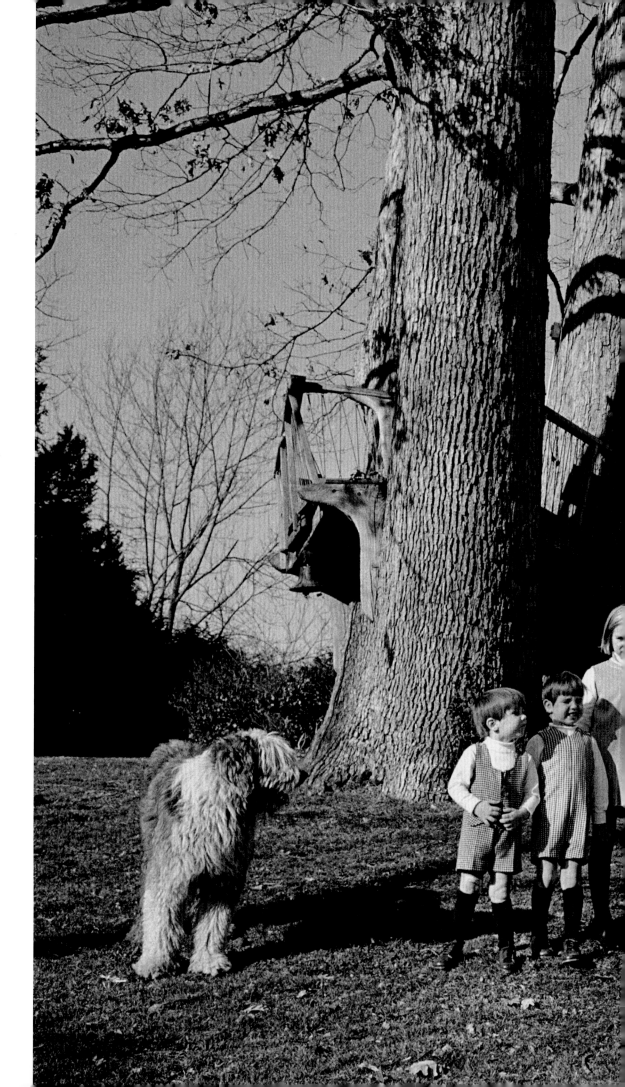

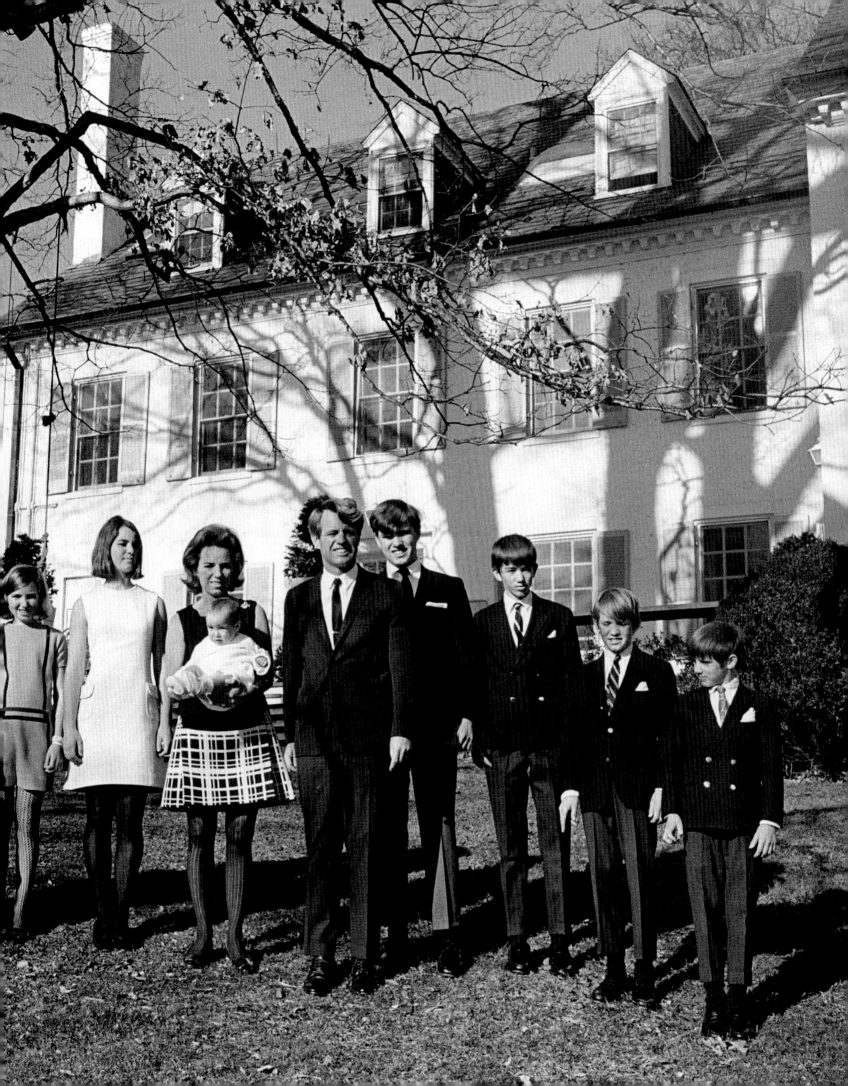

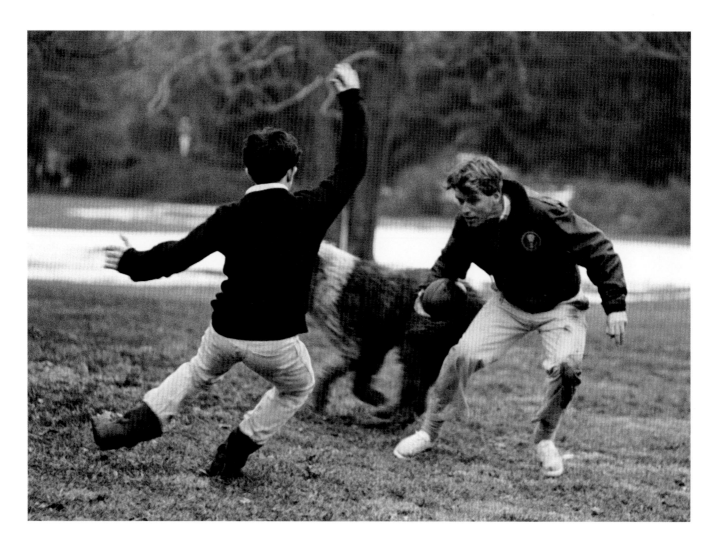

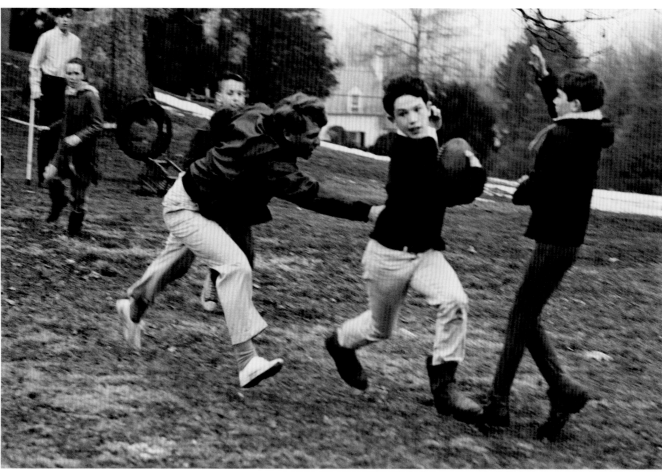

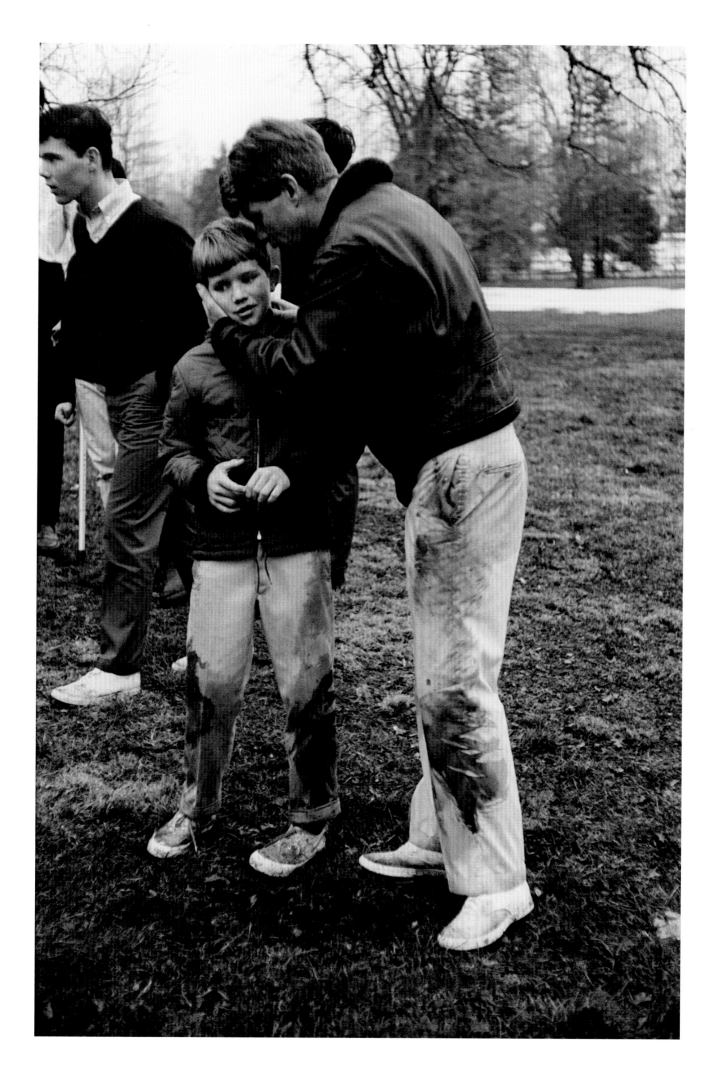

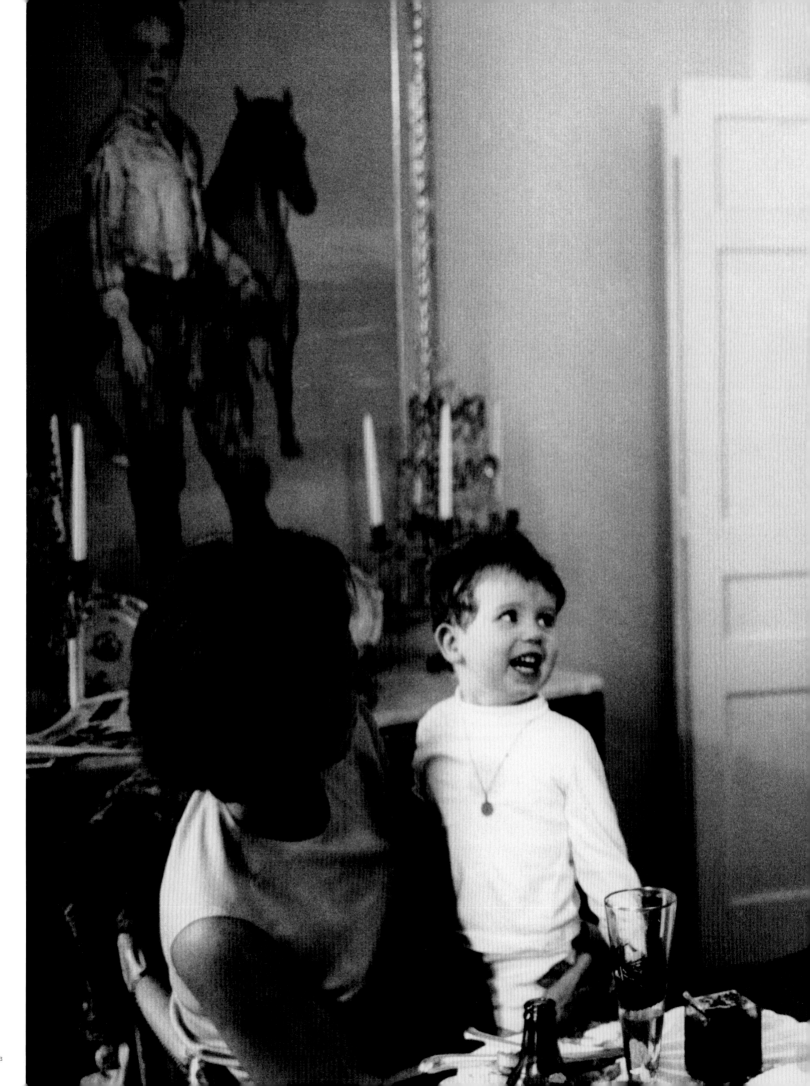

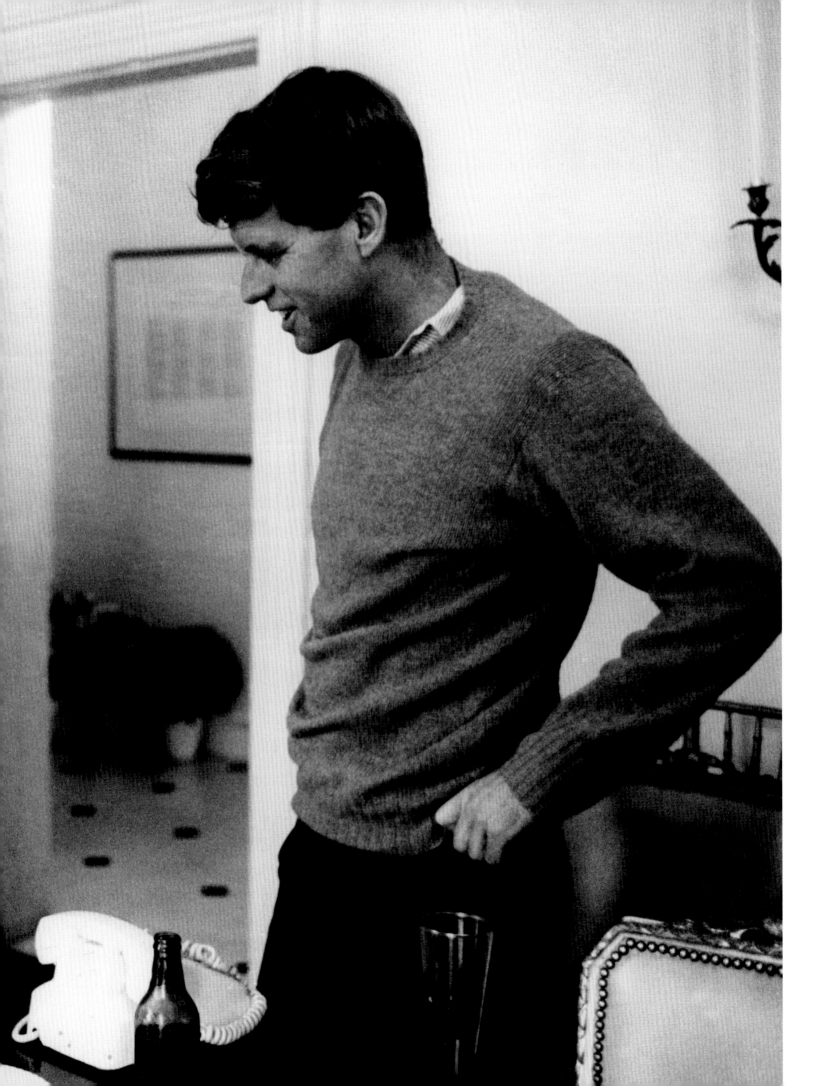

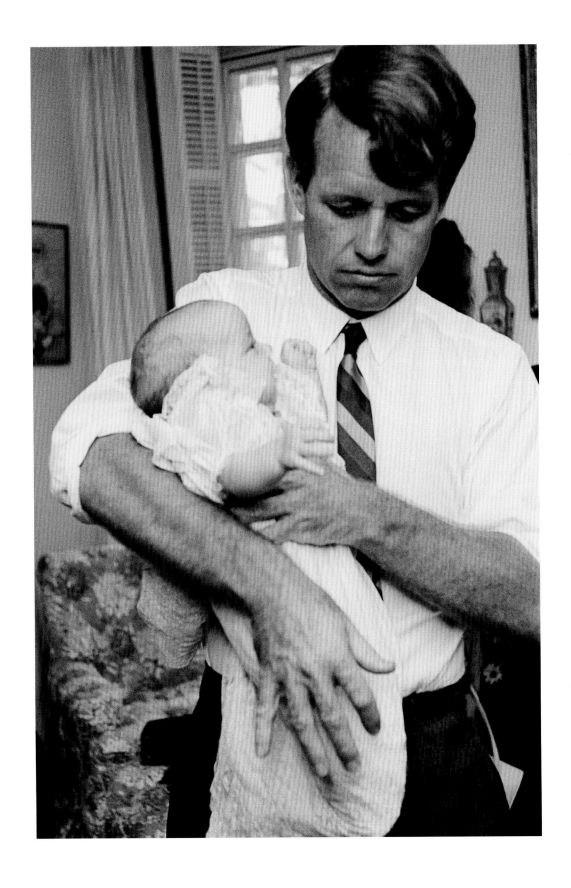

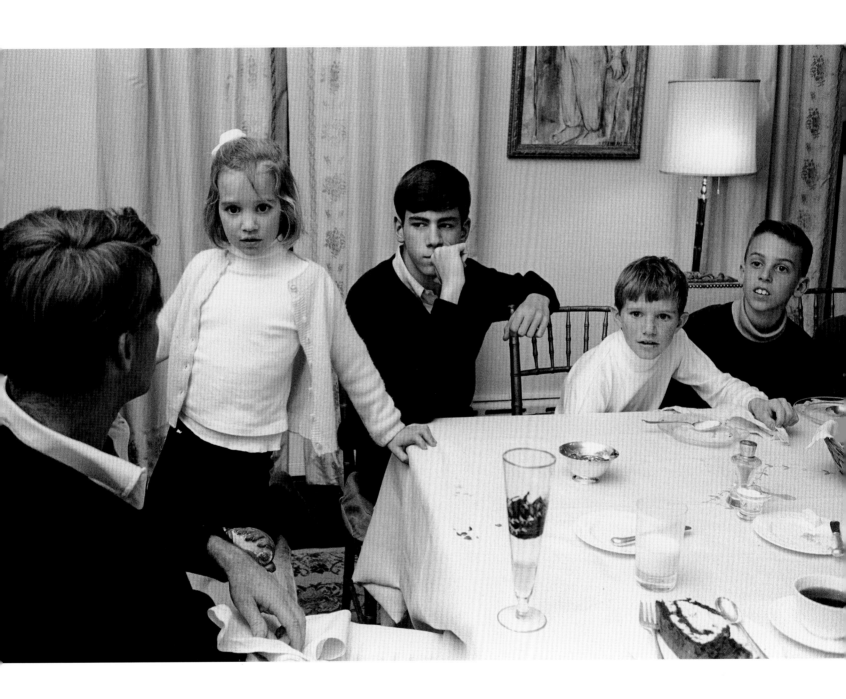

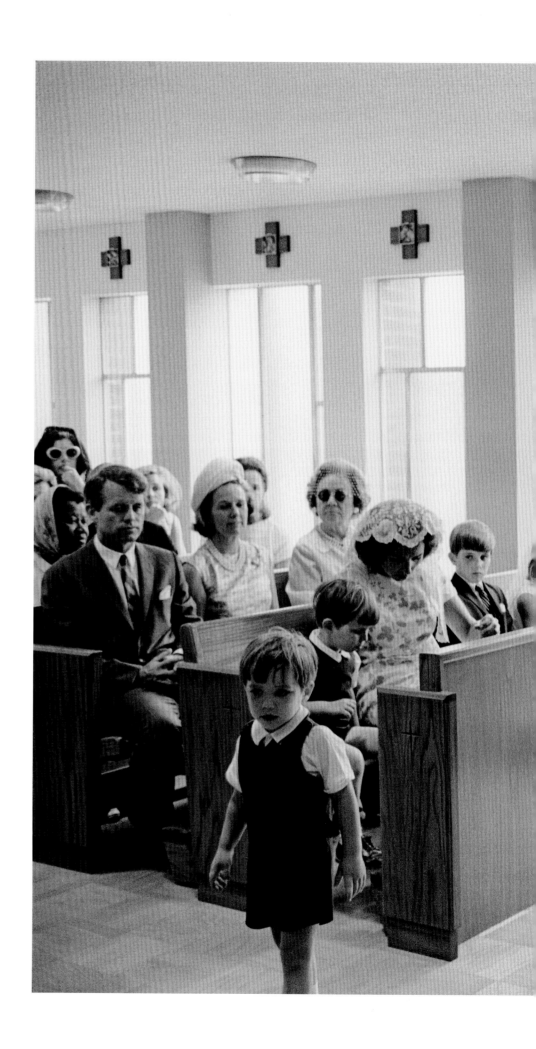

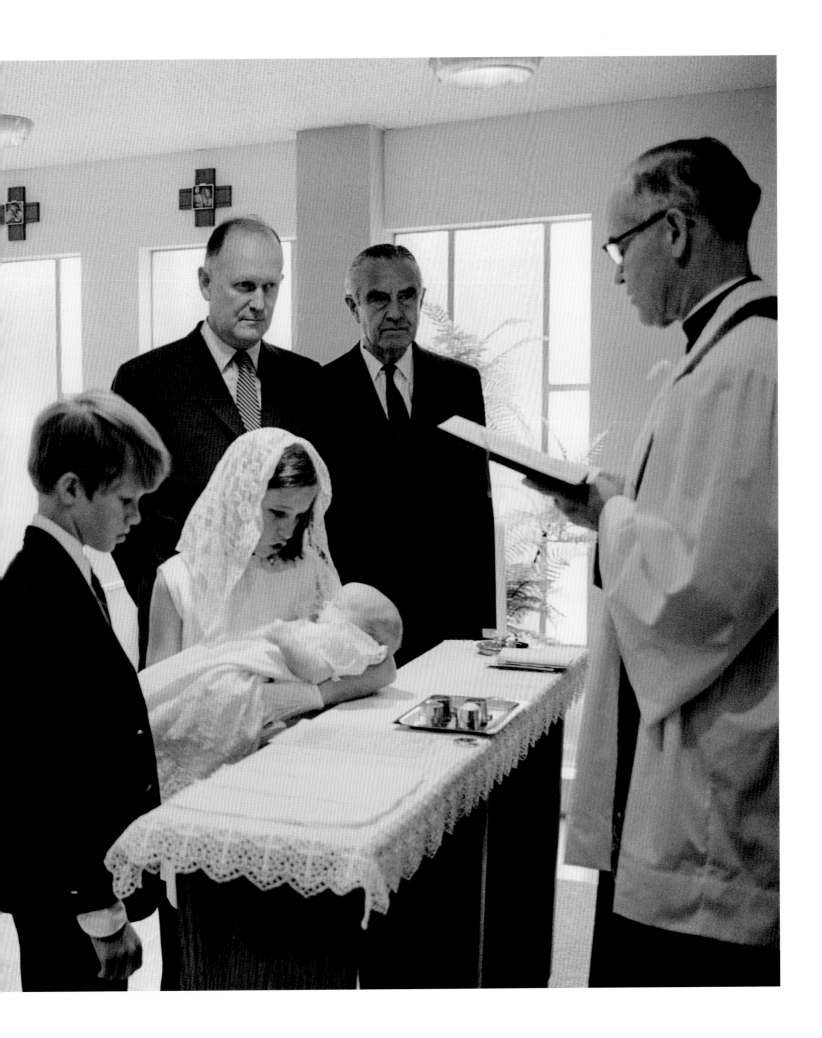

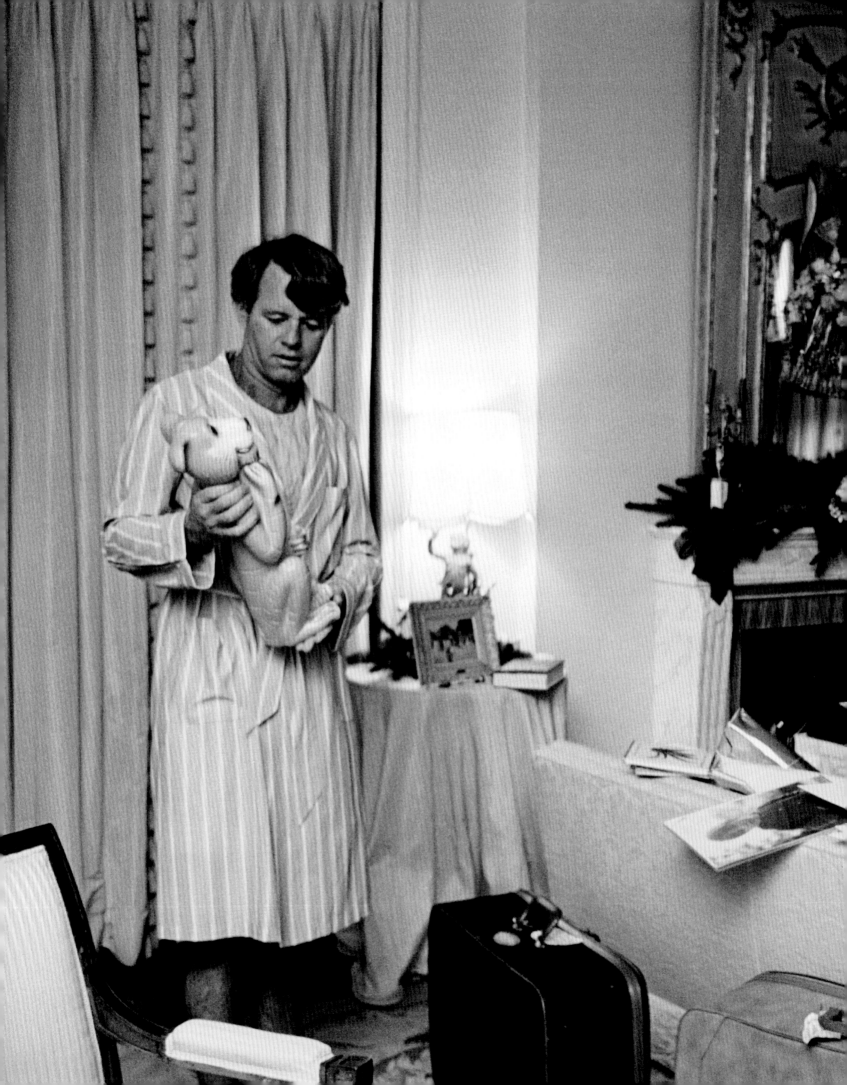

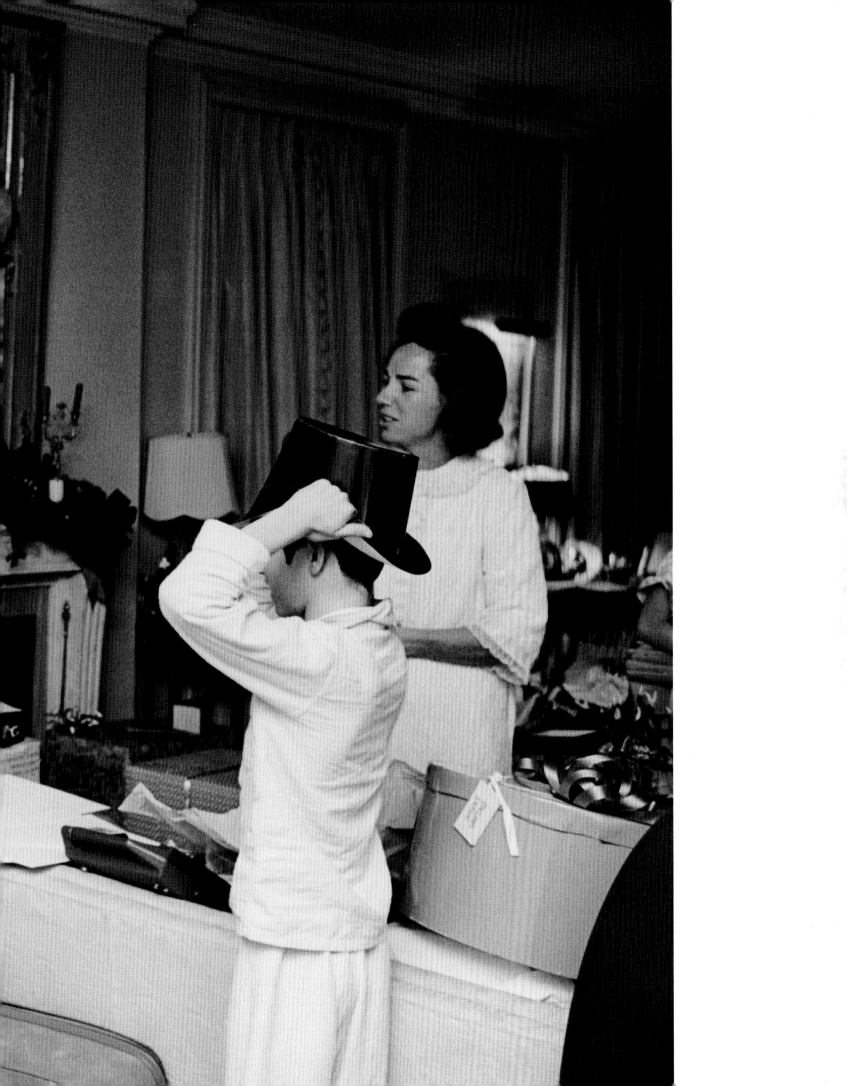

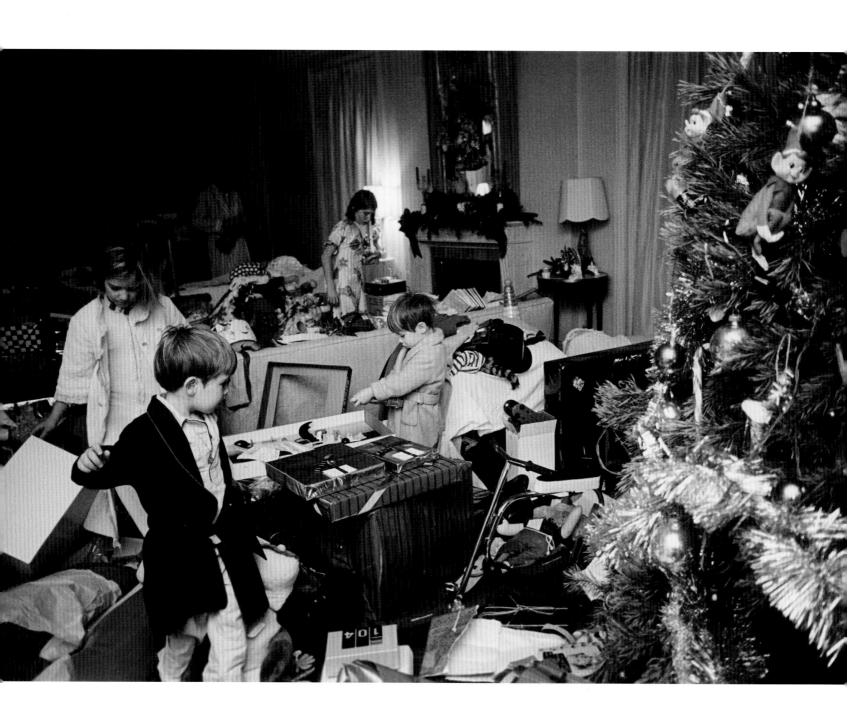

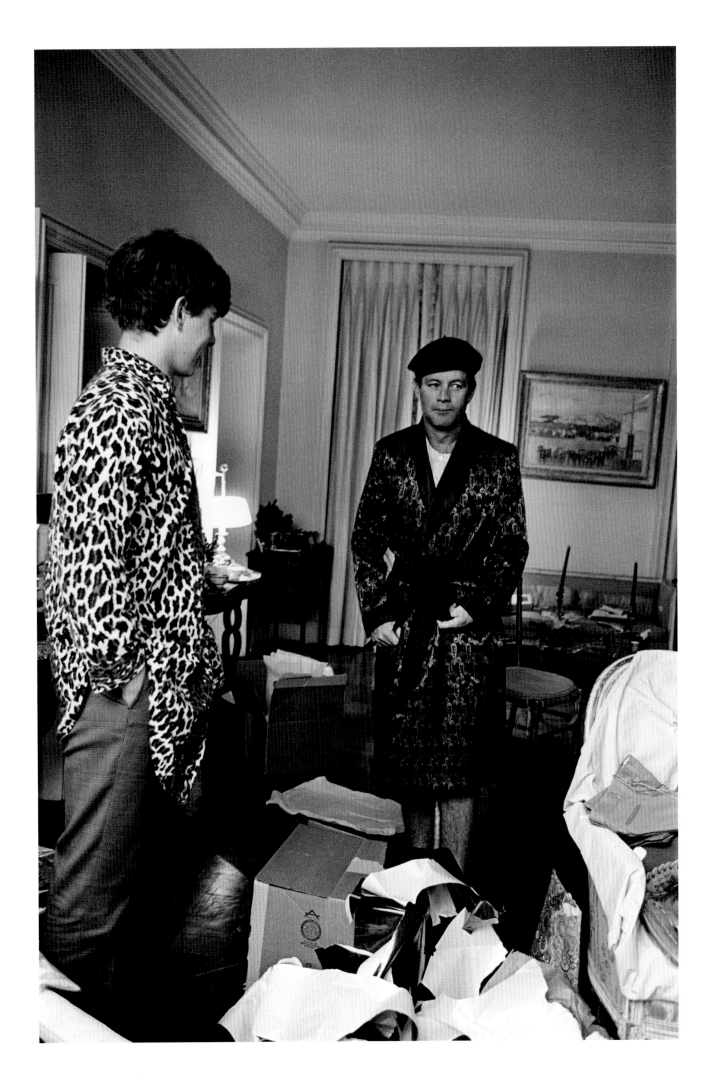

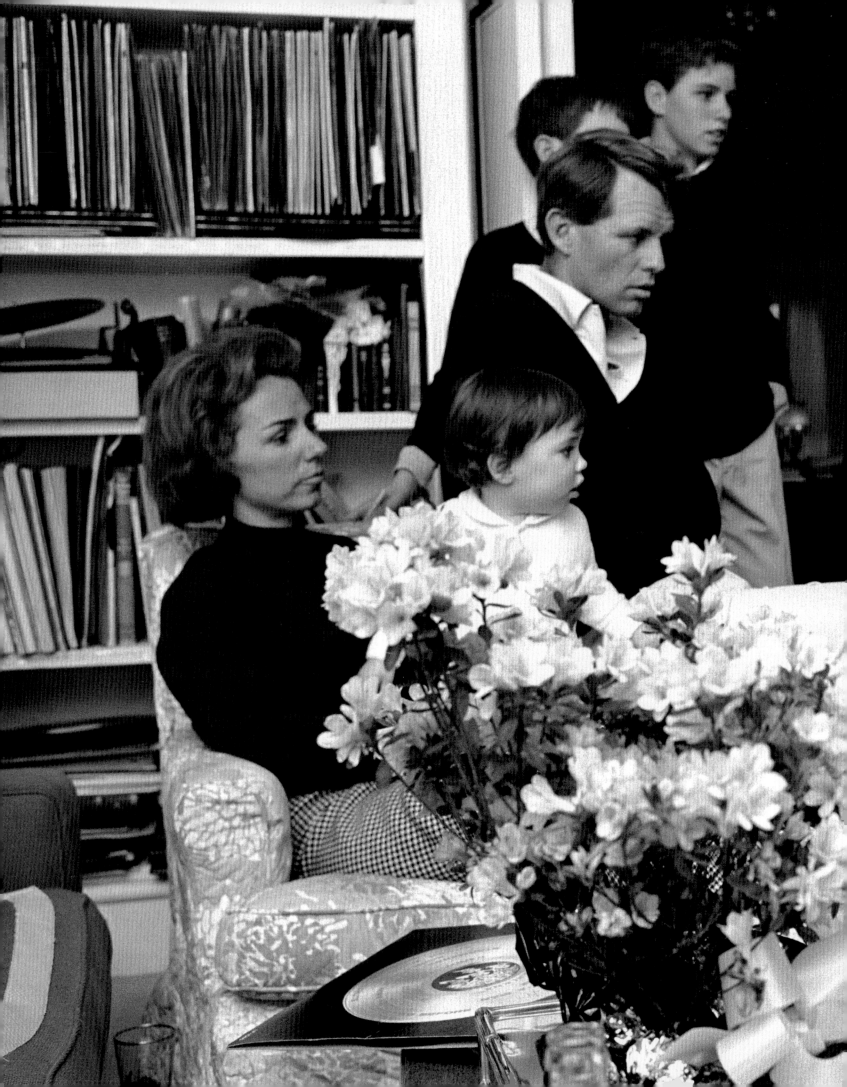

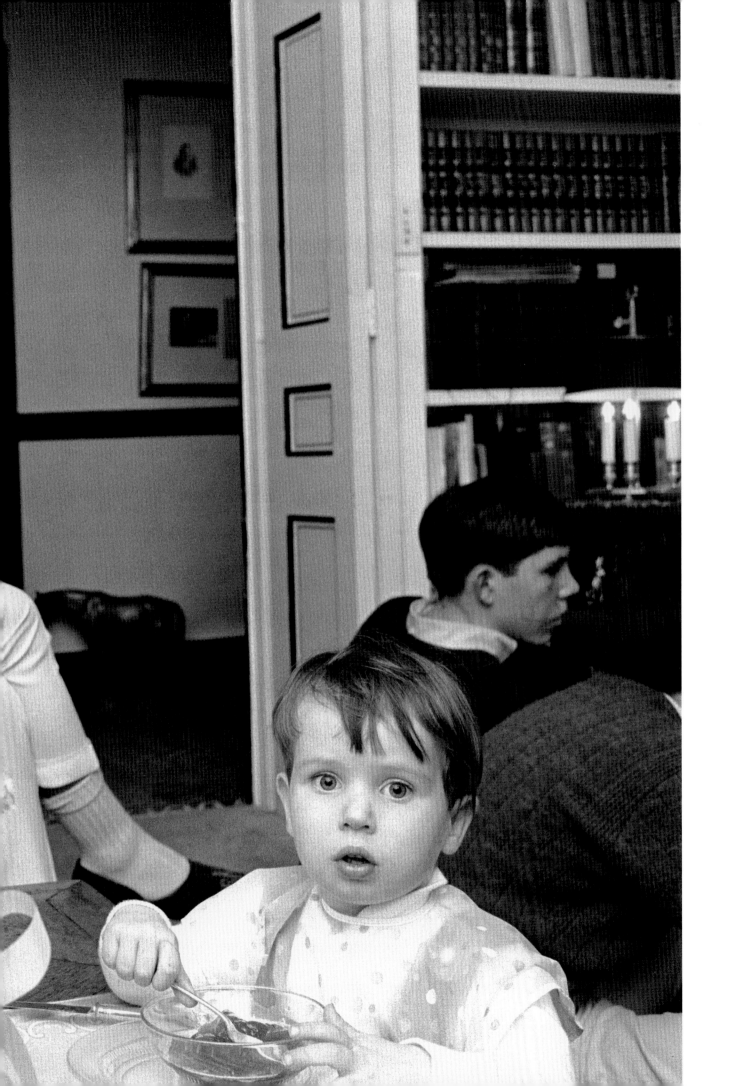

Each time a man stands up for an ideal, or acts to improve the lot of others, or

strikes out against injustice, he sends forth a tiny ripple of hope, and crossing each

other from a million different centers of energy and daring, those ripples build a

current that can sweep down the mightiest walls of oppression and resistance.

—Robert F. Kennedy

JACQUELINE KENNEDY ONASSIS

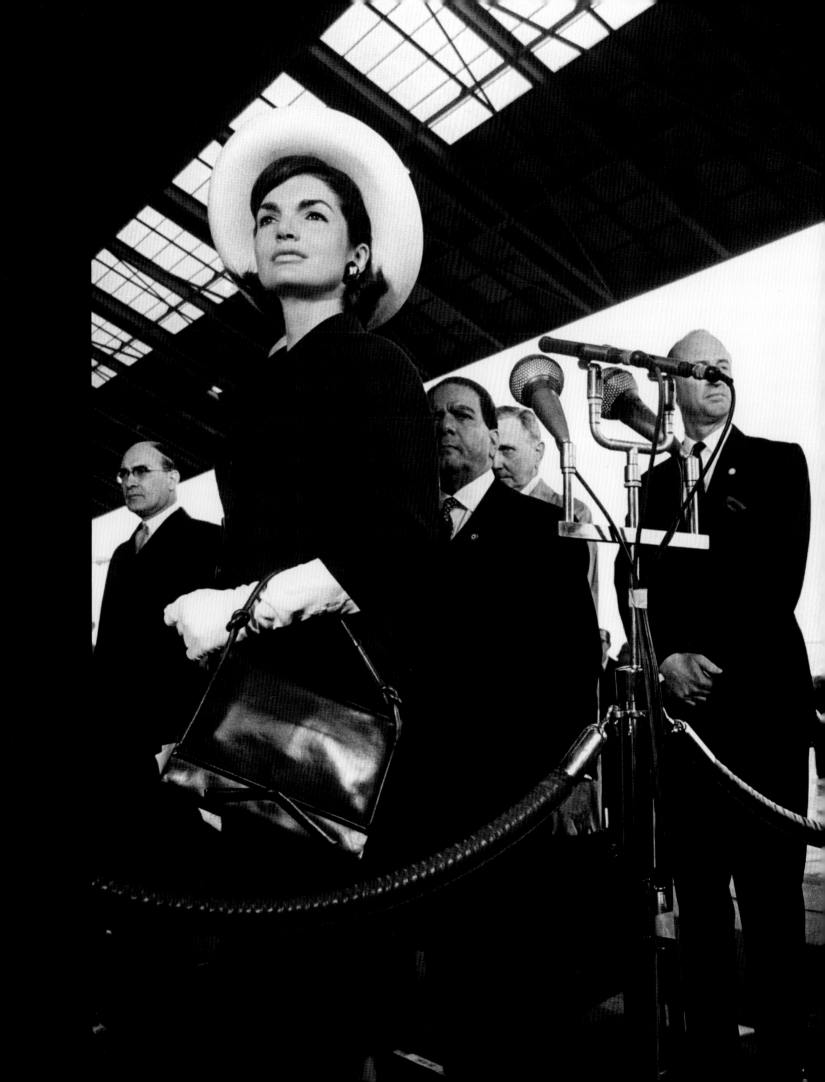

...d be lying if I said I really knew Jackie Kennedy. Bobby Kennedy once brought her over to my table at P.J. Clarke's to say hello, but that was out of politeness. The photographs I took of her were all at public events, and I was never the only photographer. Still, like the rest of the world, I was in total awe of her.

Her genius was not in literature, statesmanship, or the arts, but in the ability to create an enigmatic "persona," drawing attention to herself but not appearing to. It happens with people you can't quite figure out. Her looks were hypnotically appealing, but what was she really thinking? When she was out of sight, the memory of her charisma always lingered.

I first photographed Jackie in 1963 at the Washington, D.C. airport, when the Shah of Iran and Empress Farah Diba first arrived in America. The press was carefully placed in an area very close to where Jackie would be standing, definitely setting up for a photo op.

Generally, seasoned press photographers arrive an hour before a public event to claim the best photo spot, even though the event itself might be scheduled to last a mere four or five minutes. I was definitely not a regular at these Washington gatherings, and when I arrived, the press line was already completely filled. In these situations, photographers tended to get very aggressive and competitive, and there was already a lot of adrenaline-fueled pushing and shoving. Getting the best picture meant a great deal to photographers, particularly when their publications were in fierce competition with each other.

The line of cameramen being full, I waited for the right moment and then took advantage of my short height to quickly crawl under everyone's legs. I heard abusive bantering above my head. After getting banged and kicked, there I was at the front. The Washington press corps was not at all happy with me, but I did get an engaging photograph from a very low angle.

During the ceremony, Jackie seemed entirely immersed in her own thoughts, never looking at the cameras or showing any awareness of the steady flashing of strobe lights in front of her. The camera loved what it saw; was she really as oblivious to all of us as she seemed? For me, that was a big part of her genius.

Events like this create a different kind of photo-essay. You aren't given the time to really delve into your subject's life or travel with them. You have literally just a couple of minutes to form your shots and to find something visually special in them.

When Avedon had only a few minutes to photograph the Duke and Duchess of Windsor, he told them his dog had just been hit by a car. It hadn't. However, he got the expression he wanted. When Karsh photographed a very bored Churchill, he pulled the cigar from the Prime Minster's mouth, which definitely got the reaction he wanted.

People whose images create lingering mysteries stay with us: Garbo, Monroe, James Dean, Pope John Paul II. They photograph well, but keep their innermost secrets to themselves.

Jackie Kennedy lived between glamour and tragedy; both were part of her life. If there was a "Camelot," there was Greek drama as well. Photographers could carefully choose which moments to snap the shutter in order to help create the Camelot illusion, but that sense of tragedy was always there. That, perhaps, was the key to the enigma of Jacqueline Kennedy Onassis.

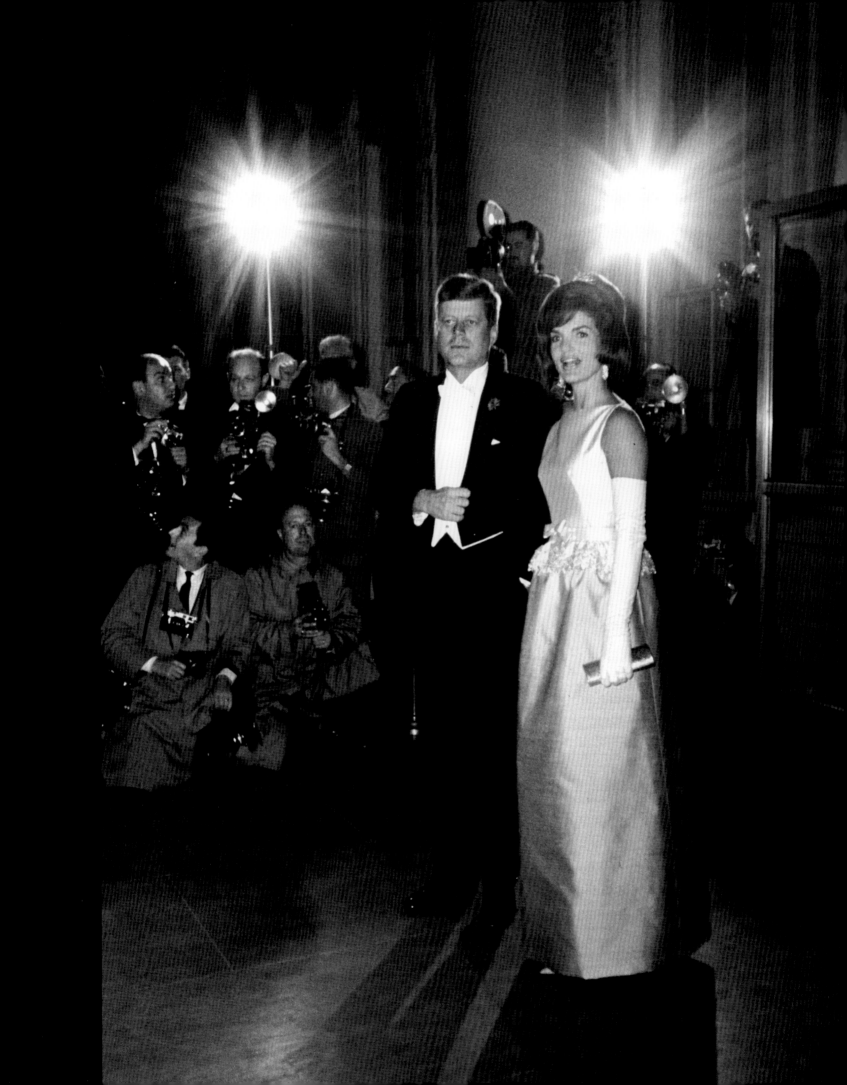

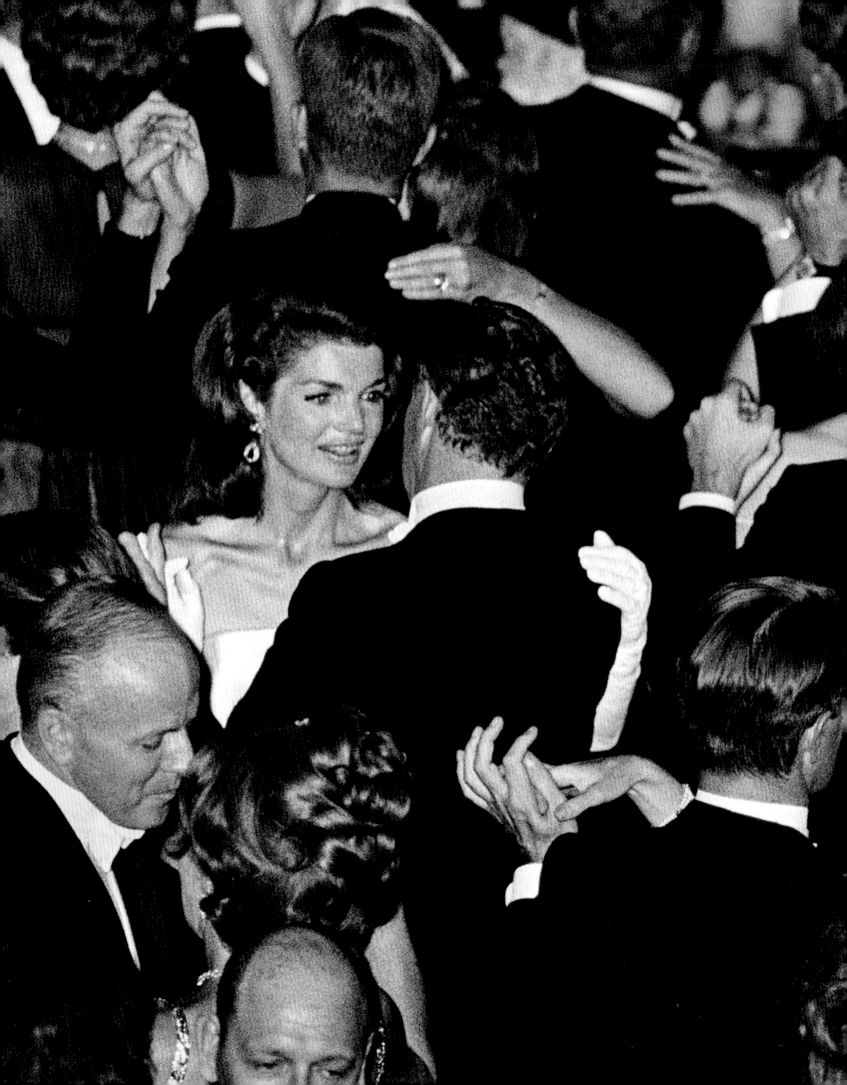

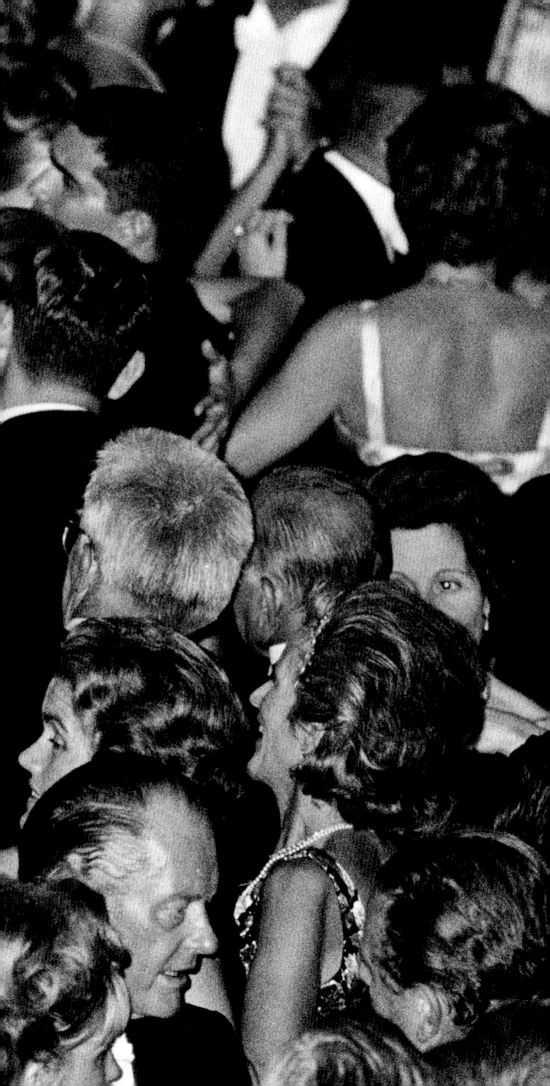

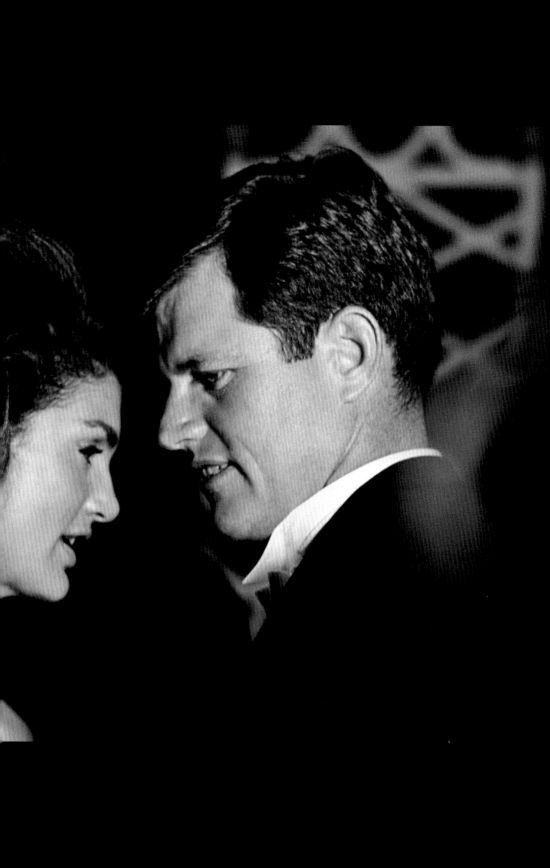

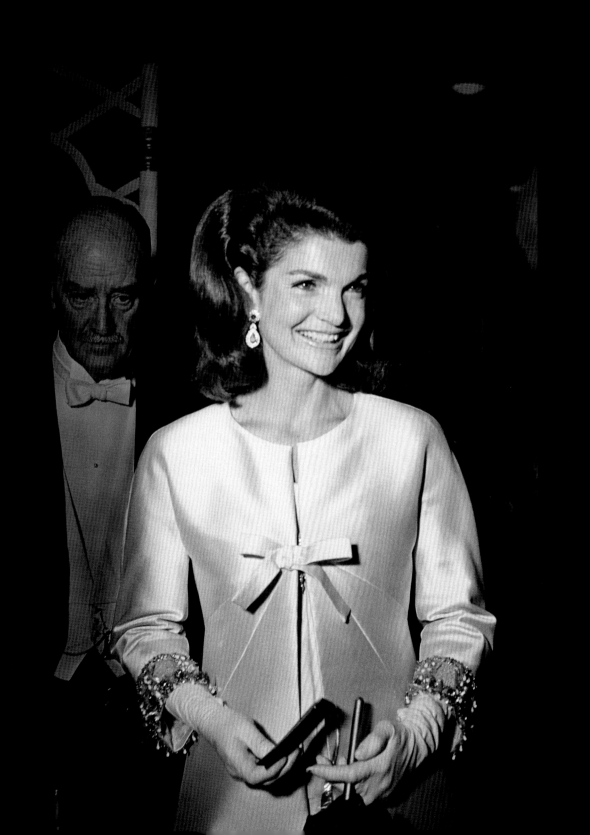

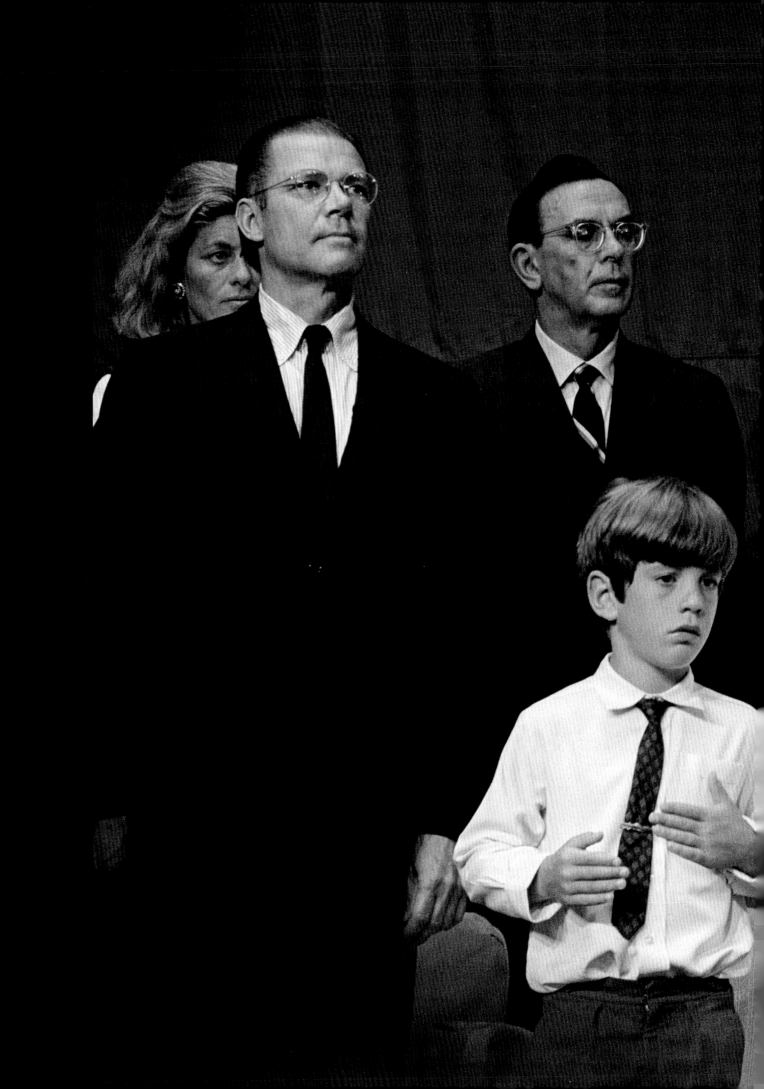

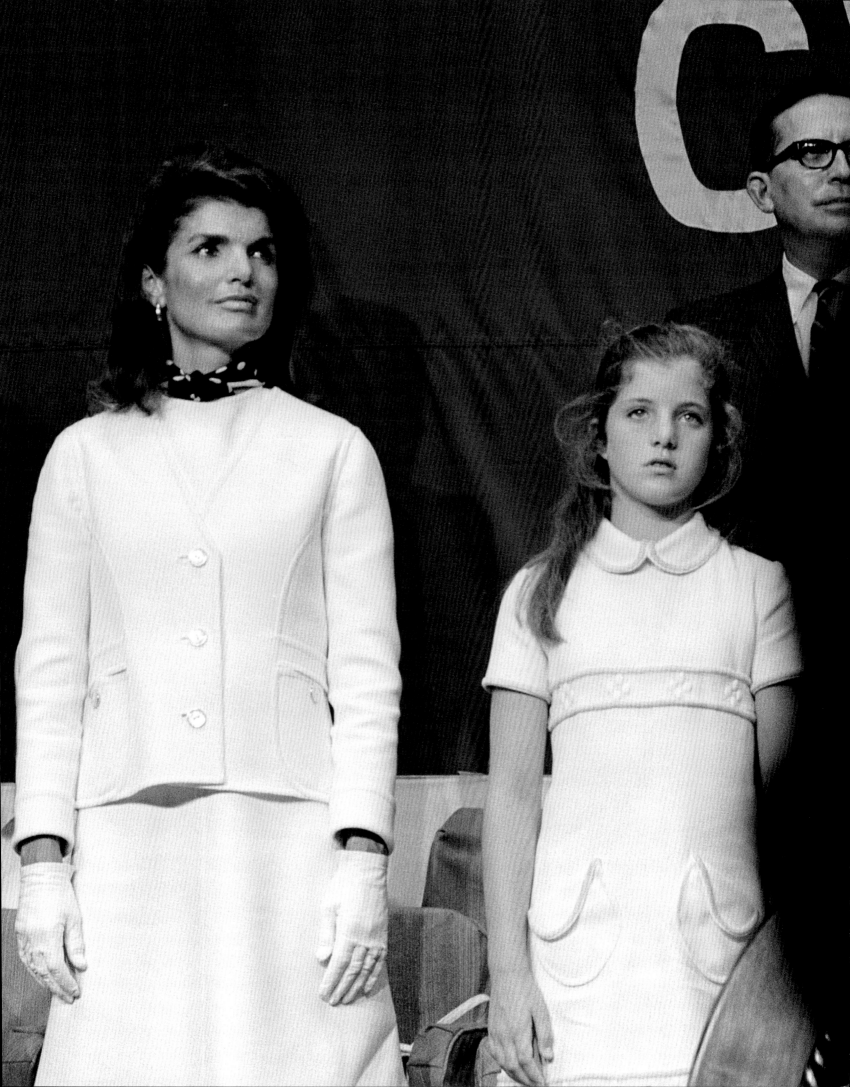

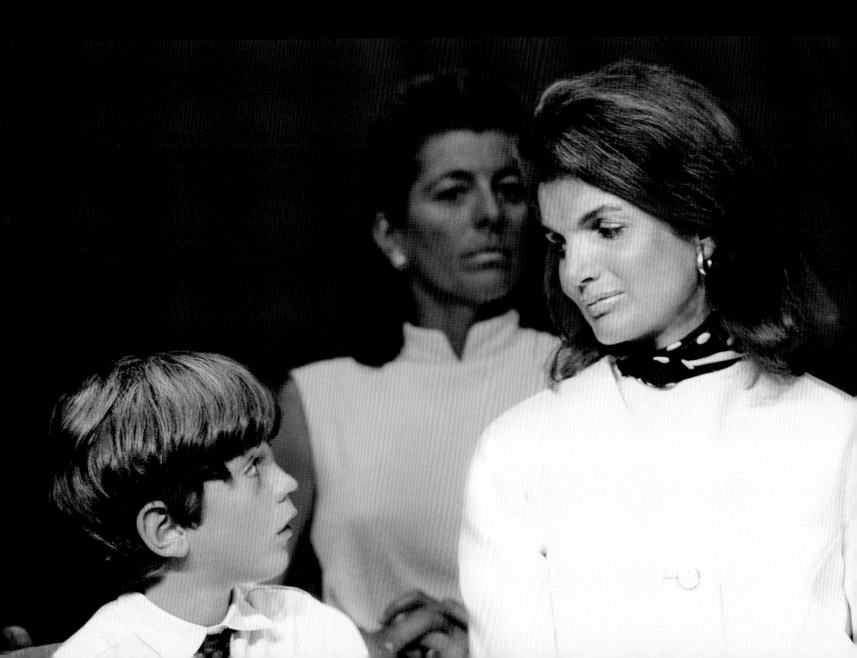

JAMES BALDWIN

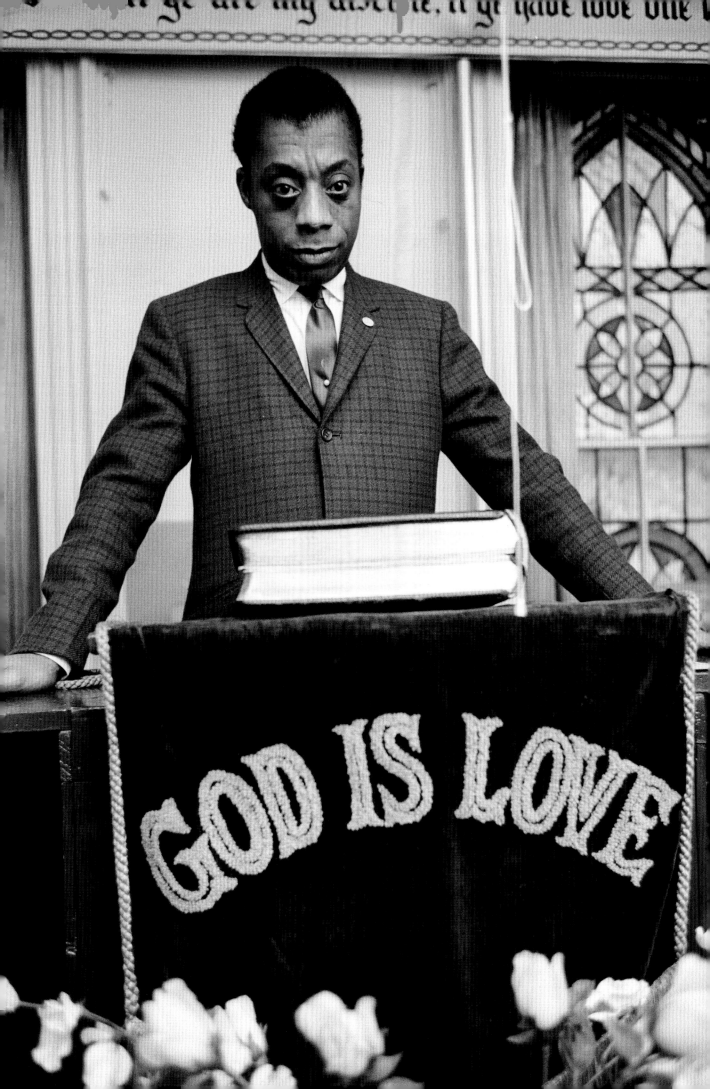

James Baldwin's stepfather told him he was the ugliest child he had ever seen.

Some people live in a state of perpetual crisis. James Baldwin was one of these. He moved with erratic but brilliant energy. His attachment to family was strong and he was intense in all the things he did. He was passionately connected to art, theatre, and politics, and was a force to be reckoned with in the civil rights movement. Though it is not readily known, Baldwin's influence did much to change and hasten the movements for black voting, school desegregation, and especially the attitudes of the Kennedy government for nationwide reform.

Jimmy always seemed plagued with personal sadness. He drank too much, smoked too much, and always seemed lonely.

I had been aware of his novels, but when *The New Yorker* published "The Fire Next Time," an essay by Baldwin on the state of black people in America, I asked *Life* magazine if I could do a long photo-essay with him. He and they agreed, and I started traveling with Jimmy wherever he would go.

In the course of the next few months, we traveled to Mississippi, New Orleans, North Carolina, and New York. We rarely made our flights by more than a minute or two. In the South, we visited with James Meredith, Medgar Evers, and poor children in Durham. We saw kids who were not being properly educated, and people who were being intimidated against voting.

We stood at the pulpit inside churches. We hung out in front of a store with signs that read "Colored Only," the storekeeper peering out at us as I took pictures. We visited storefront mosques, ate fried chicken, and laughed a lot. Outside a store in Durham, a teenage black girl pointed to a deputy sheriff and said to us in the calmest of voices, "That man caused me to spend 30 days in jail"; the moment characterized the nonviolent "We Shall Overcome" church spirit. In New York, we met up with Rip Torn, Lena Horne, activists, and students, and discussed the plight of the black man in America.

Through Jimmy, I met Jerome Smith, who had been one of the original freedom riders. Jimmy brought Smith to a meeting in New York with Bobby Kennedy. The room was filled with prominent black activists. The Kennedy clan had expected to be applauded for their stance on civil rights, but Baldwin and the others were not satisfied. Jerome Smith declared, "This meeting nauseates me"; that was the general tone. Bobby had to go back to his brother Jack with a report of anger and dissatisfaction. It was shortly after that meeting that the Kennedy government became seriously active in civil rights, having discovered that they did not have the black vote in their pocket. It was also after that that a government tap was put on Jimmy's phone.

When Jimmy and I visited civil rights leader Medgar Evers at his home, Evers put a towel over the license plate of our rental car so that the vehicle could not be identified, half as a joke and half out of serious concern. We all knew that we were constantly being watched. Soon after that, Evers was shot and killed. In Jackson, Mississippi, we met up with James Meredith, the first black student to attend the University of Mississippi, and encountered a case of reverse segregation. Meredith and Baldwin went out to dinner but had to leave me behind at Meredith's house, so as not to draw attention on the streets.

Life magazine laid out the Baldwin story for 12 pages, which was totally unrealistic. Bernie Quint, who did the layout, was a brilliant art director; he had prepared many of W. Eugene Smith's great essays. Quint found ways to incorporate a point of view in his layouts so that the pictures had a strong emotional flow and complemented each other on the page. Yet, when it came time to put the layout for this story into the actual magazine, there were not 12 pages available. The story was consolidated down to six.

The shortened essay was to open on a single right-hand page. It was a strong, dramatic, close-up shot of Jimmy standing at a church pulpit. When the final layout was decided and the magazine was about to go to press, it was discovered that the left hand page facing Baldwin carried an advertisement for chocolate pudding. The editors immediately pulled the Baldwin story from the issue. However, it did run a few weeks later.

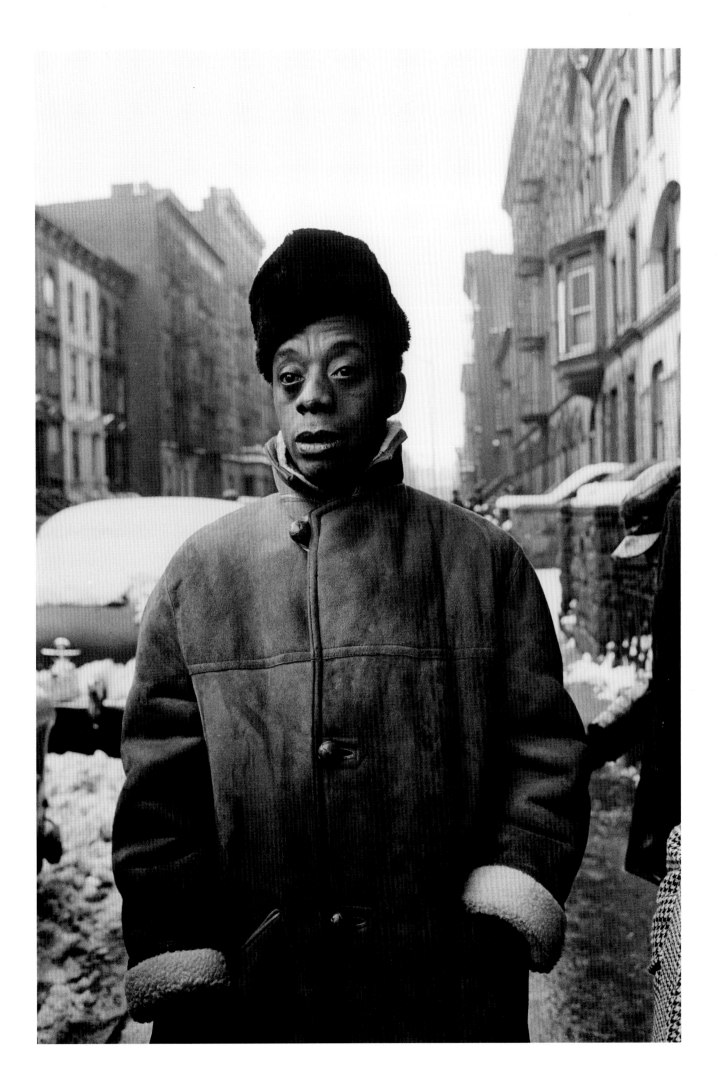

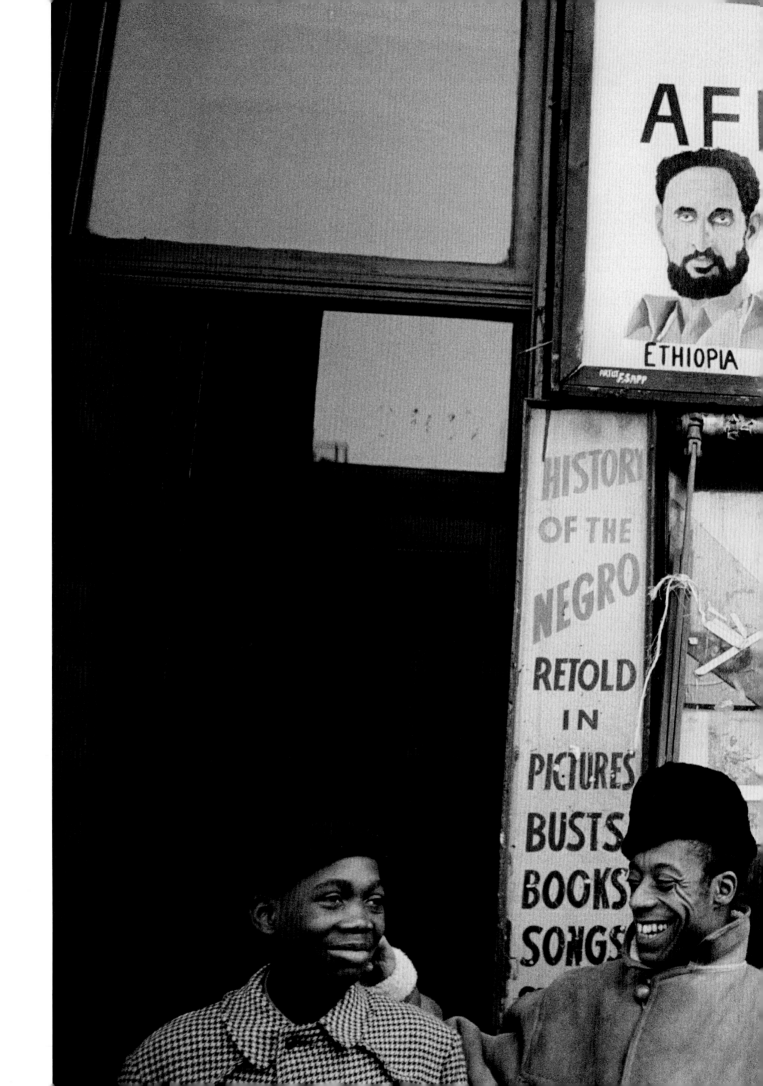

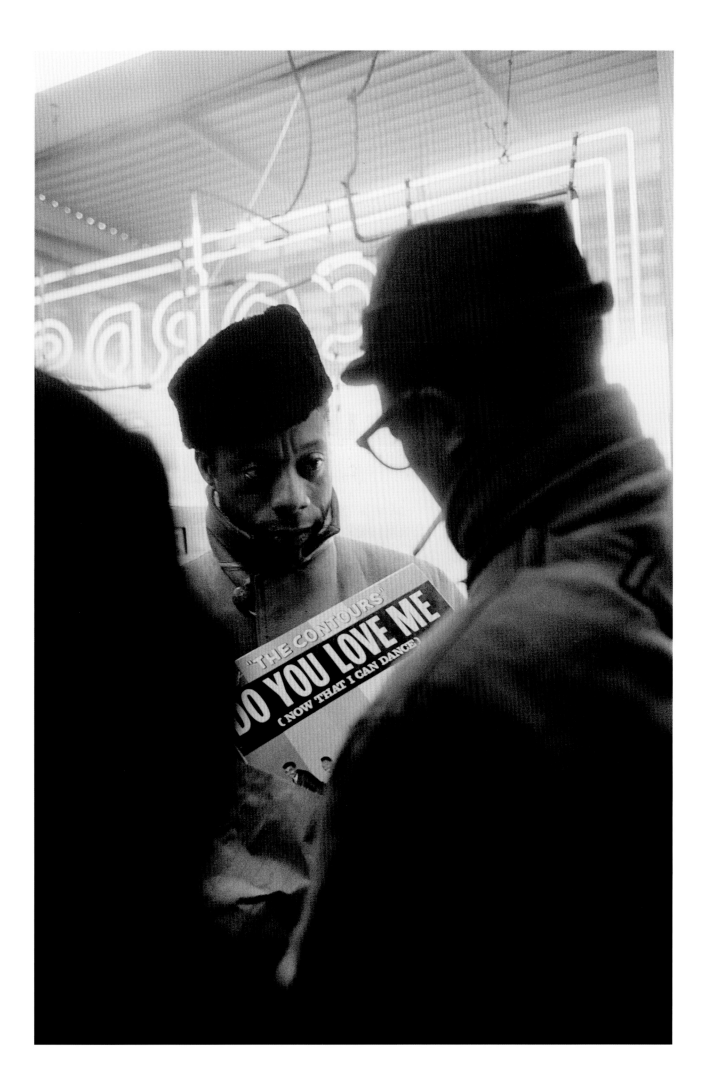

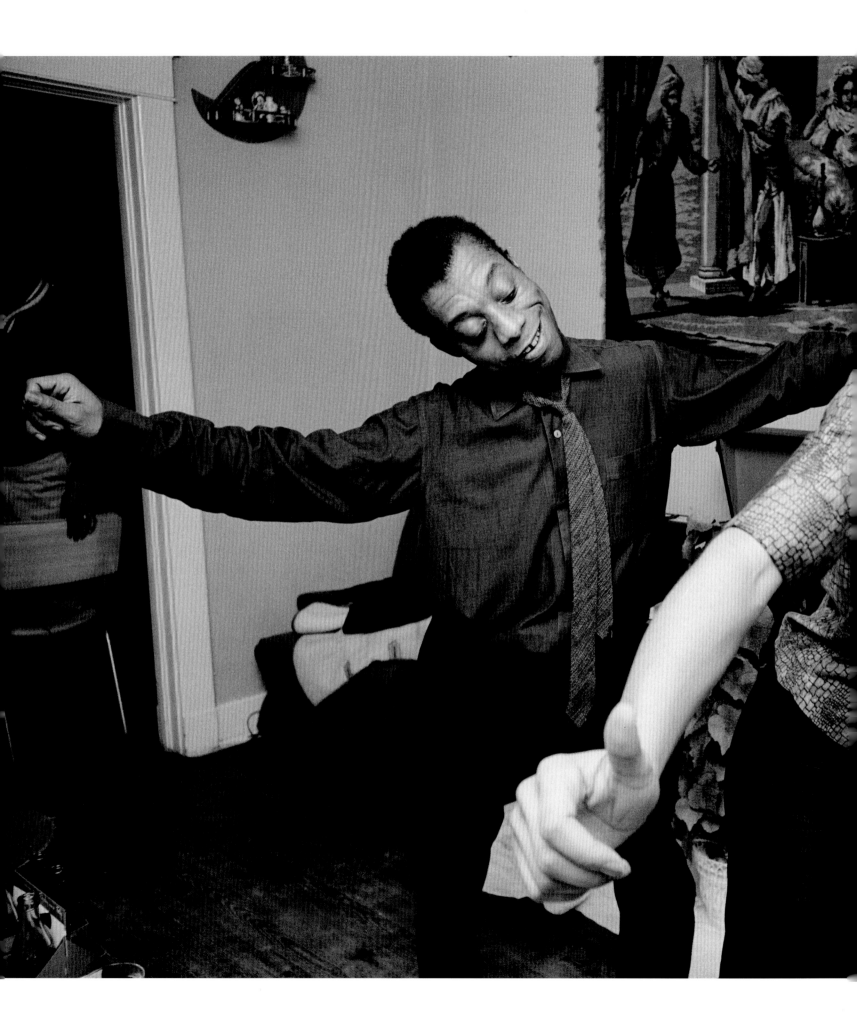

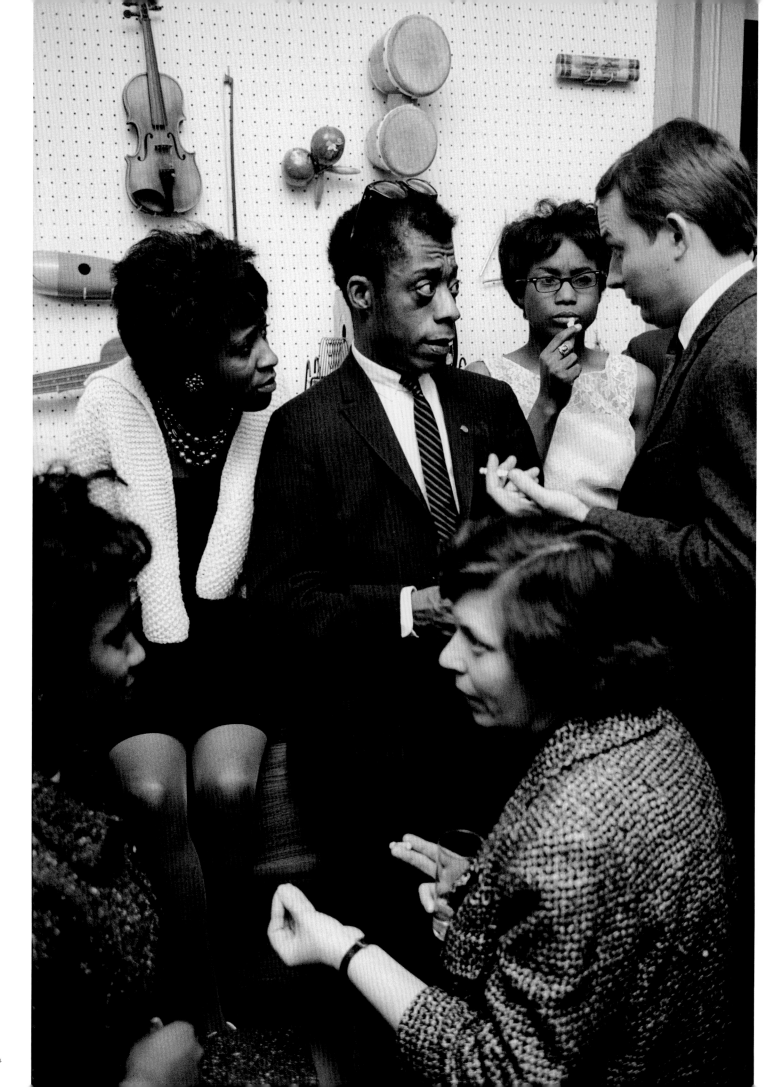

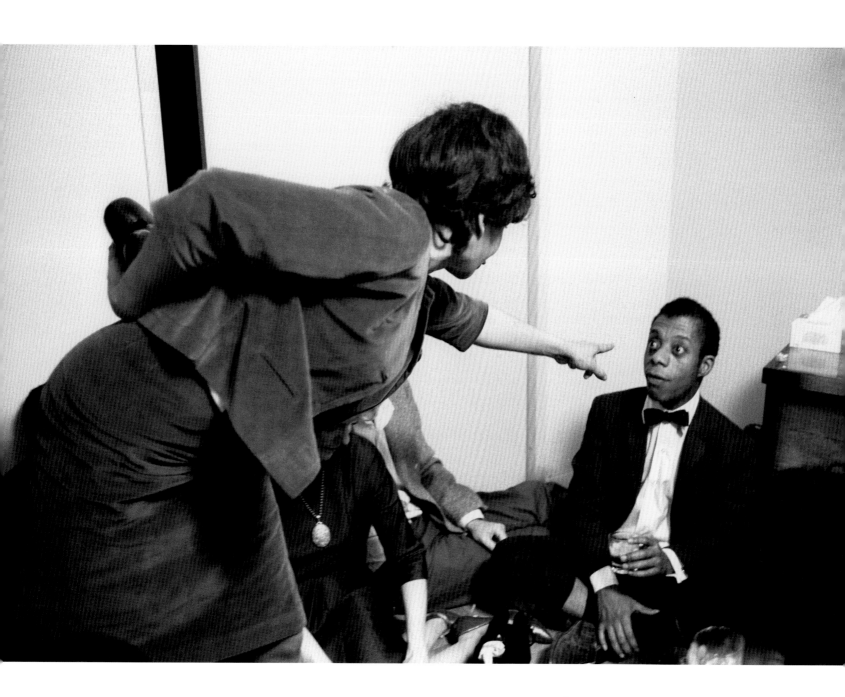

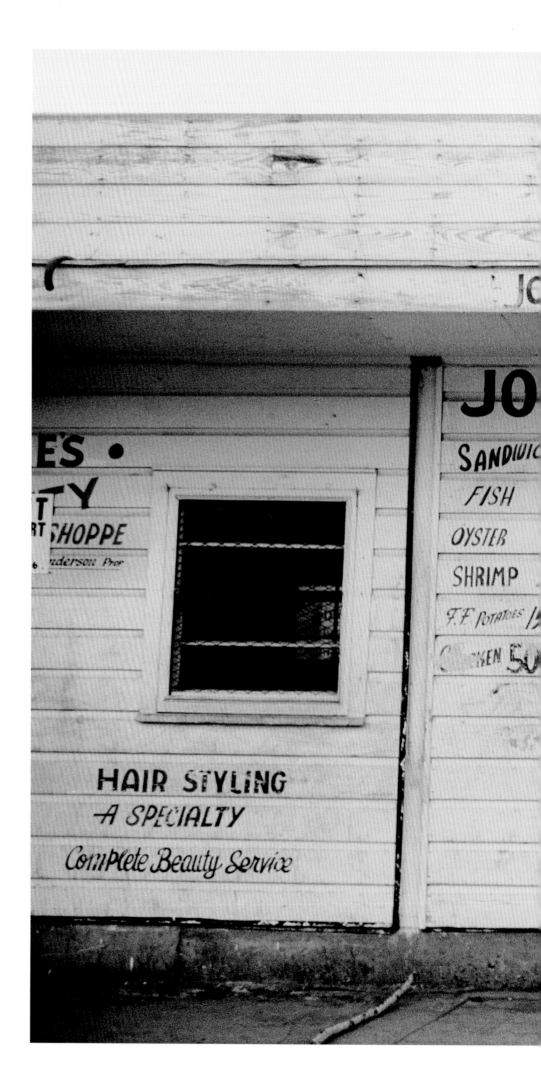

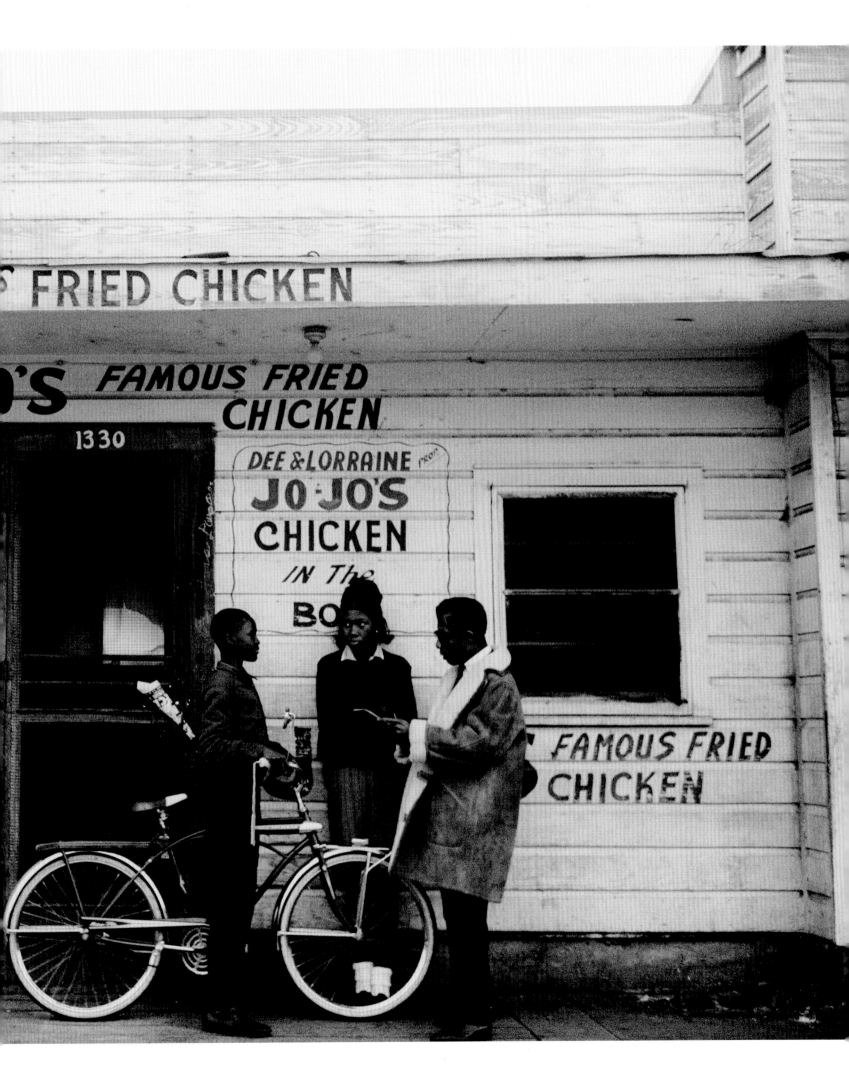

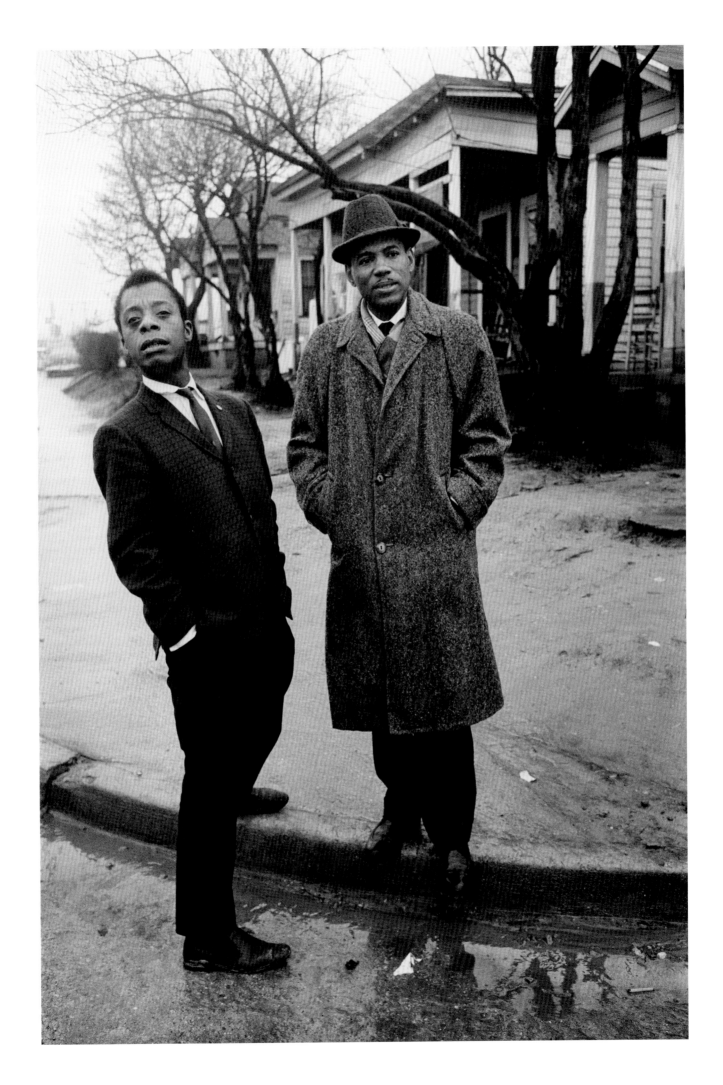

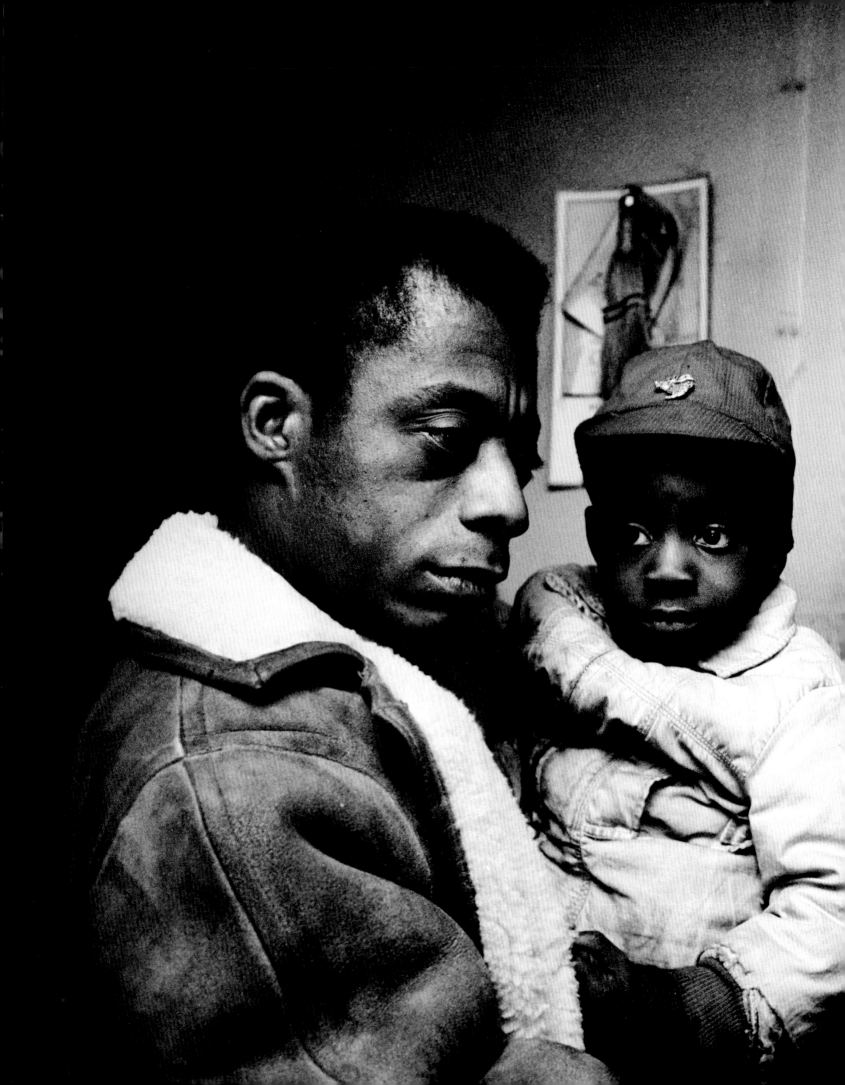

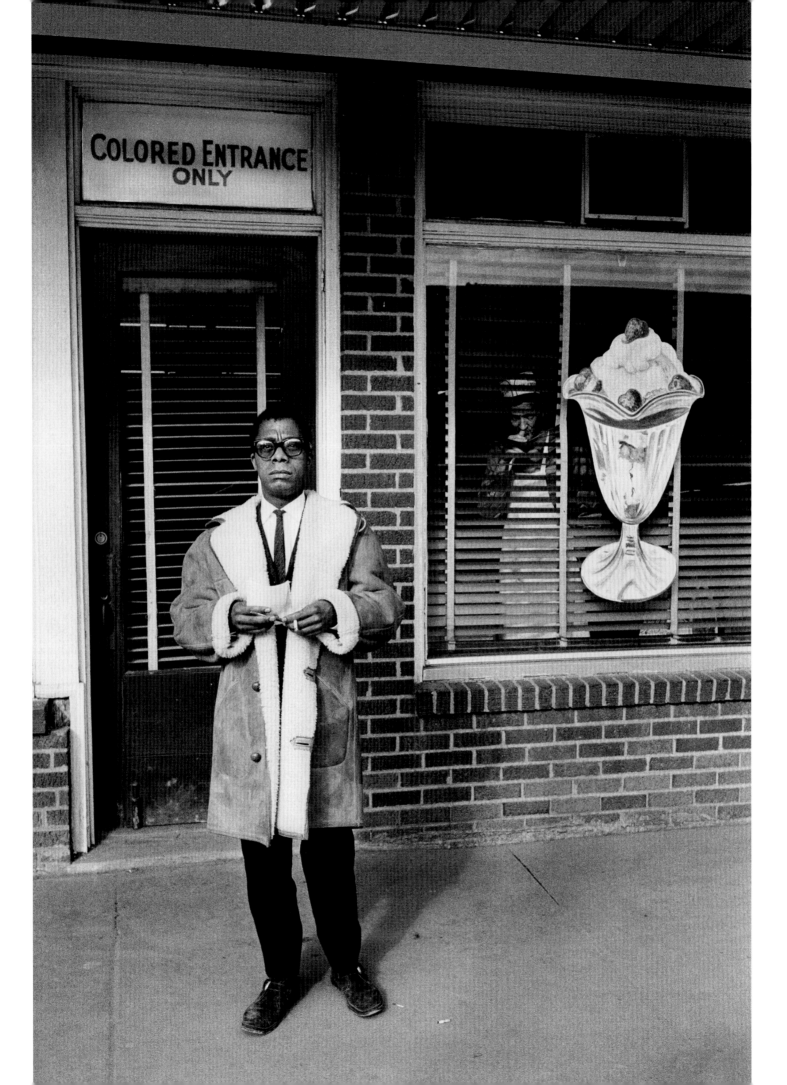

TRUMAN CAPOTE

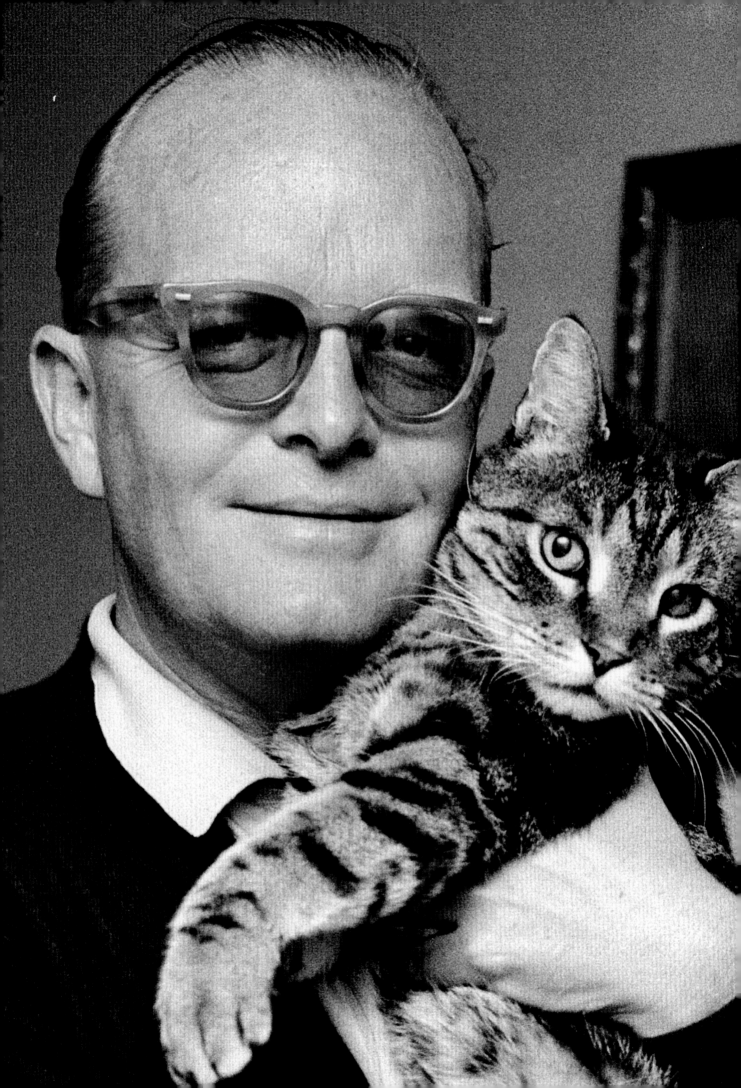

Truman Capote wrote the best-selling book *In Cold Blood* about the murder of the Clutter Family in the small town of Holcomb, Kansas. I worked on the movie based on the book, which was Truman's account of what the real killers, Perry Smith and Richard Hickock, had told him; he always claimed that he was applying fiction techniques to nonfiction. The photos I took of the filming became a *Life* magazine cover story. By then, it had been a year since the two killers had been put to death.

The film was shot in the very same farmhouse in Holcomb where the murders took place, and many of the townspeople had mixed emotions about the crew being there. Stars Robert Blake and Scott Wilson bore an uncanny resemblance to the real murderers, and stayed in character, even when walking around town. They knew that their future careers would be determined by how convincingly they committed the movie murders. The director, Richard Brooks, let me photograph the reenacted murders as they were played out in the basement of the real house. There was a complicated mixture of fact and fiction all blending together.

And then Truman came to town.

The true murders had already occurred. The book had been written. So Truman could relax, showing off the rooms in the murder house to visitors and going off to chat with townspeople in this oasis far from New York. In a local store, he bought the cap in which he would come to be photographed over and over, so that the cap itself became famous.

The experience of writing the book had created for Truman an emotional relationship with murderer Perry Smith, and Smith's spirit continued to haunt him. Truman confided, "It's strange, but the first thing every morning when I wake up, and the last thing before I go to bed, I think of Perry." But Truman was not lonely in Kansas. He had brought his entourage: Harper Lee, the author of *To Kill a Mockingbird*, stayed with him throughout the movie-making experience. In his hotel room he presided, signing stacks of *In Cold Blood* books.

Truman Capote had charm. Everyone in Holcomb invited him to cocktail parties, and Truman went to all of them. Loving to gossip, he was the star attraction with women wearing fur stoles indoors, and men in their nifty suits and ties. Even the children dressed impeccably. Truman was the most important celebrity most of the town would ever meet. He sauntered around town, enjoying the reception he had known he would receive, and talking to everybody. With the actors remaining sullen and withdrawn, all the attention was on Truman.

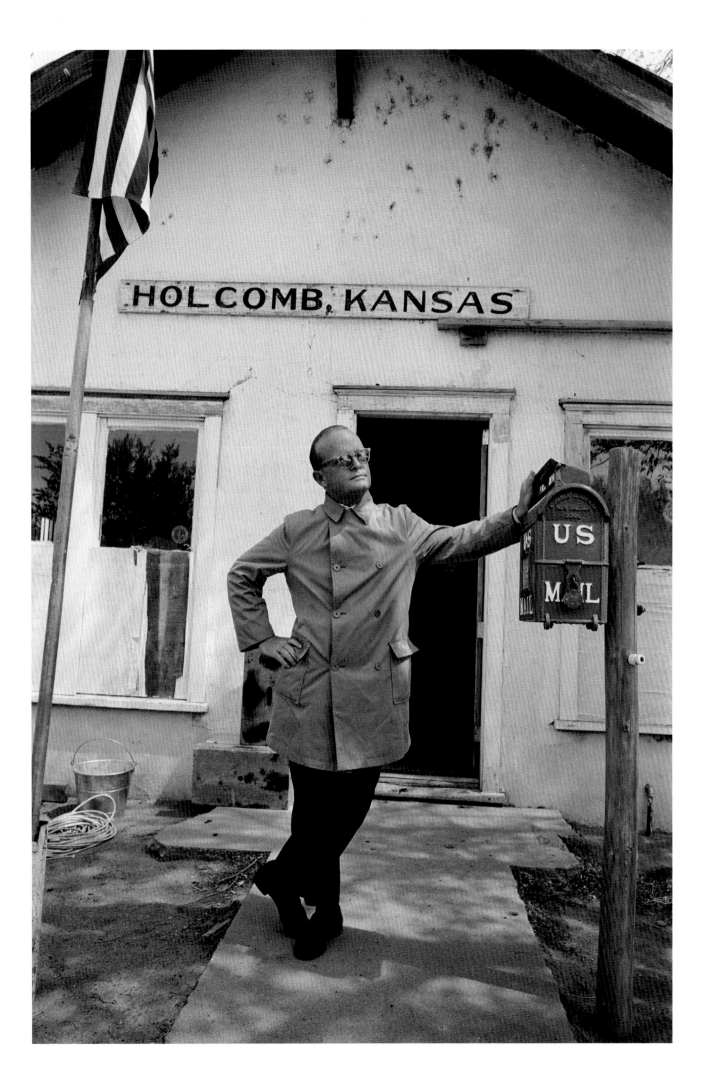

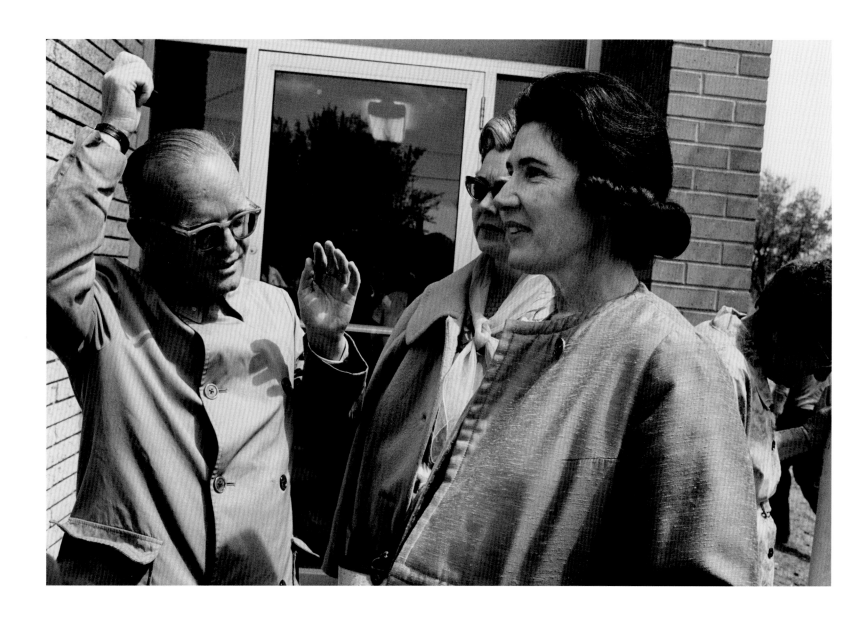

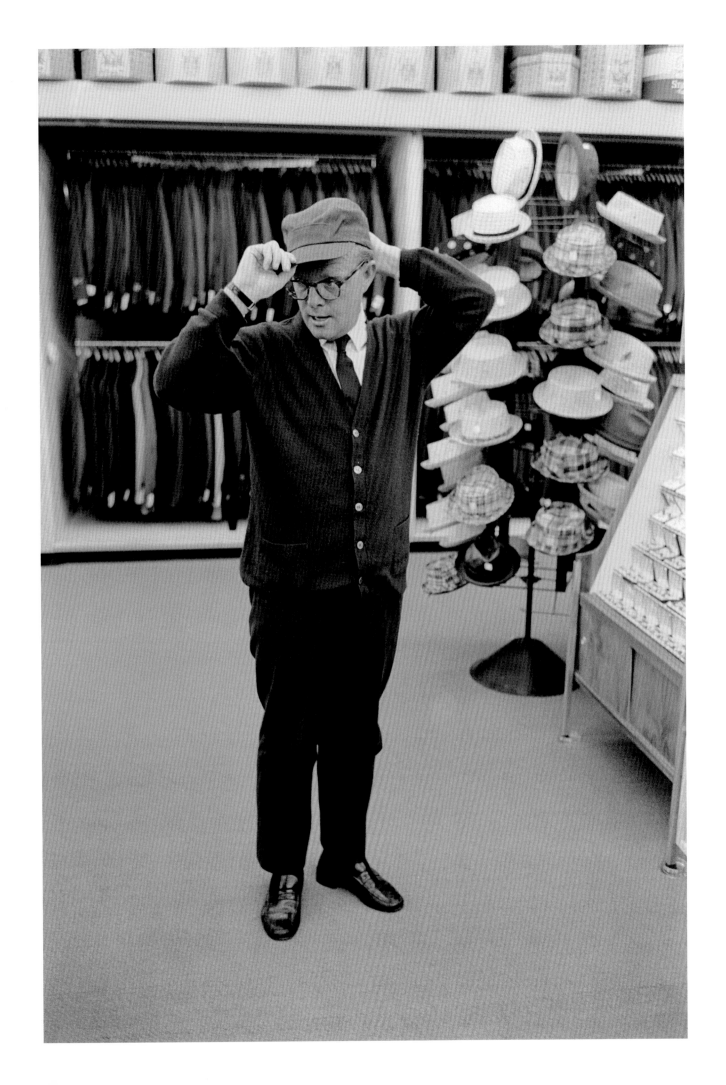

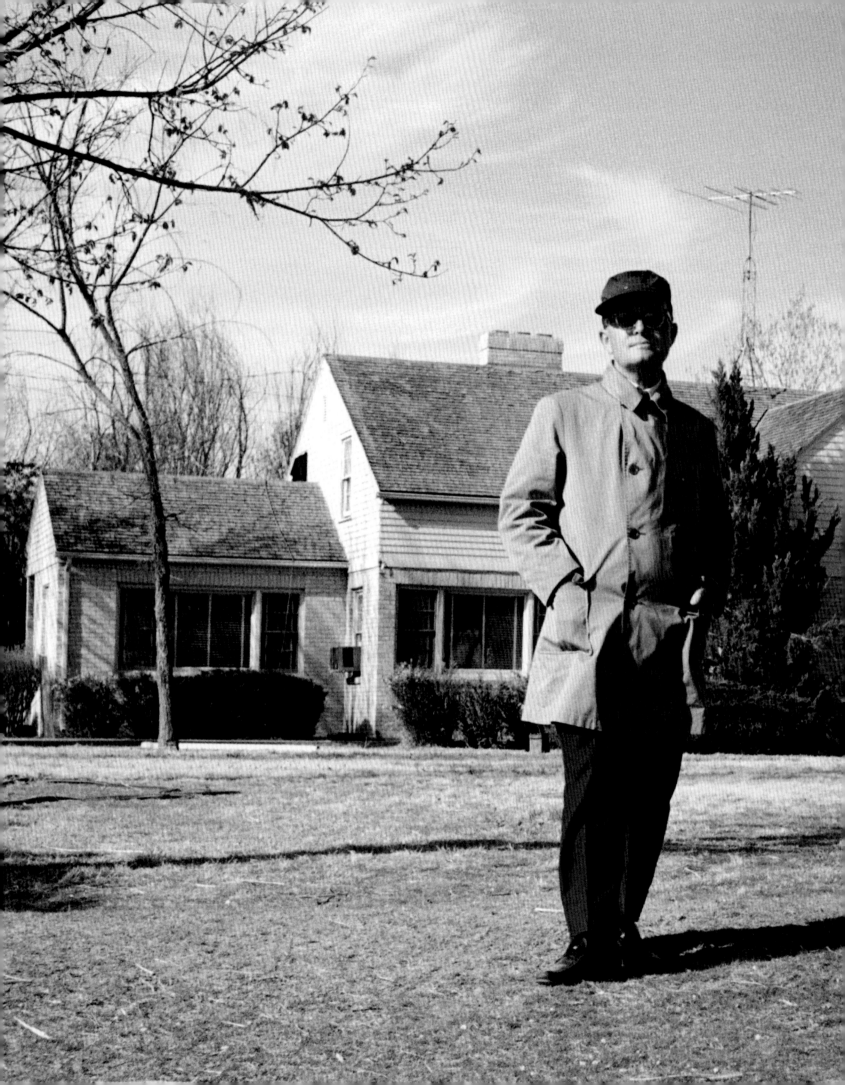

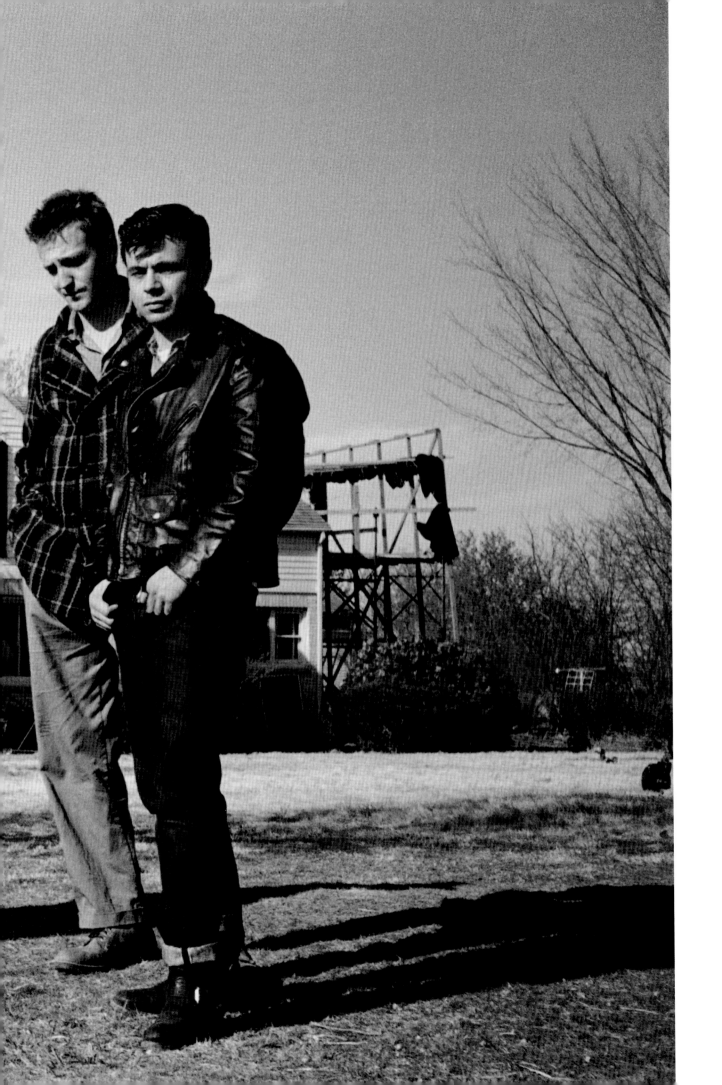

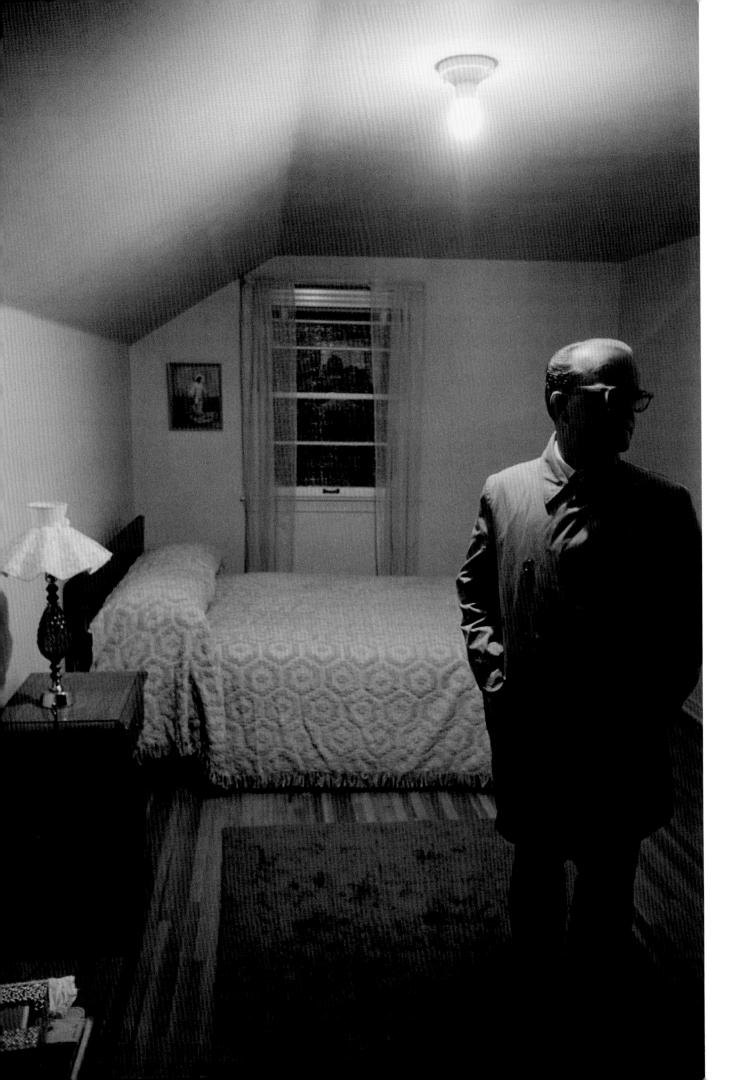

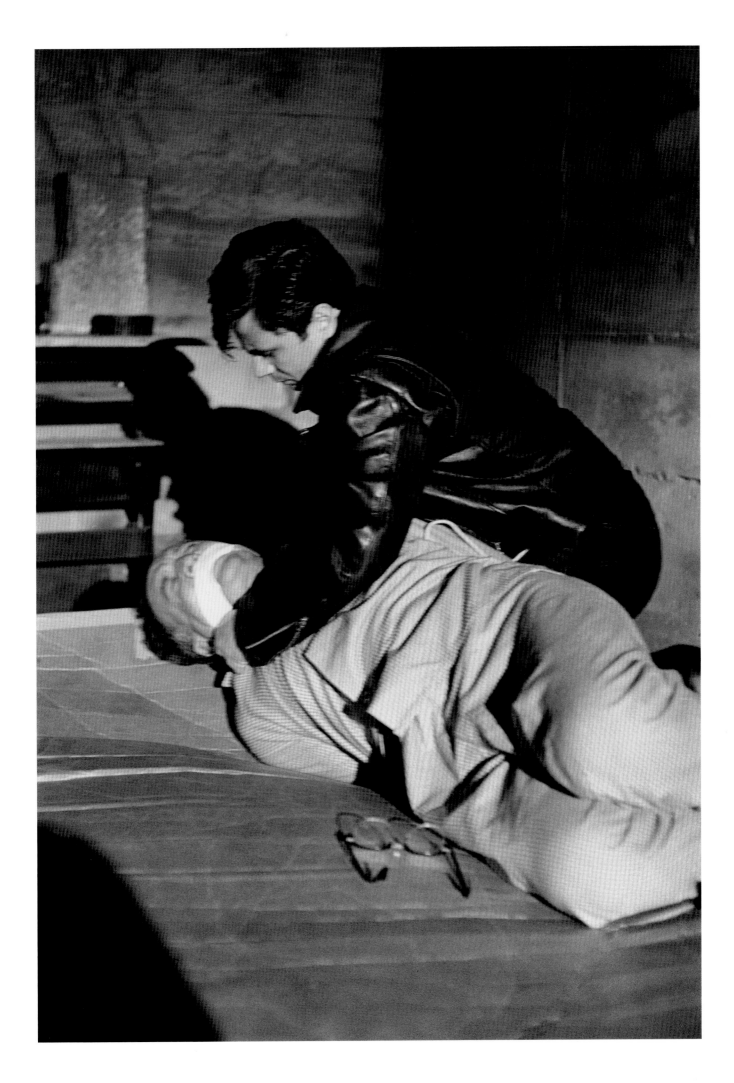

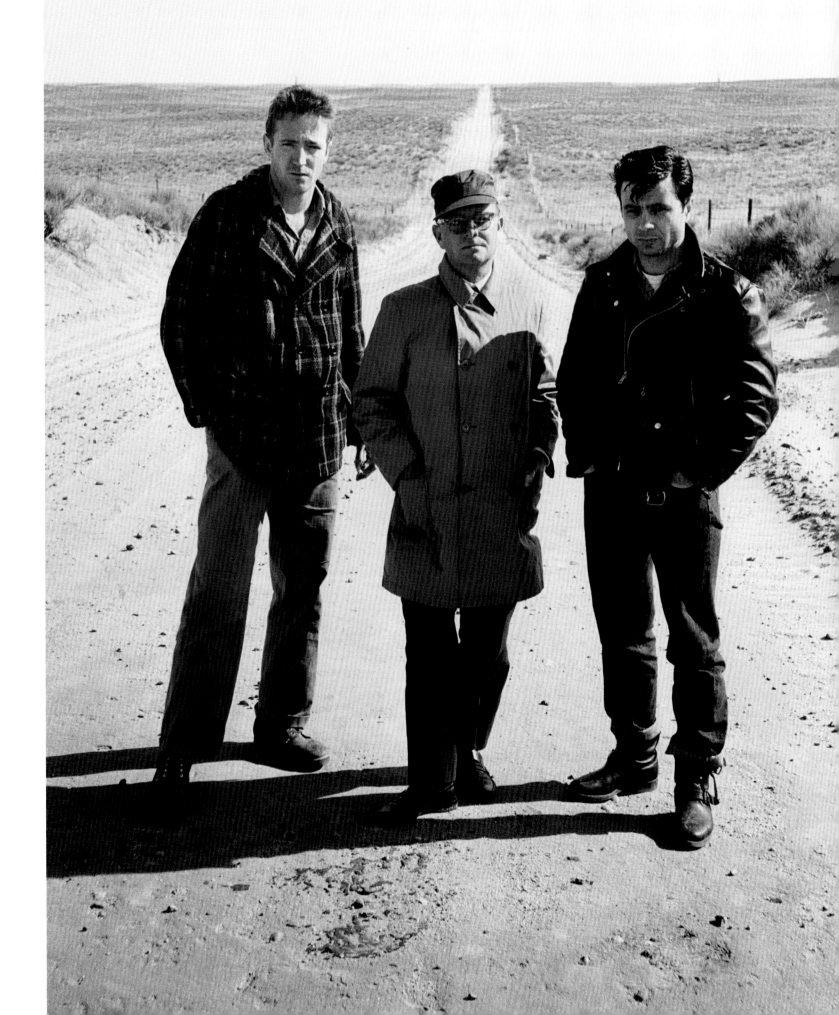

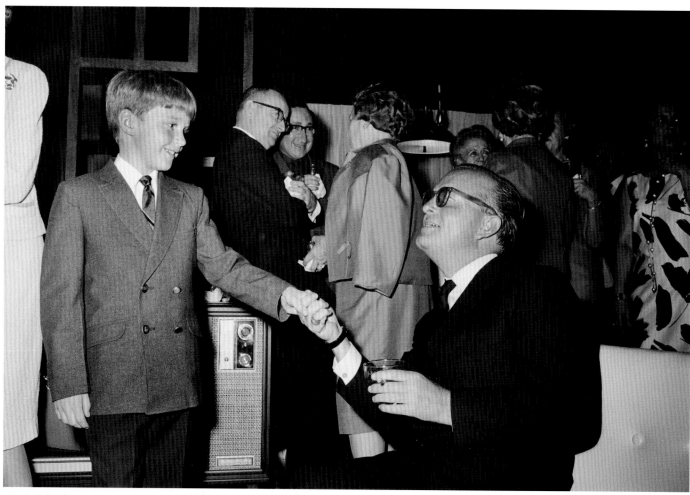

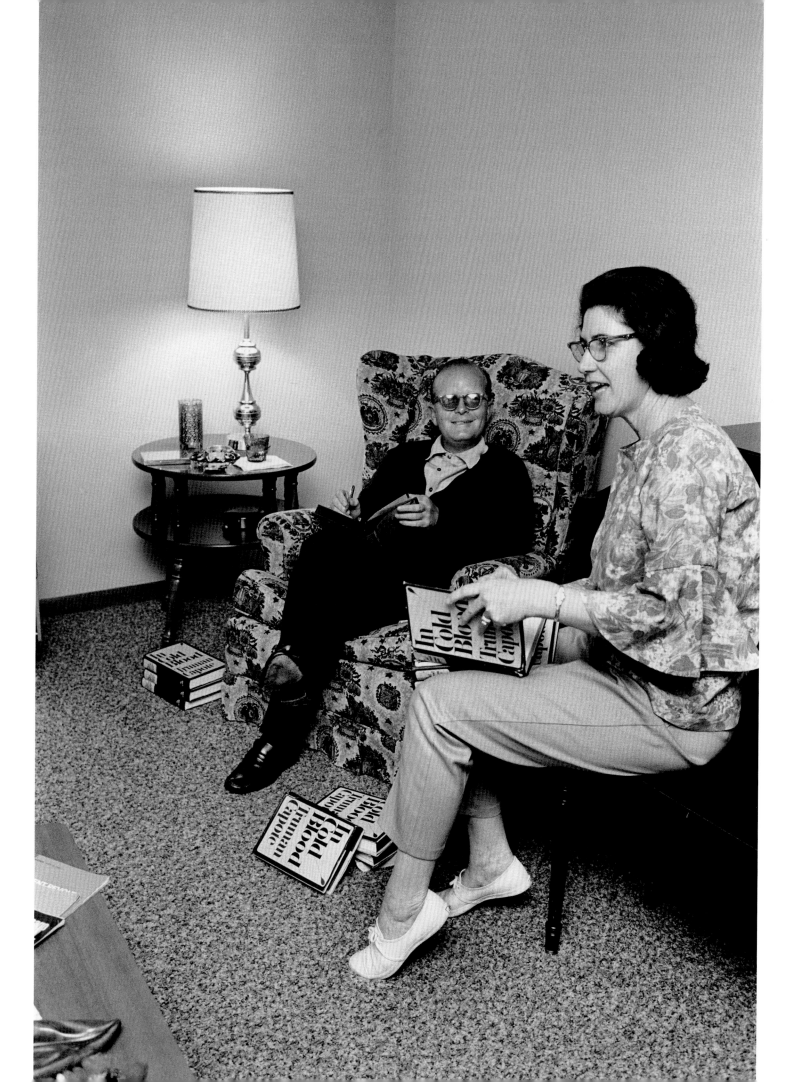

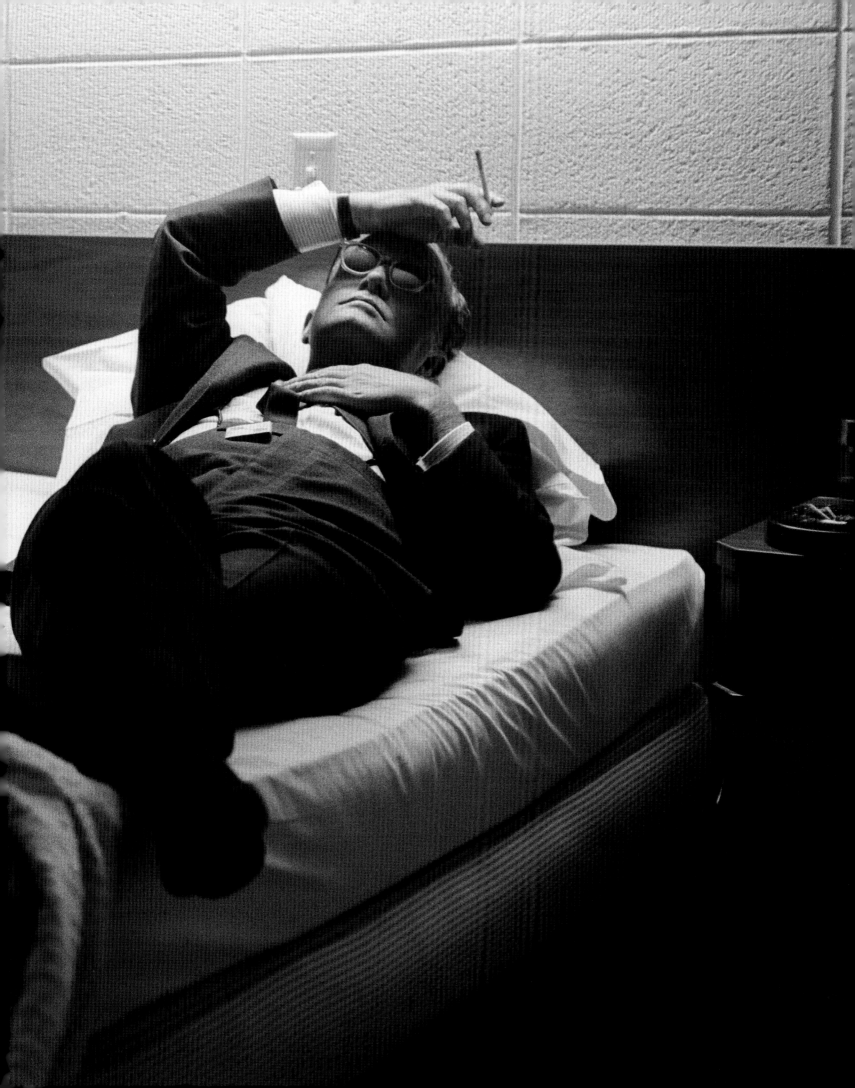

BARBRA STREISAND

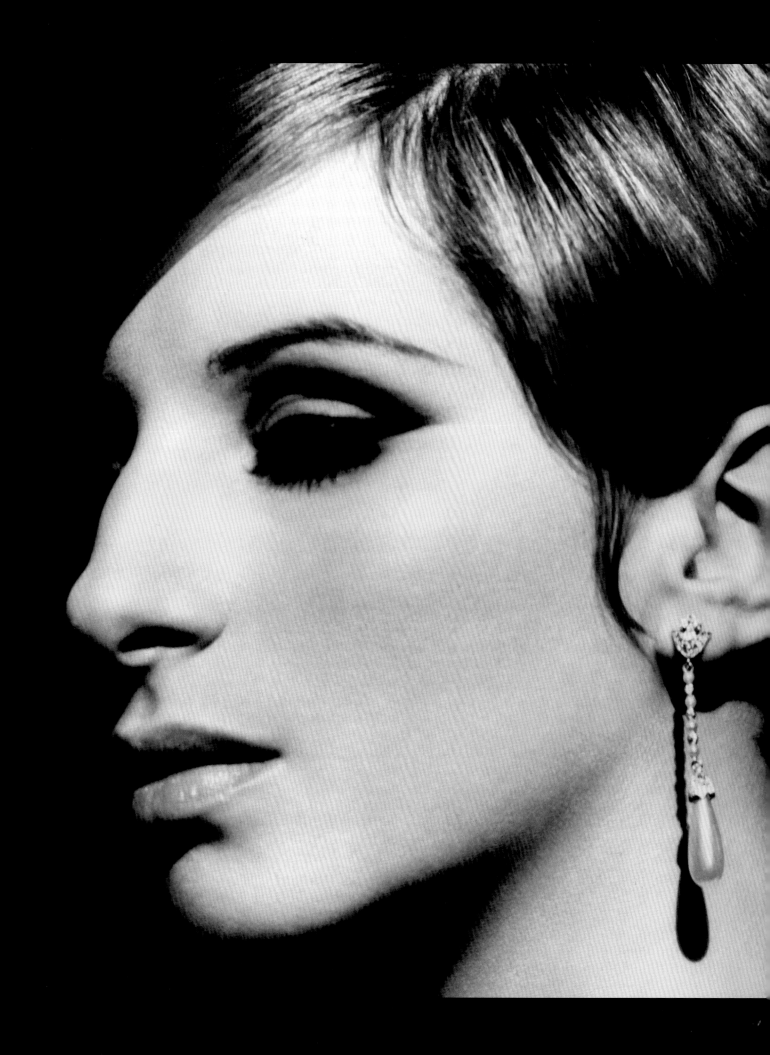

That amazing voice, kooky style, and sense of humor captivated the American audience when she first appeared on Johnny Carson's *Tonight Show* in 1962. Through talent and tenacity, she was able to go from Greenwich Village clubs to the Broadway stage to Hollywood. Streisand became a movie star, a diva, a film director, and a worldwide touring concert celebrity, known simply as "Barbra." Songs like "People," "Evergreen," and "The Way We Were" instantly identify her.

I worked with Barbra on *Funny Girl*, her first film. One afternoon, production stopped completely because Barbra did not feel the set lighting was right for her. She argued with veteran film director William Wyler, who refused to listen, but Barbra was adamant. From the Broadway stage, she had learned how to tell when the lighting was good for her from the heat of the lamps. On this day, Barbra knew the lighting was not right; she would accept nothing less than perfection. Once on a film set she said to me, "I know what a director is for. It's for when I can't make up my mind."

Throughout her career, Barbra has continually come up with new ways to express herself with fashion. I photographed her for the *The Way We Were* album cover in a turban and bright red nail polish, and then for the *Streisand Superman* cover in a Superman T-shirt and shorts. Both concepts were her idea. Later came the hippie style for the *Lazy Afternoon* album, and countless other looks. She always preferred her left profile in photographs. Sometimes when I showed her slides for approval, and thought a right profile image was also good, I'd reverse the slide and usually get it accepted.

From the earliest years of her career, Barbra has had a political side. She first supported Bella Abzug In New York, and has continued to voice her political opinions and do substantial fundraising for Democratic candidates. In 1972, Barbra performed at a concert with James Taylor and Carole King to support the George McGovern campaign. She had not sung for several months, but when she opened her mouth at the very first rehearsal, her voice was flawless and perfect. Everybody stopped what he or she was doing, in awe of her vocal magic.

We played cards one evening while Barbra was making the film *Up the Sandbox* in Kenya. I was paired with Marty Ehrlichman, her longtime manager. Barbra was coupled with her best friend, Cis Corman. In the middle of the game Marty quietly whispered to me, "We've got to let them win." As if I didn't know.

If some people have found Barbra abrasive, they can chalk it up to the fact that she has always known what was right for herself and her career. She is a star because she made herself a star, and did not listen to others. That tenacity, along with her natural talent, has made her unstoppable.

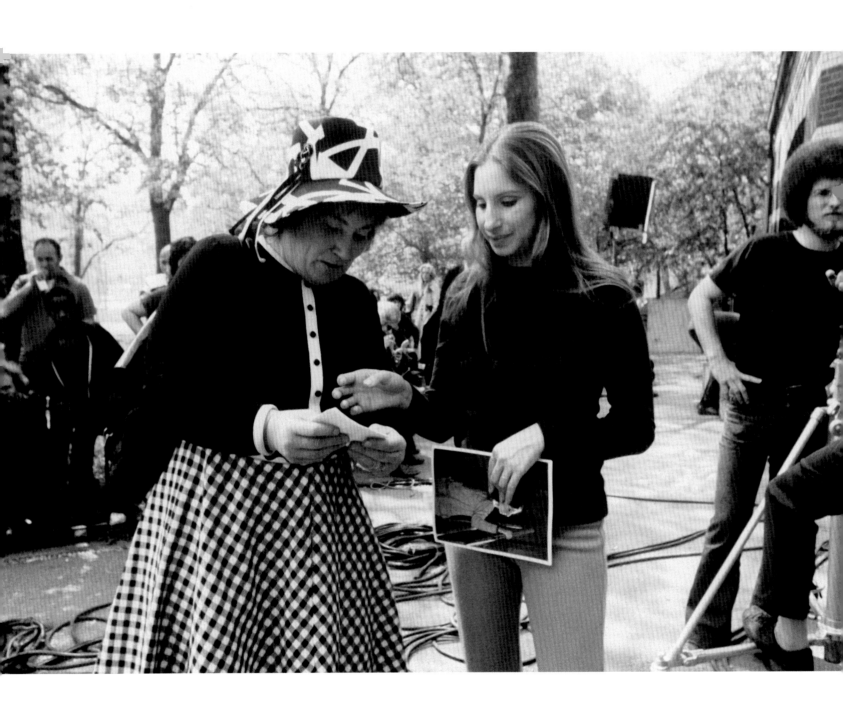

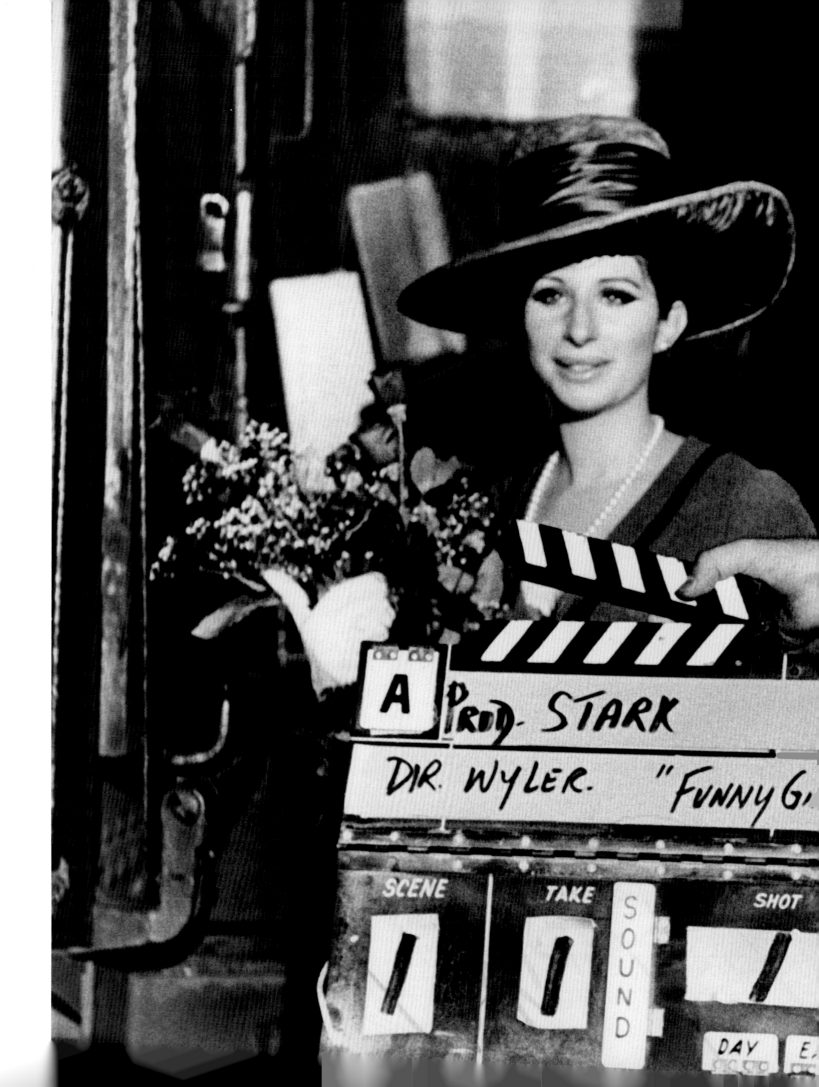

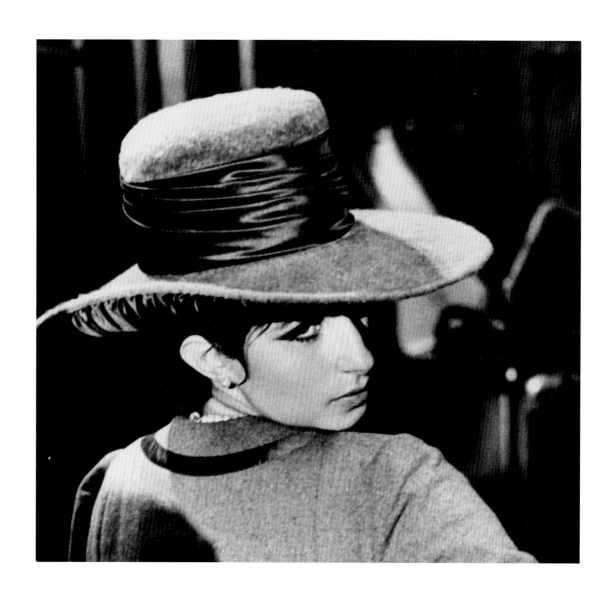

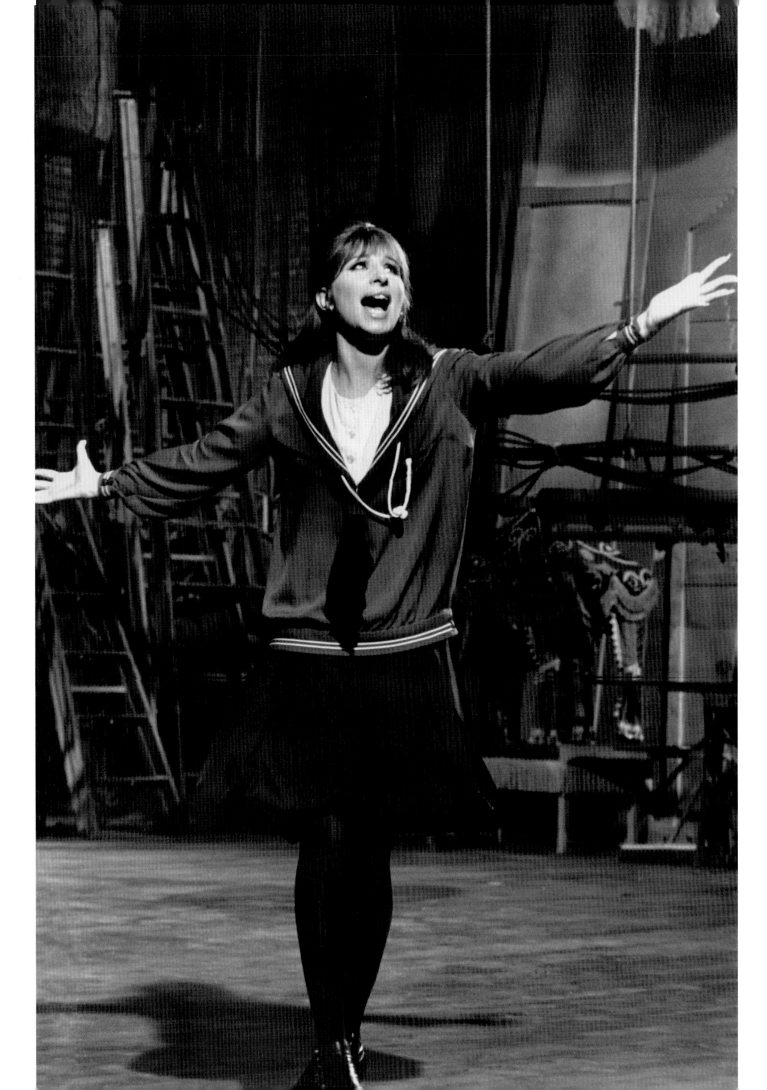

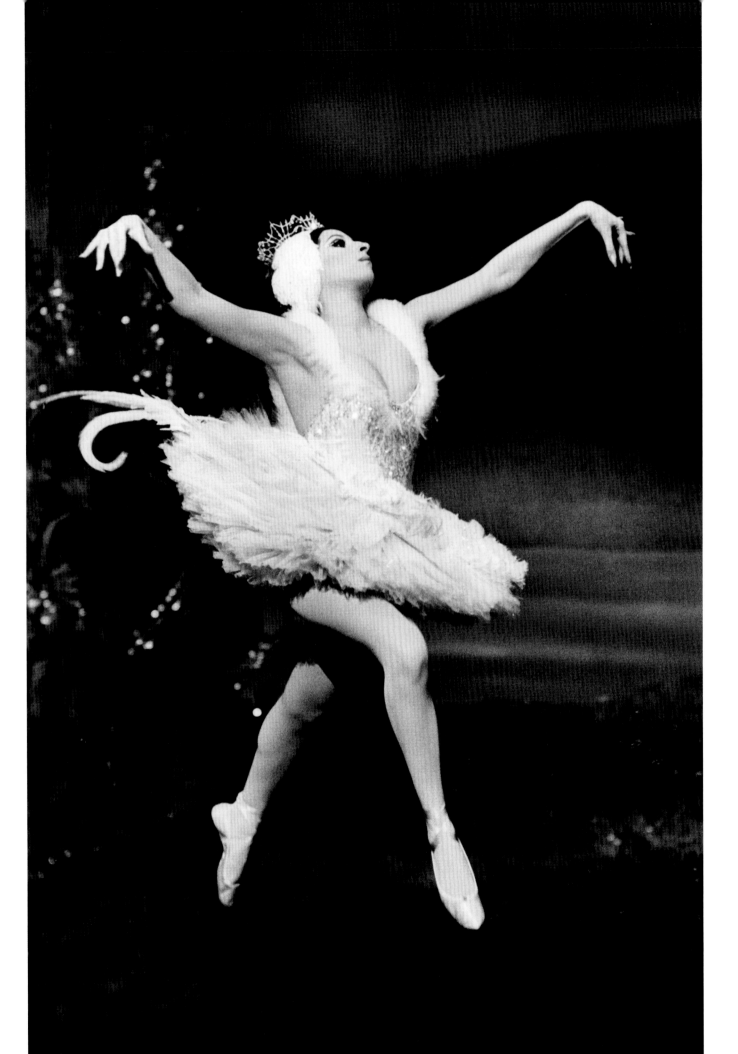

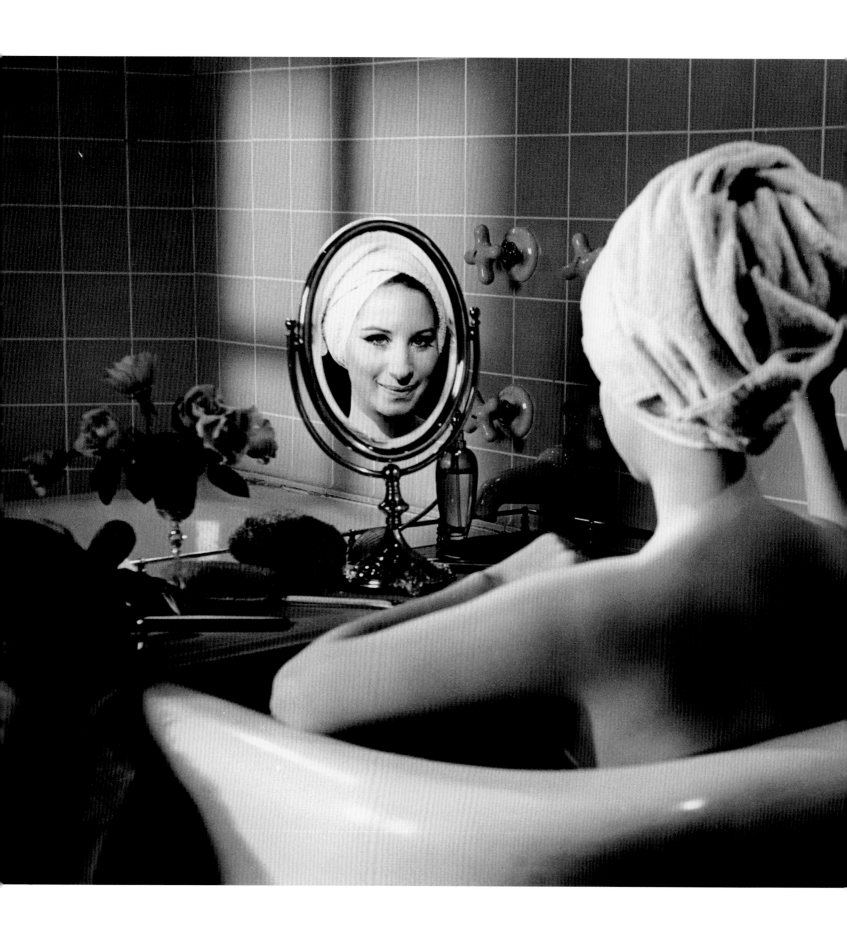

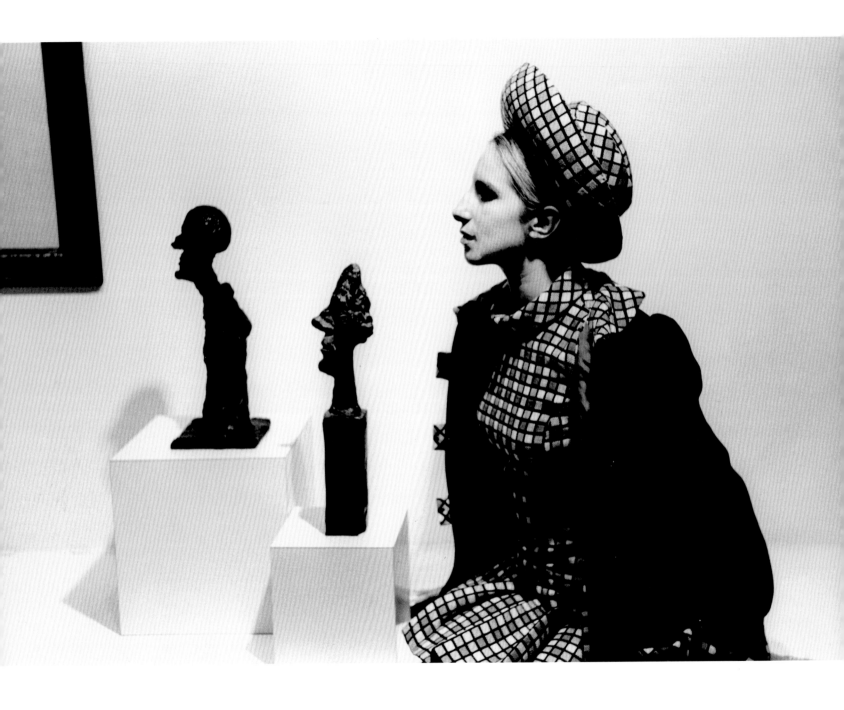

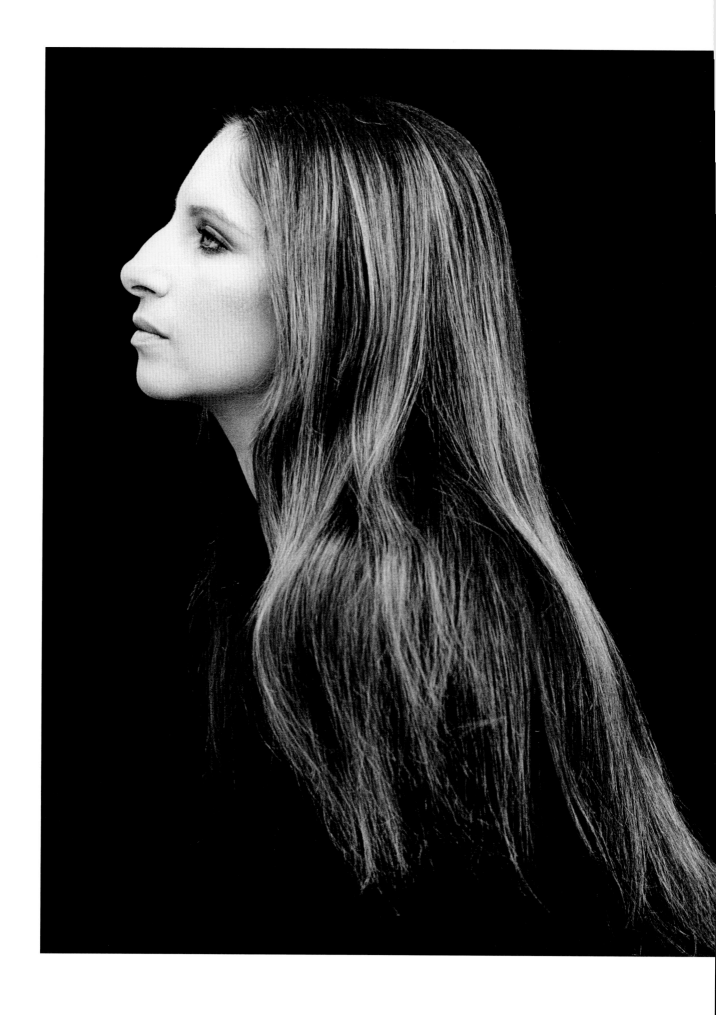

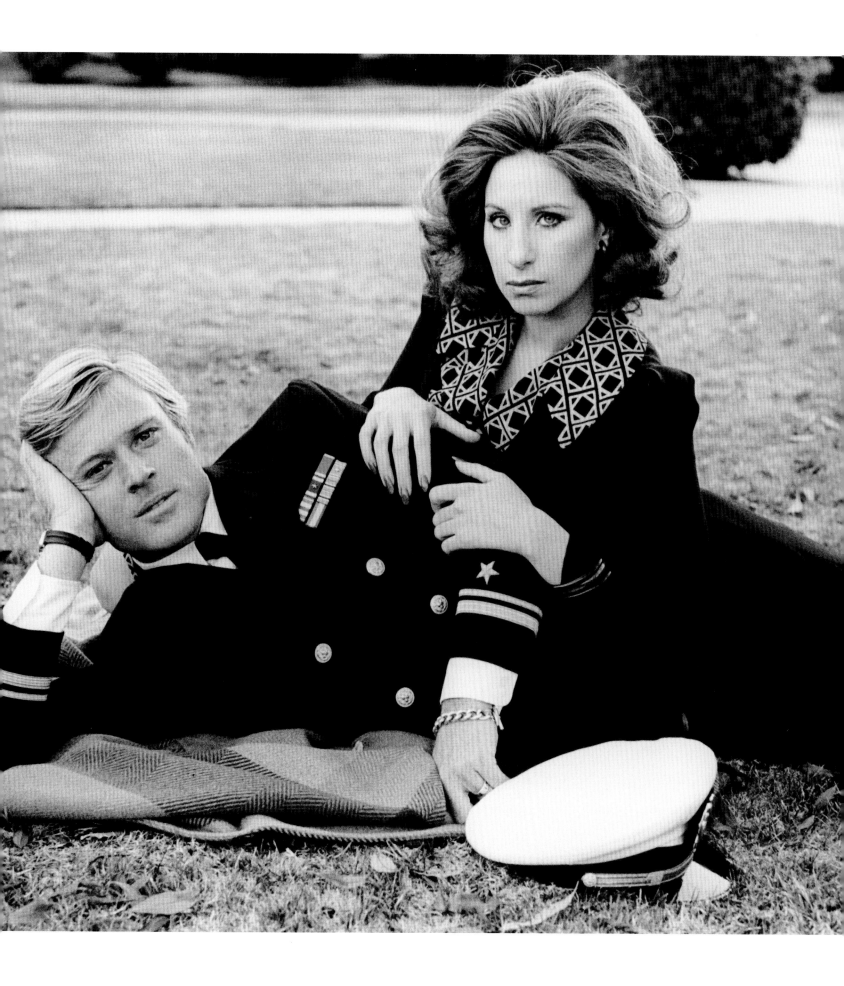

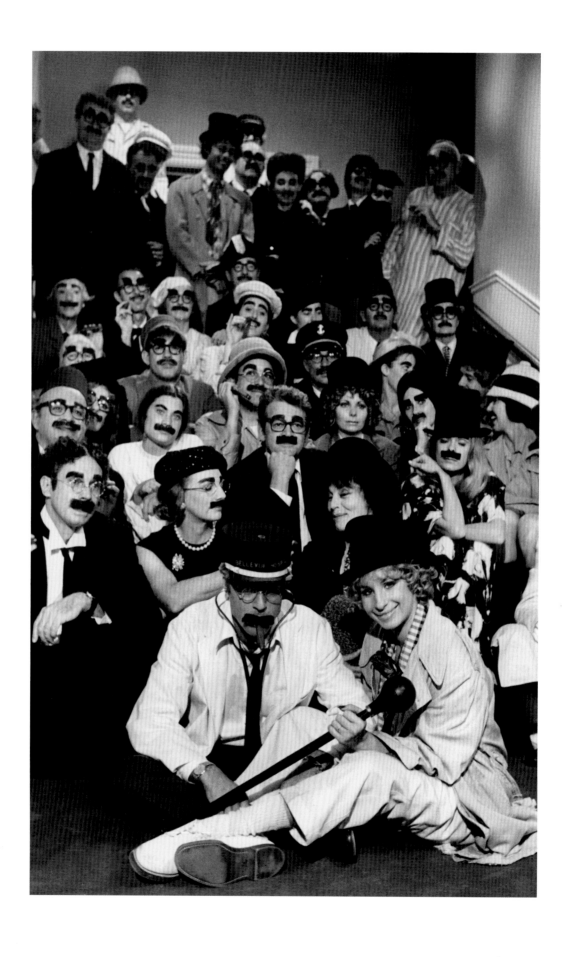

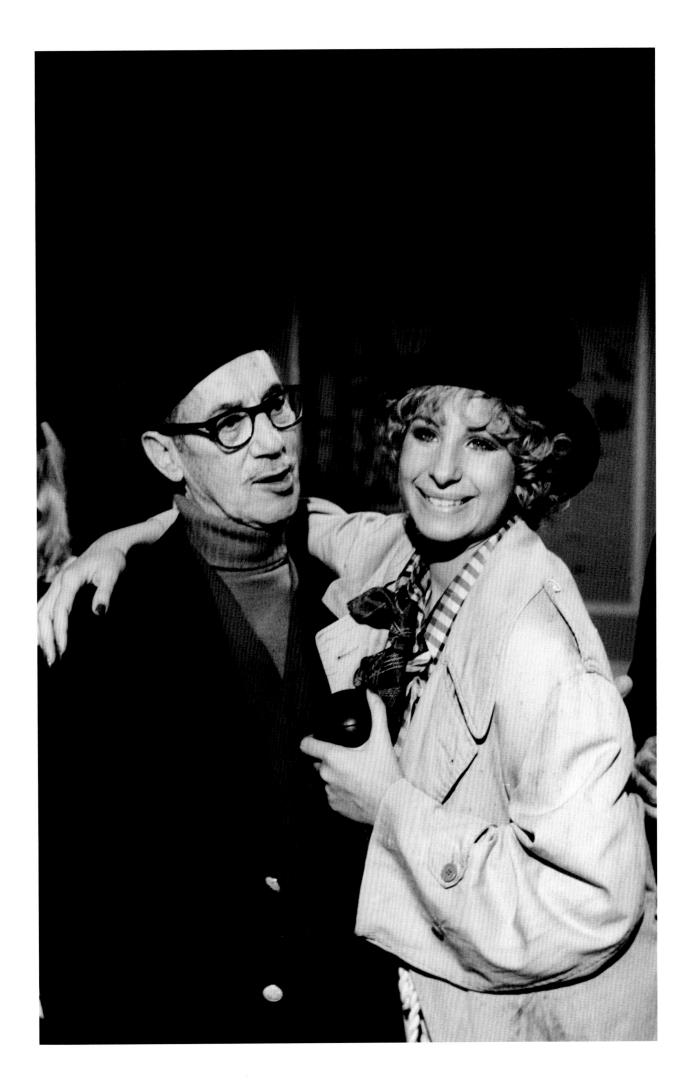

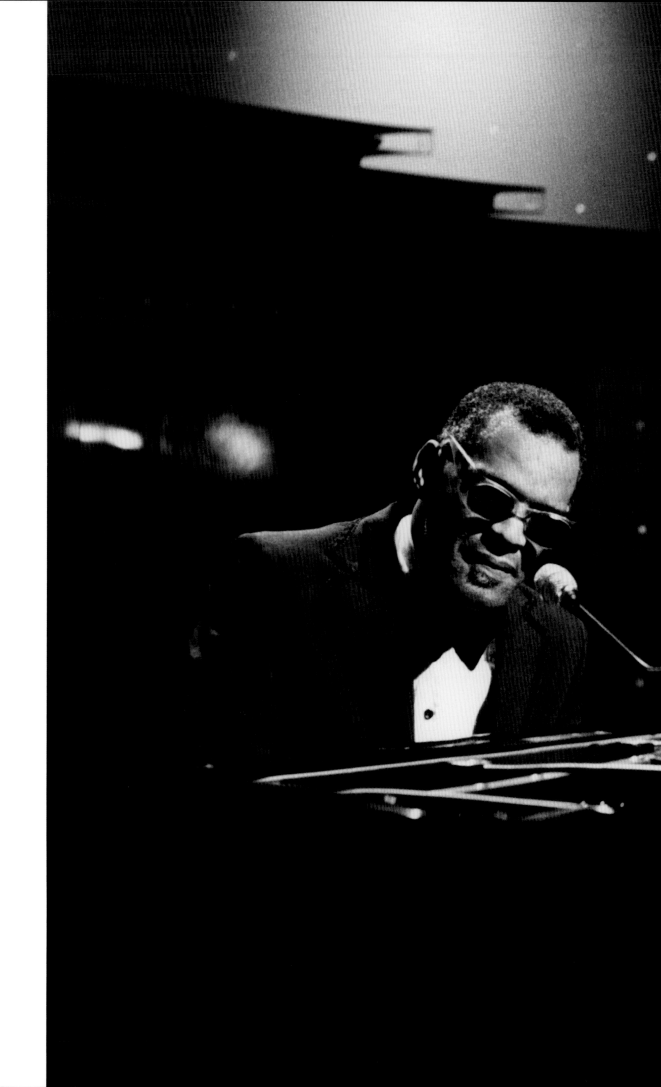

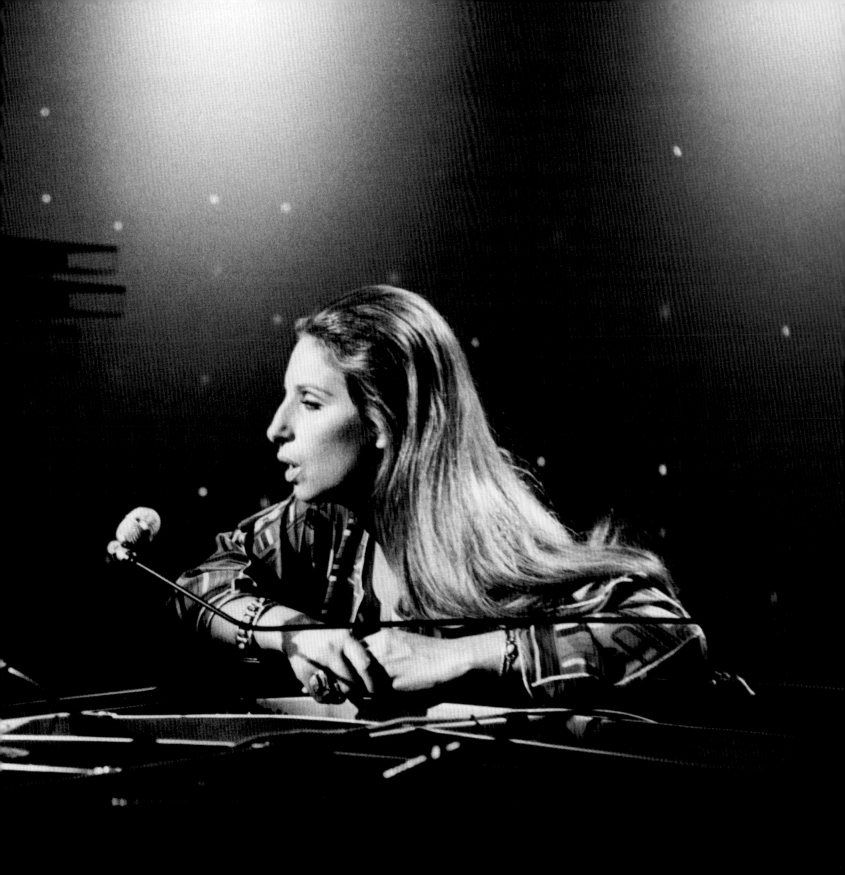

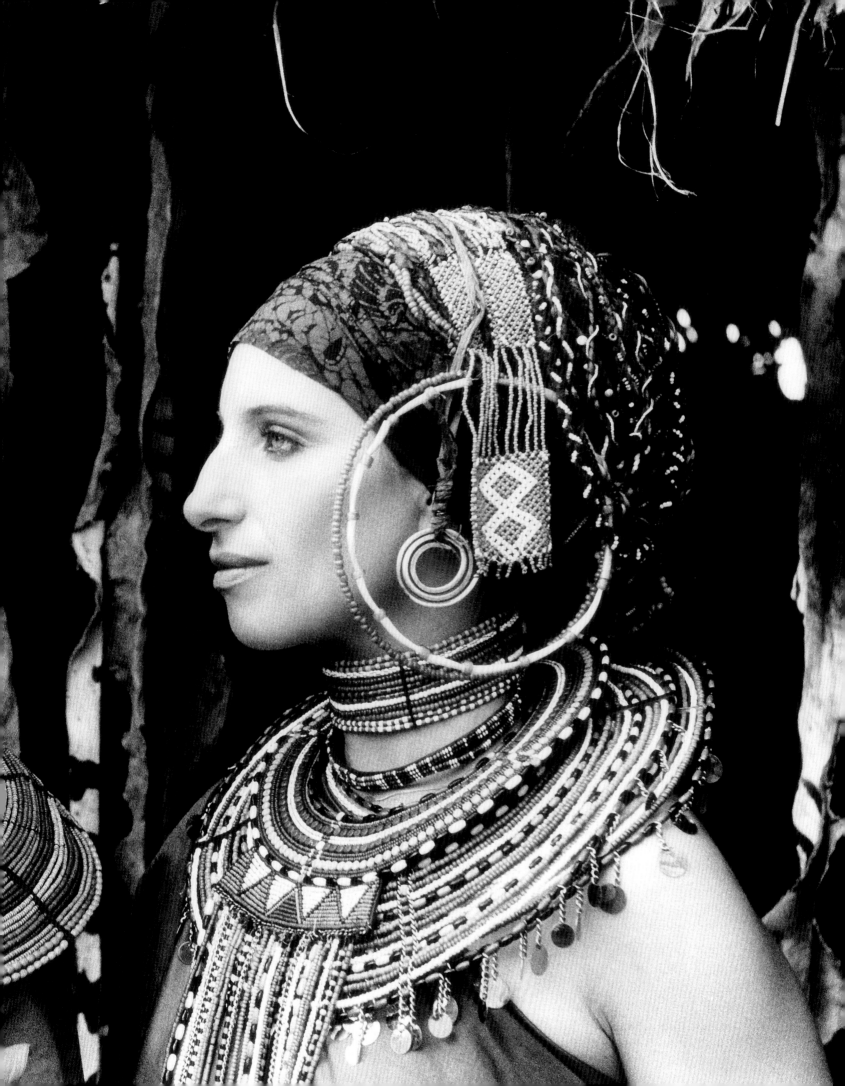

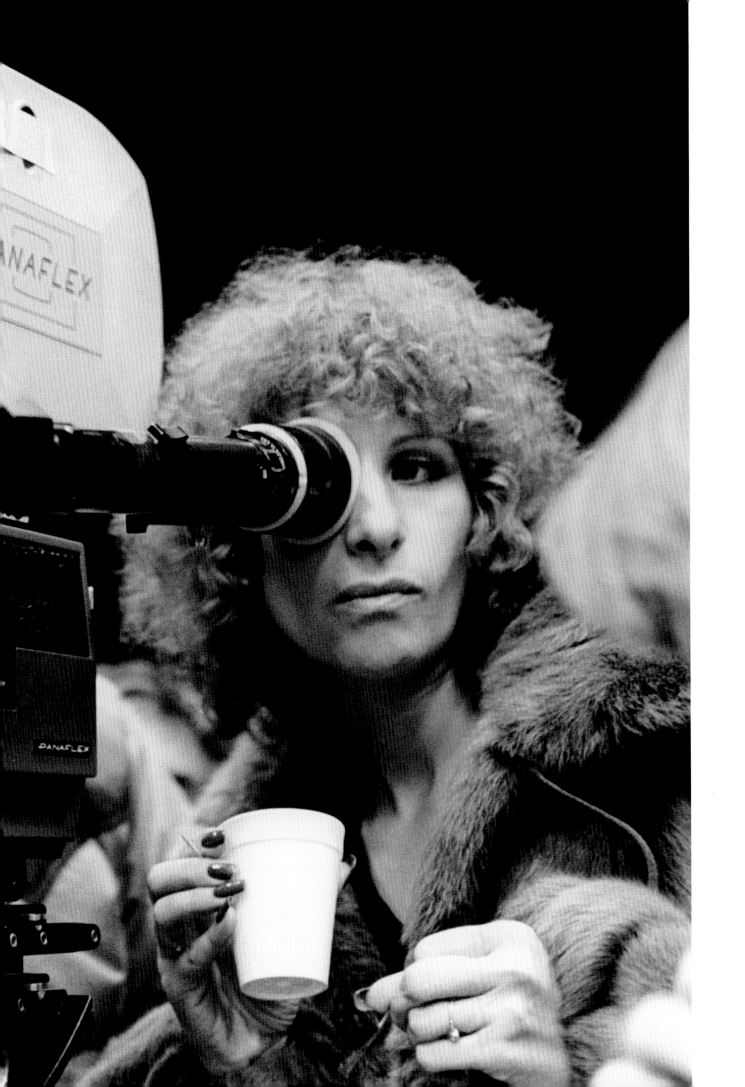

SAMUEL BECKETT

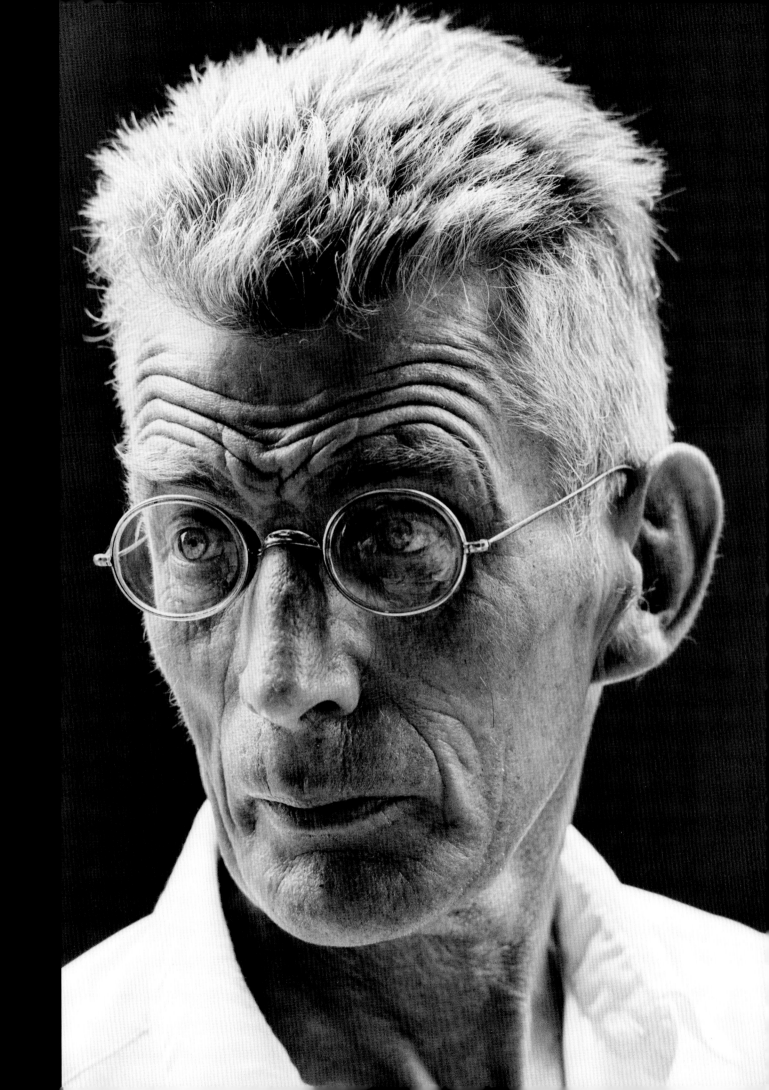

I worked with Samuel Beckett and Buster Keaton on a small experimental movie called *Film*.

Beckett had written the script. It was a story about the perceived and the perceiver, the objective and subjective viewpoints. The film portrayed Keaton's blurring vision of the world as he tried to stop everyone, even animals, from seeing him. The camera followed him objectively, never revealing his "great stone face" until the final shot of the film.

It was never clear if Keaton really understood the paces through which Beckett was putting him. Giving up the control that he had earned in having his own studio and being Hollywood's most inventive silent film star must have been a challenge to his creative spirit. Beckett had cast the original American company of *Waiting for Godot* in a similar manner: much of the cast came from vaudeville and an early film background, and had little idea of the play's real message. On the other hand, there were times when Beckett himself claimed not to fully understand his own play.

For Beckett, coming to America to make this movie was unusual. He seldom came across the pond. Although Alan Schneider was the official director, *Film* was definitely Beckett's show. Tall, lanky, and introspective, Beckett seemed inquisitive about all aspects of the filming and every object on the set, always demanding a perfect rendering of his vision.

Film has been acclaimed by some as one of the best Irish films ever made, while others consider it dribble. However, Beckett will always be thought of as one of the great Irish playwrights. He brought a new avant-garde vision to the world.

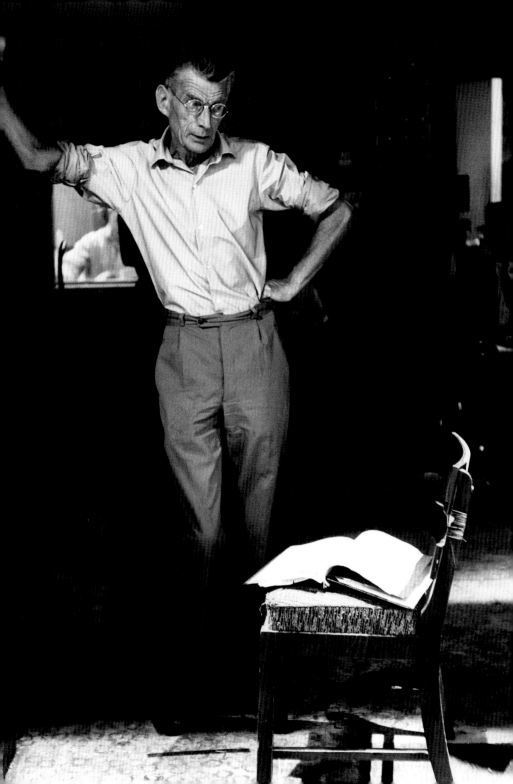

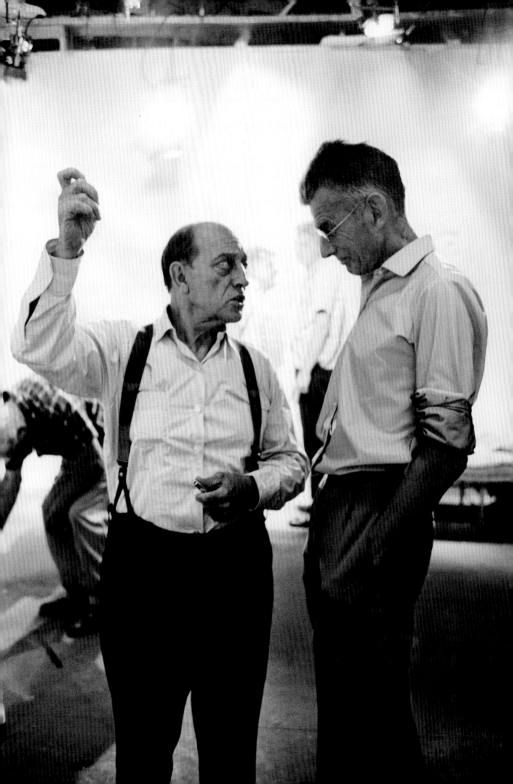

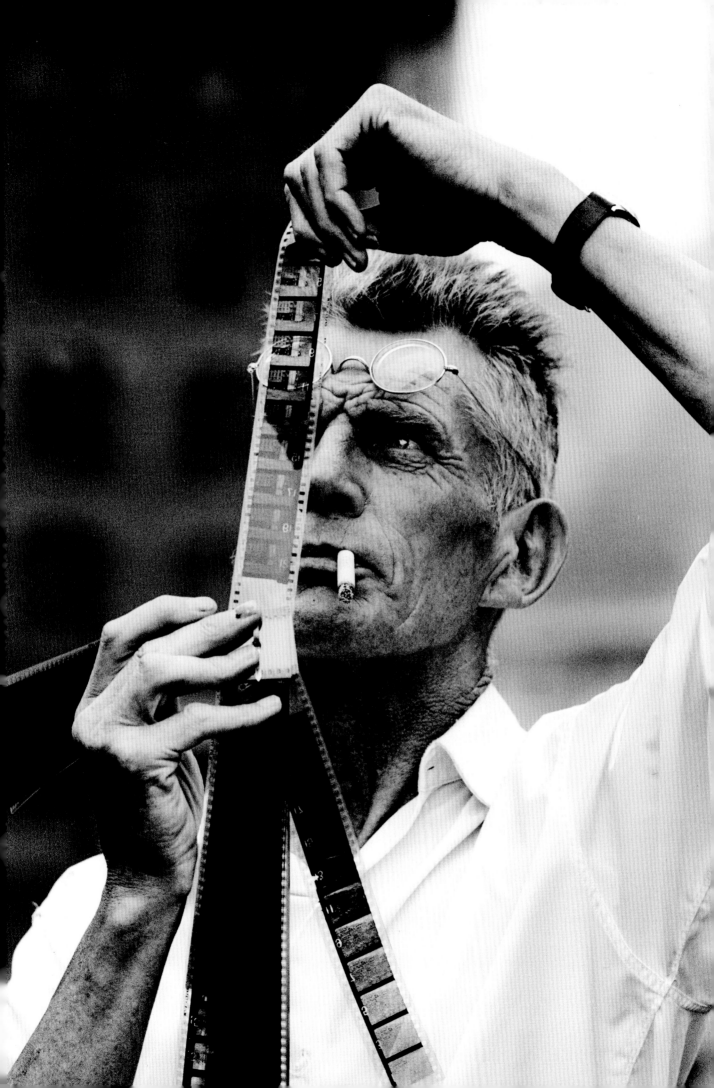

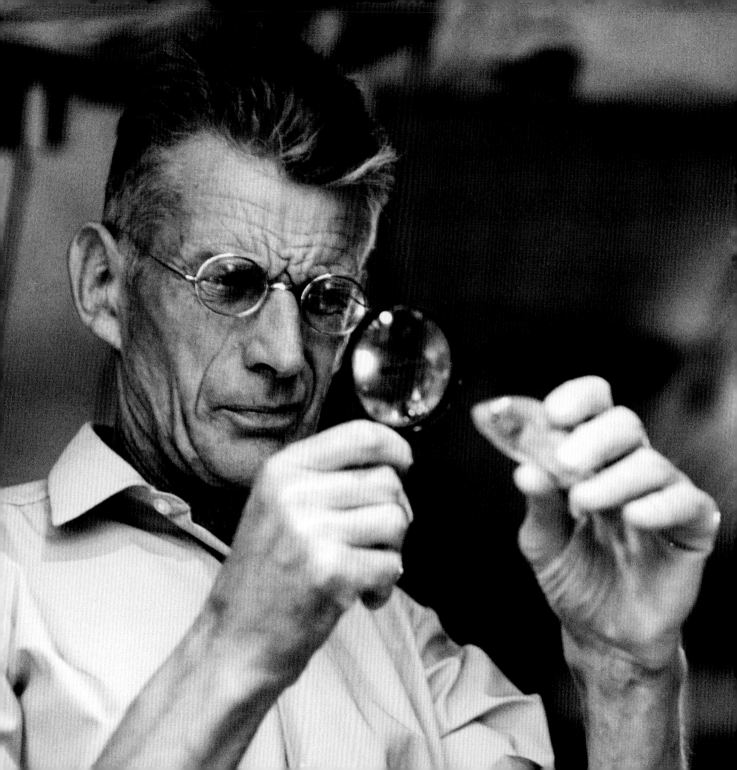

MARTIN LUTHER KING JR.

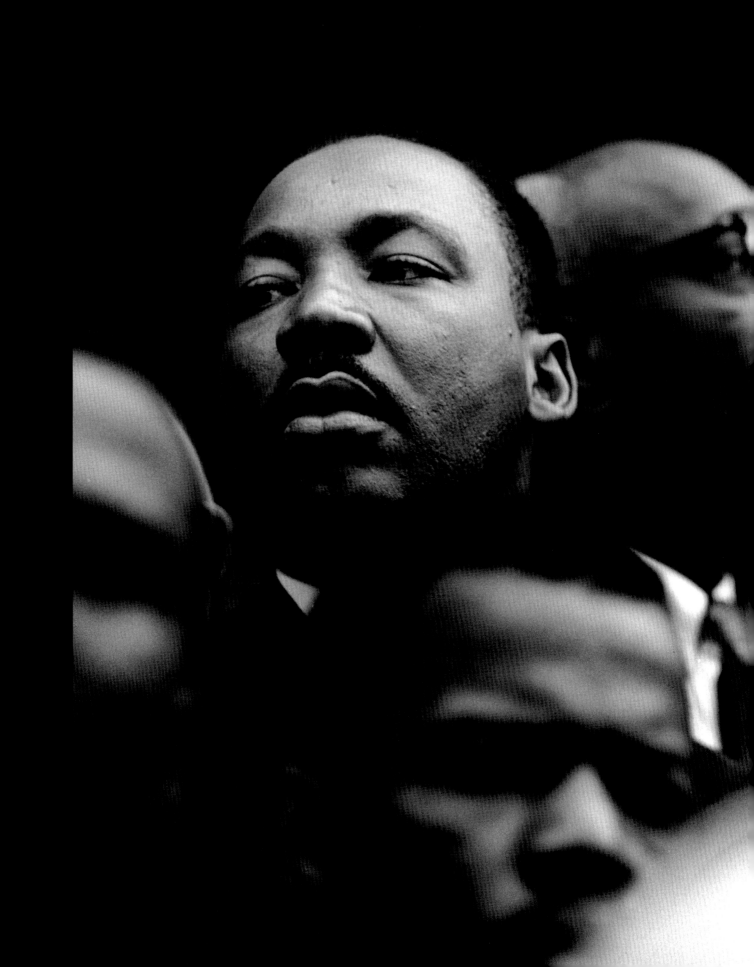

Martin Luther King was the American Moses, except that the biblical Moses was not as good at speeches. While King is said to have received only a C in public speaking at school, he quickly made up for it.

Fate, luck, concern, and talent brought Reverend King to the fore during the Birmingham bus strike in 1963. His strong emotional and rational voice from the church pulpit energized the development and growth of the nonviolent movement in America.

I started working in the South during the civil rights times through James Baldwin and Jerome Smith. *Life* arranged for a white stringer named John Gregory, who had gone to Ole Miss, to be my reporter. When I arrived in Jackson, Mississippi, I had on my old leather jacket and my hair was past my shoulders. Gregory took one look at me and pulled me into the nearest barbershop. He said I had lost a bet and told them to give me a marine haircut. He had me purchase a red golf shirt, white corduroy pants, and a transistor radio case to hide my camera in. It was only then that he felt comfortable enough to go anywhere with me.

We visited many SNCC and CORE storefronts in small towns, and were always followed. Usually Gregory would drop me off, then park the car in the cemetery. When I was through taking pictures, I would call him on a walkie-talkie. He would zoom by to pick me up and we would race out of town.

Though I photographed Dr. King in many churches and on marches, I rarely saw him relaxed. A photograph I took during the Selma march did become the cover image for King's book *Where Do We Go From Here*, but like many other civil rights photographers, I was privy only to public events.

In looking back at the photographs I took of King, I eventually started to take careful notice of his eyes. I see something in his eyes that, despite his strength of leadership, could only be called a wariness or a foreboding fear. Martin Luther King Jr. had to be incredibly brave to become the voice of the southern Christian nonviolent movement. The threat of death was enormous and constant, and King himself said he doubted he would ever reach the age of 40. He did not.

The two most poignant speeches of my lifetime have been John F. Kennedy's "Ask Not What Your Country Can Do for You" and Martin Luther King Jr.'s "I Have a Dream." But equally poignant was the speech King made in Memphis on the last night of his life. "I've been to the mountaintop…" he proclaimed, "…and I've seen the promised land. I may not get there with you. But I want you to know tonight that we, as a people, will get to the promised land."

I have no real anecdotes to tell about Martin Luther King Jr. I can offer only mournful respect.

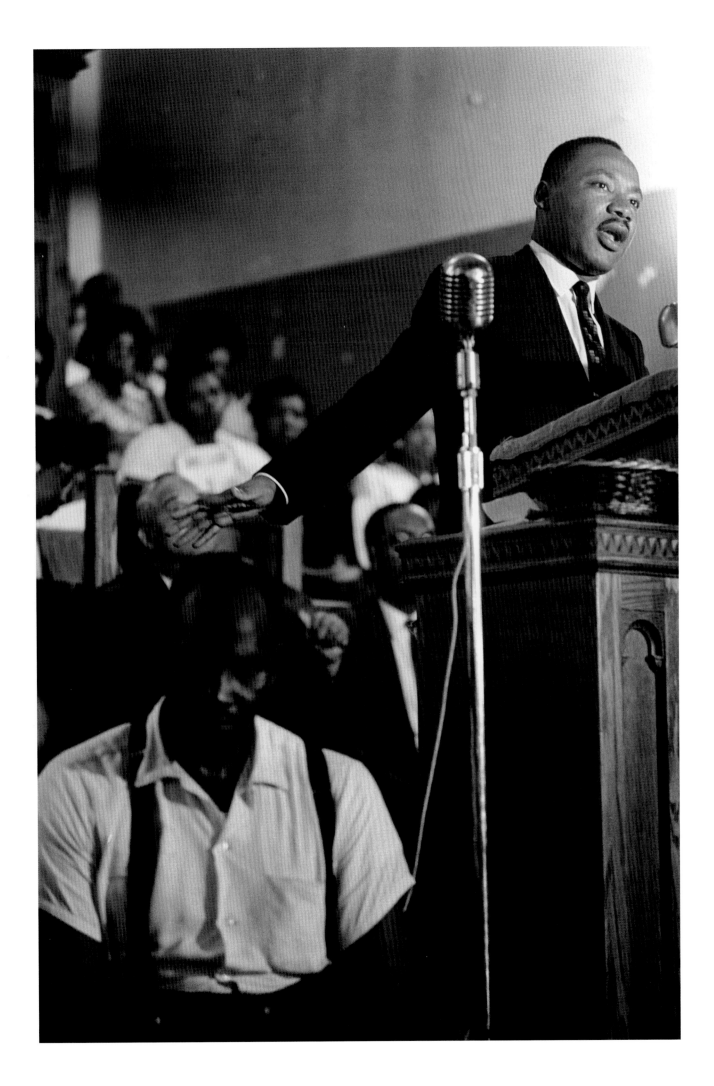

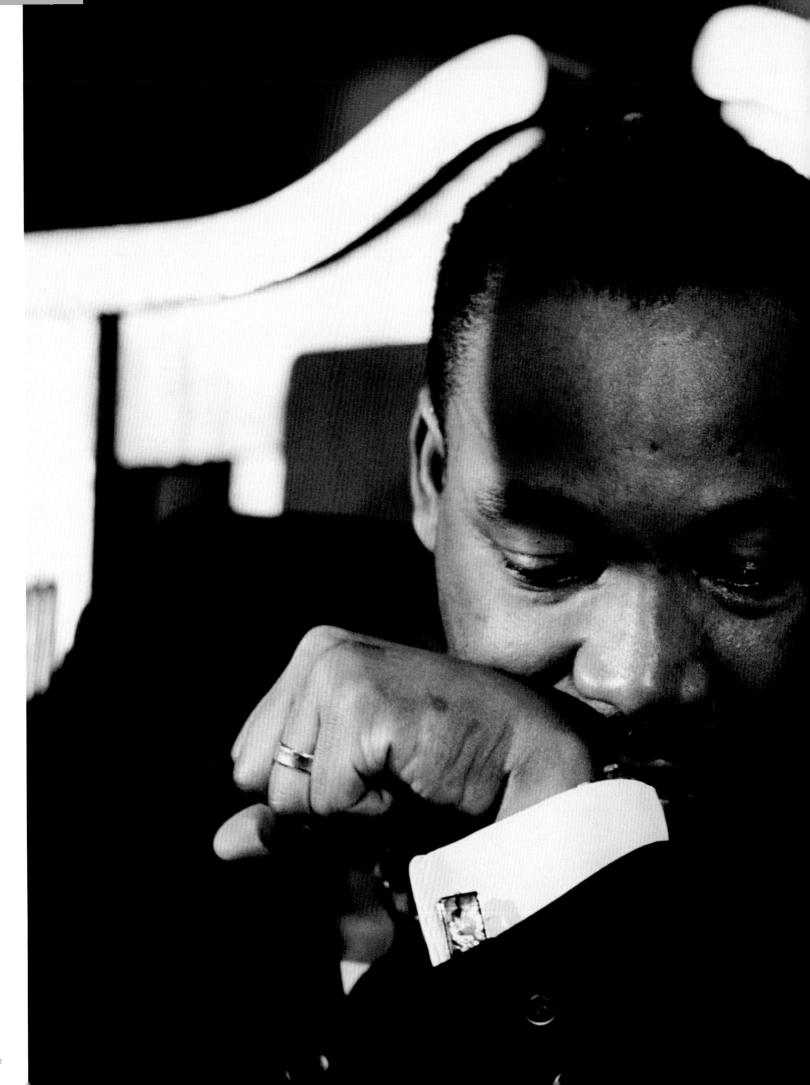

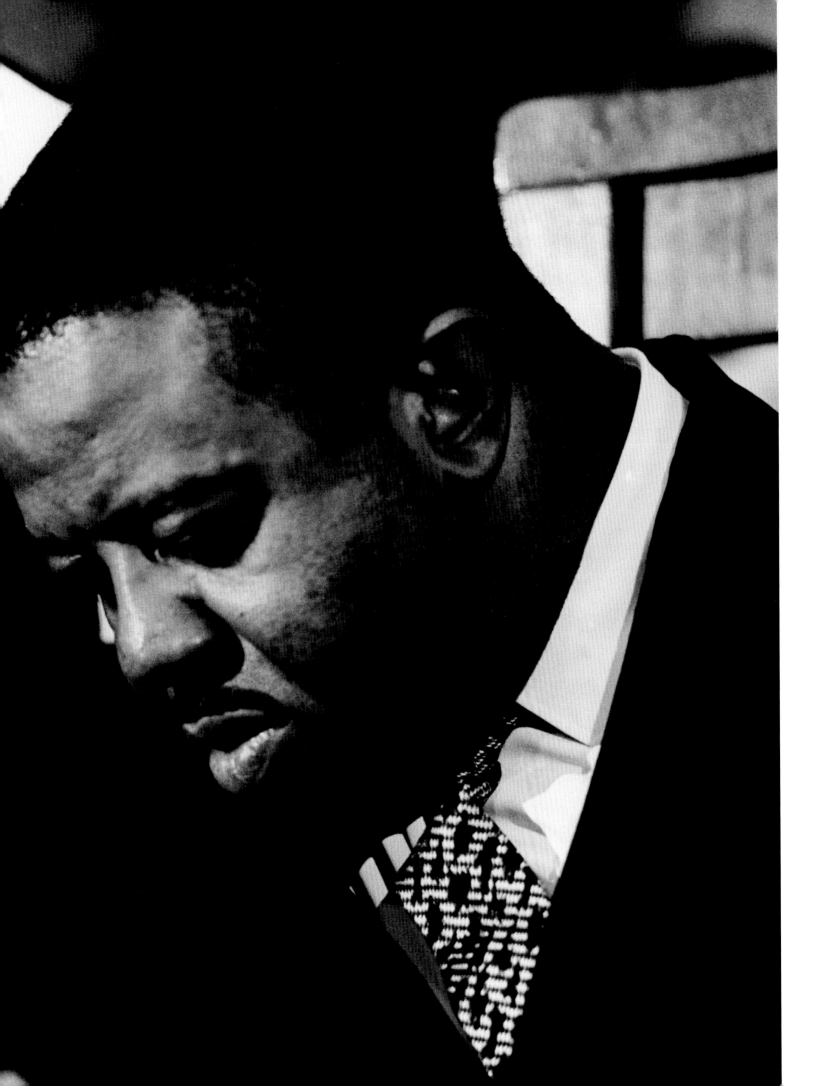

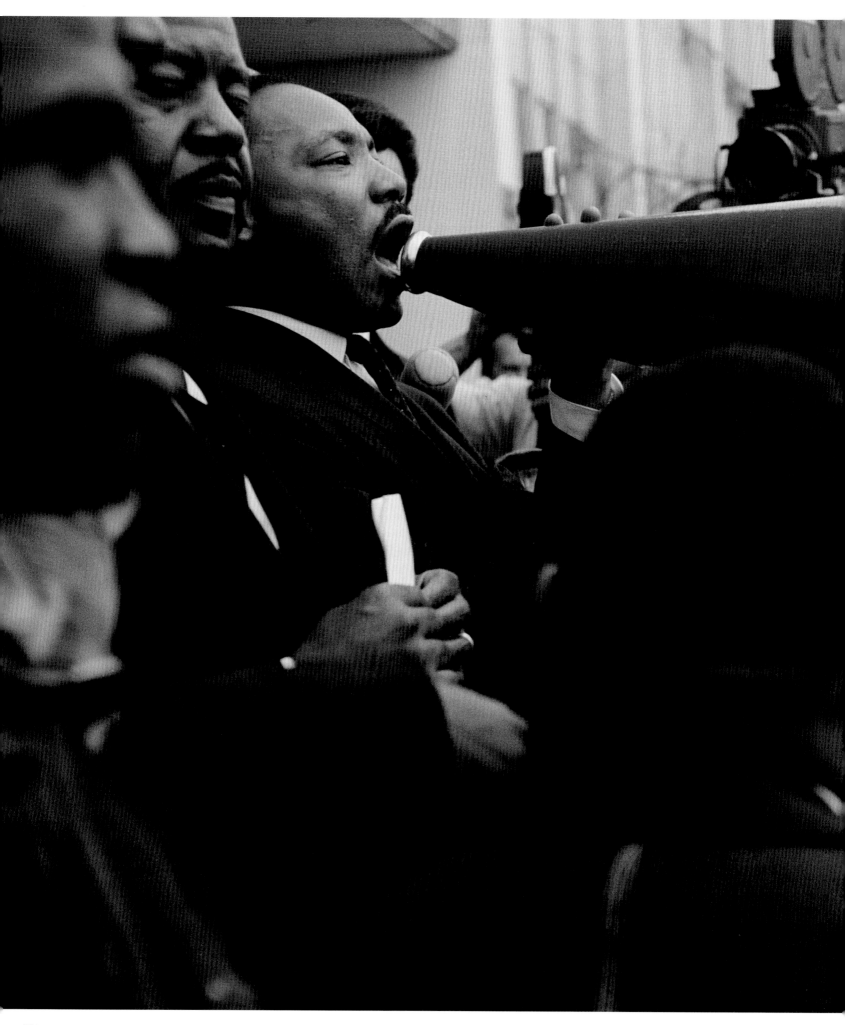

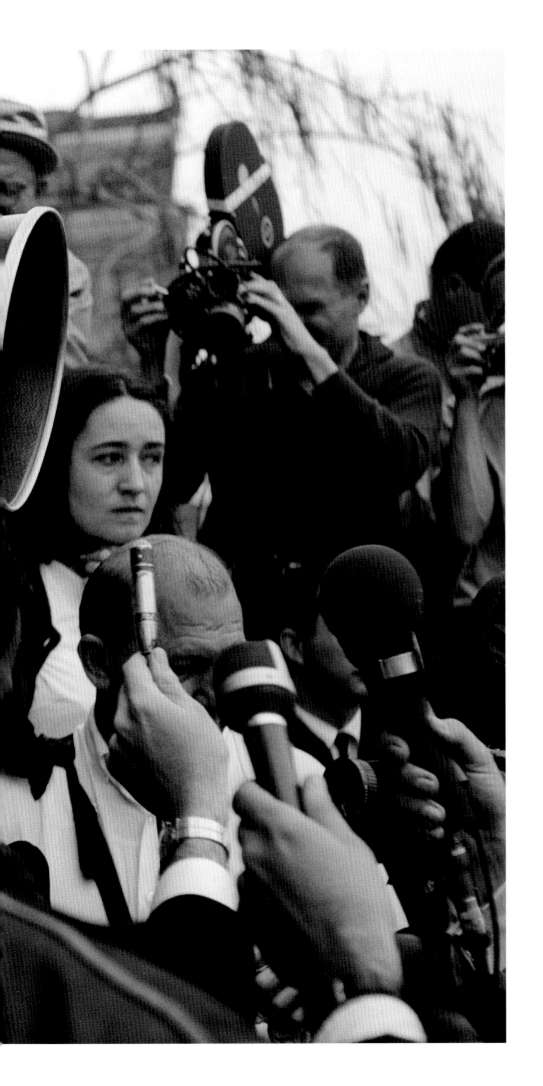

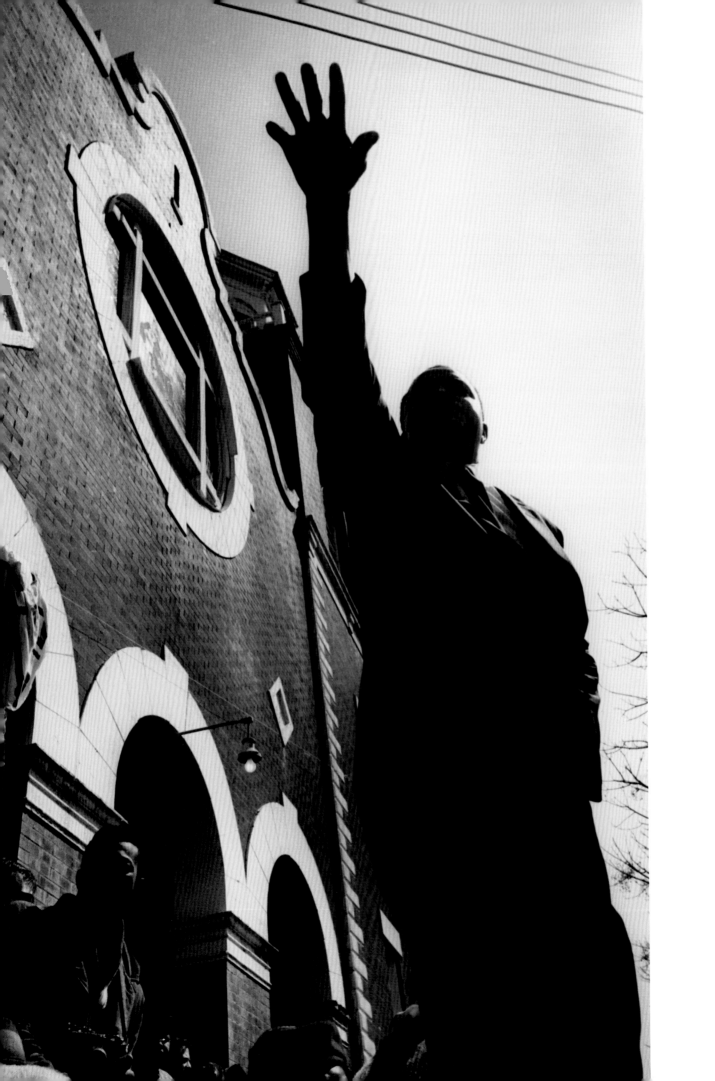

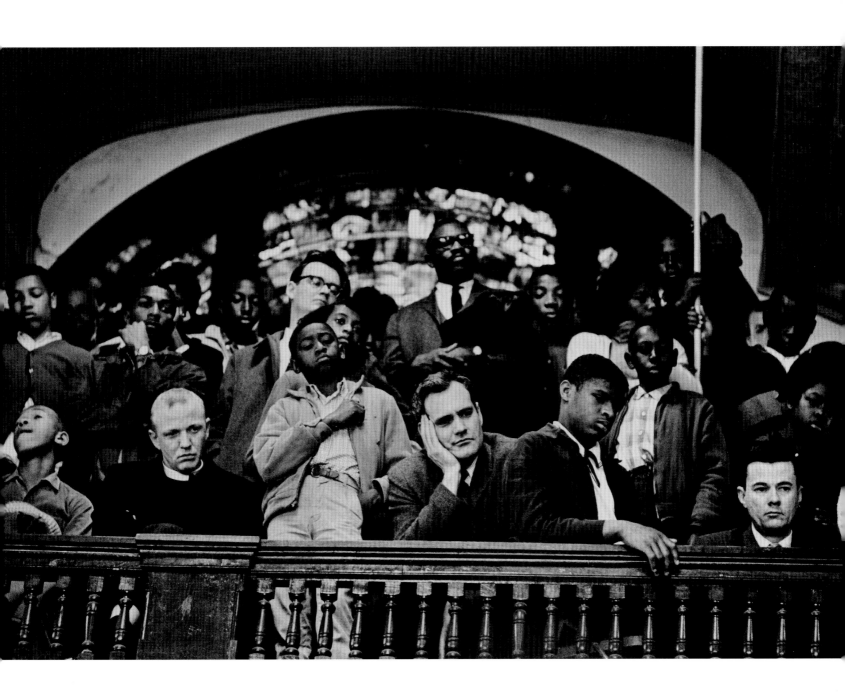

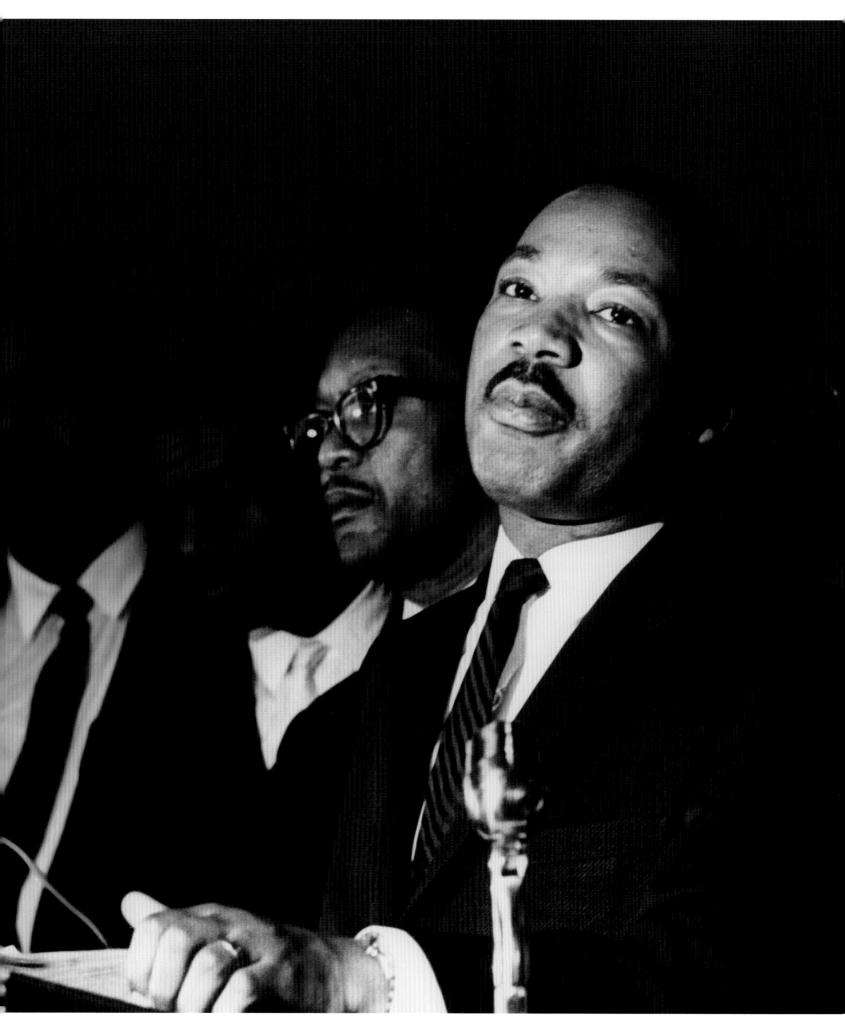

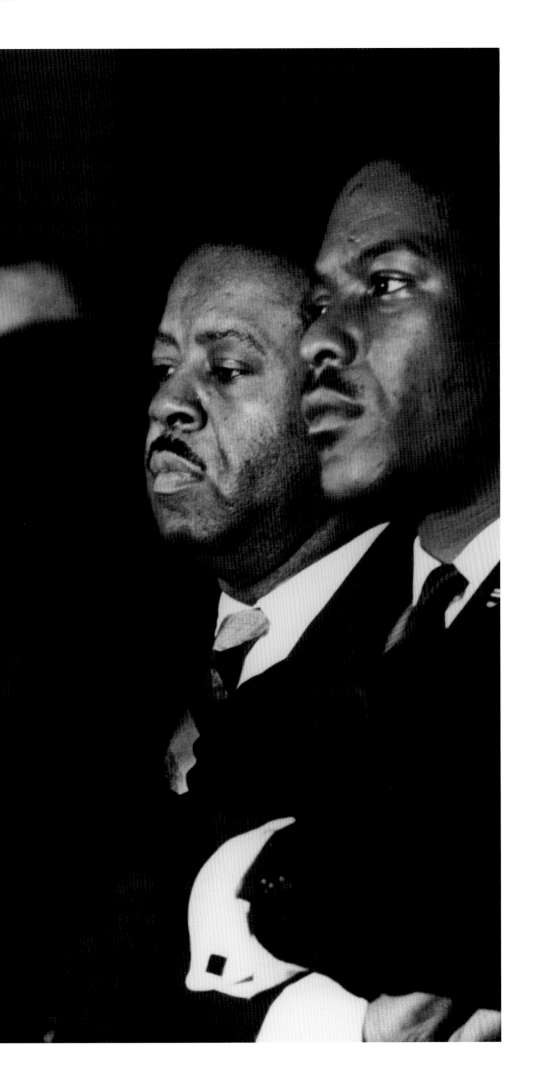

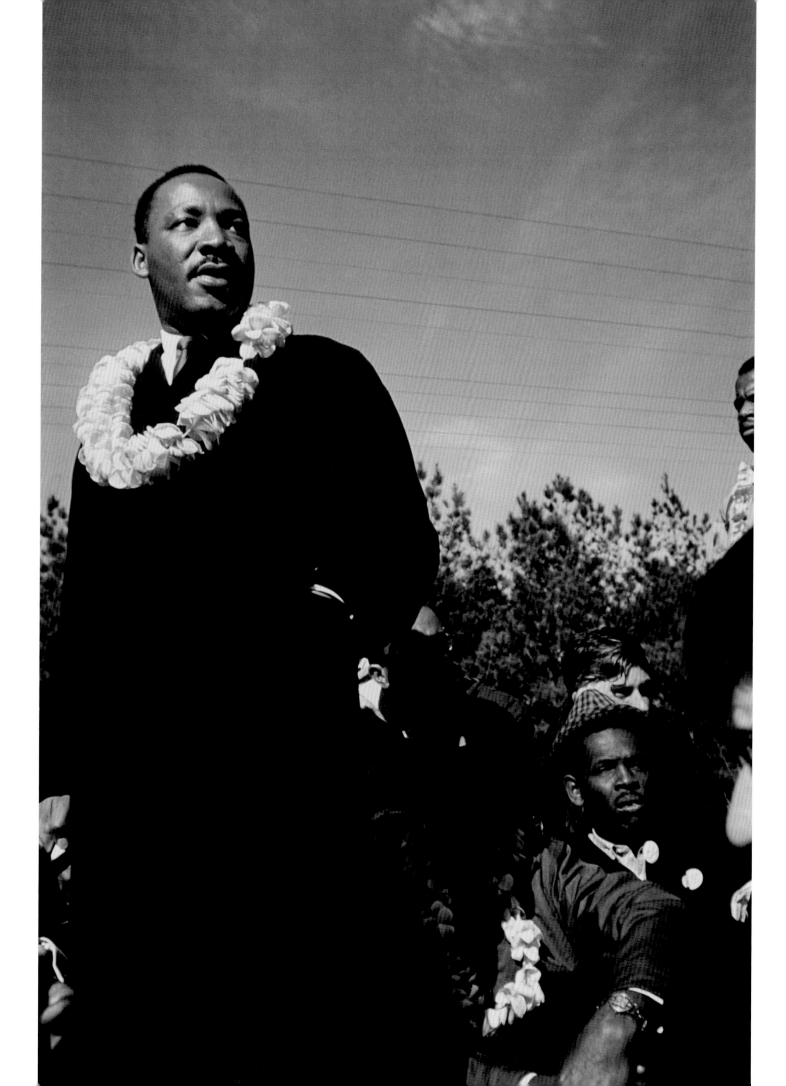

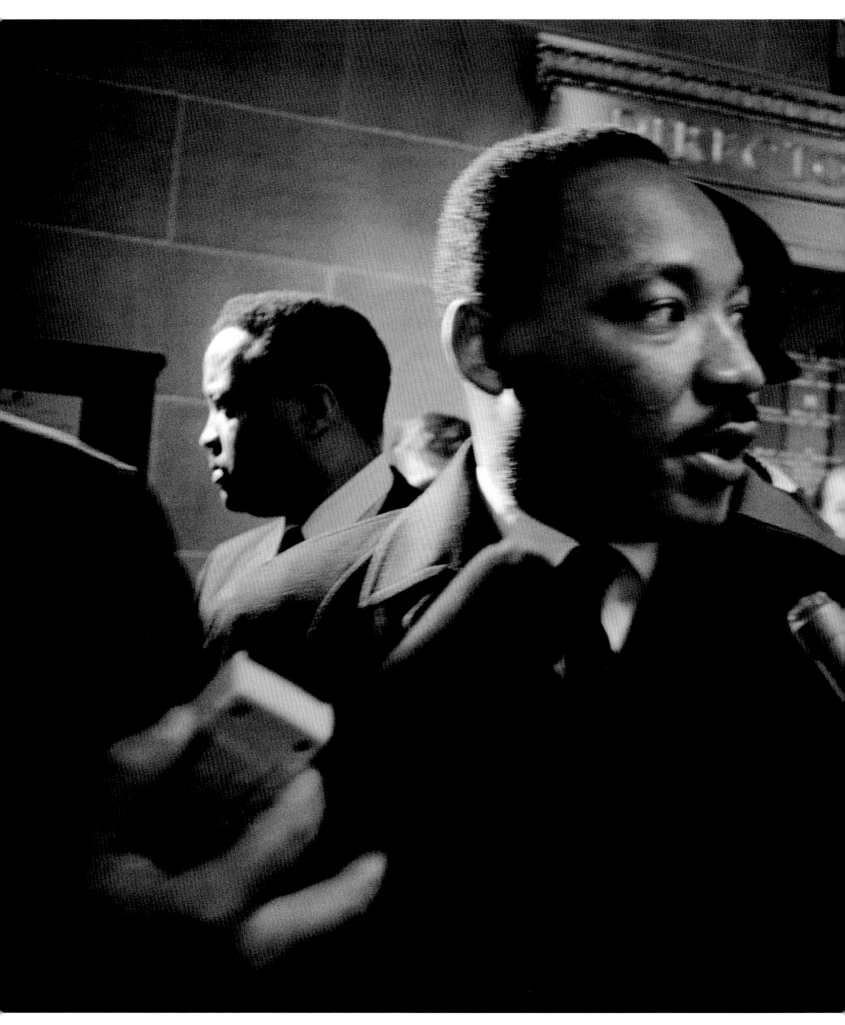

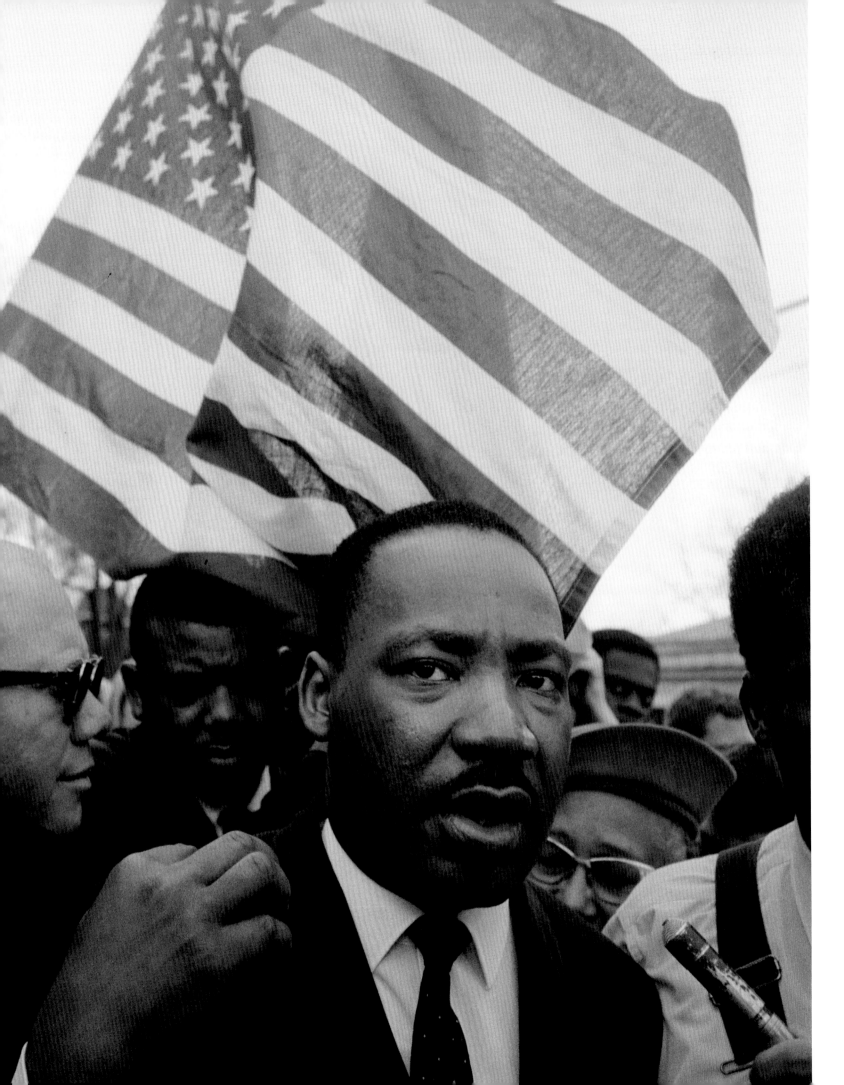

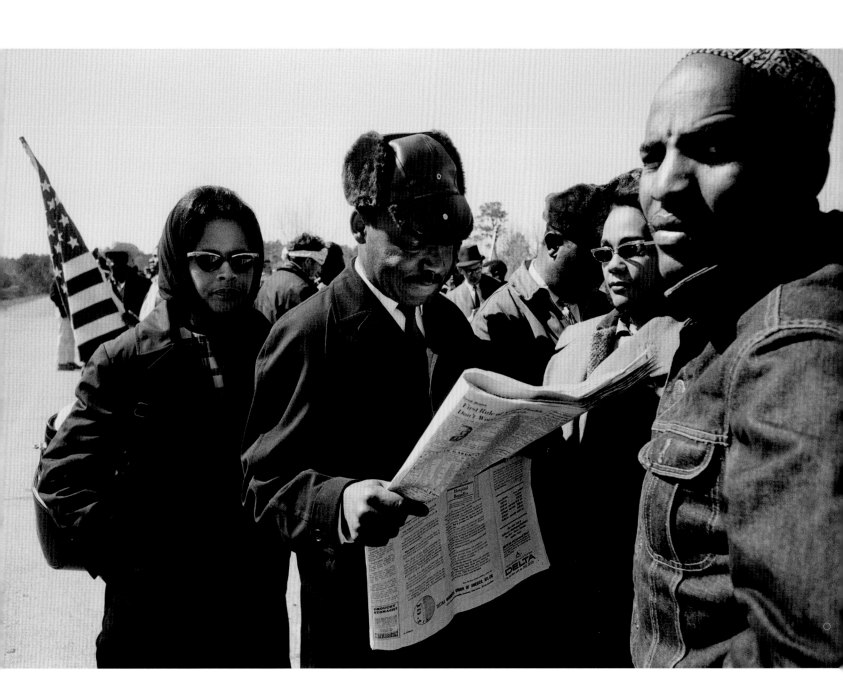

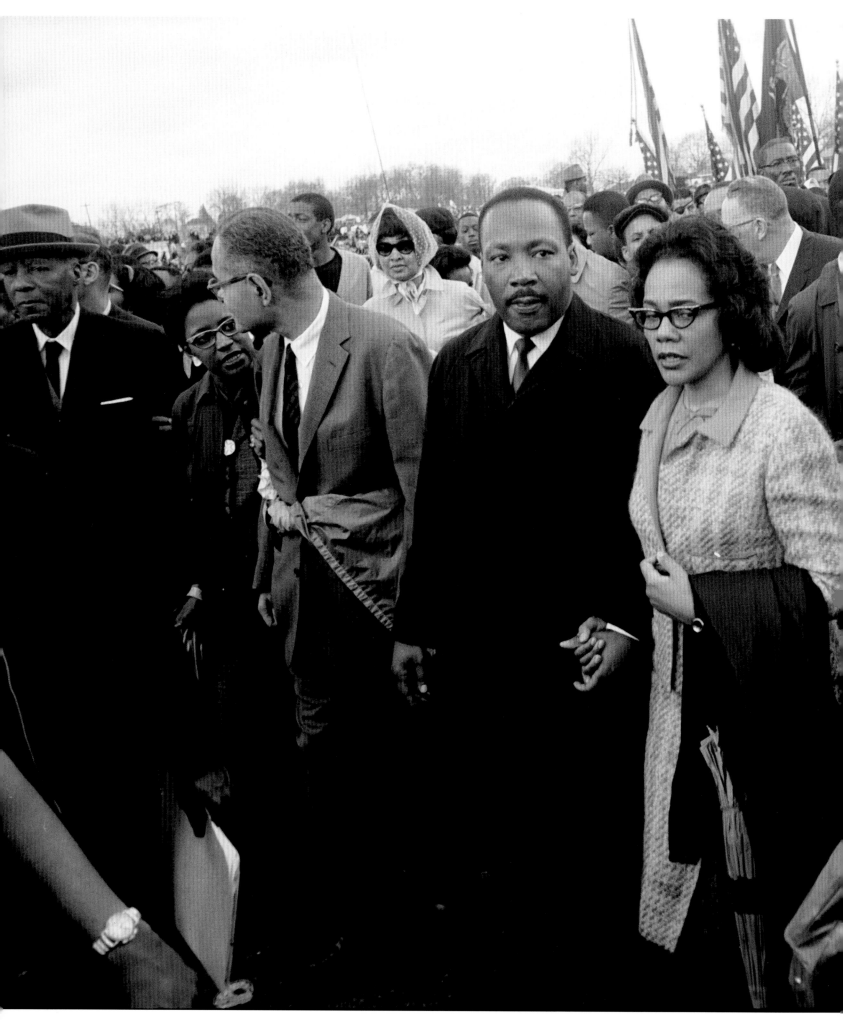

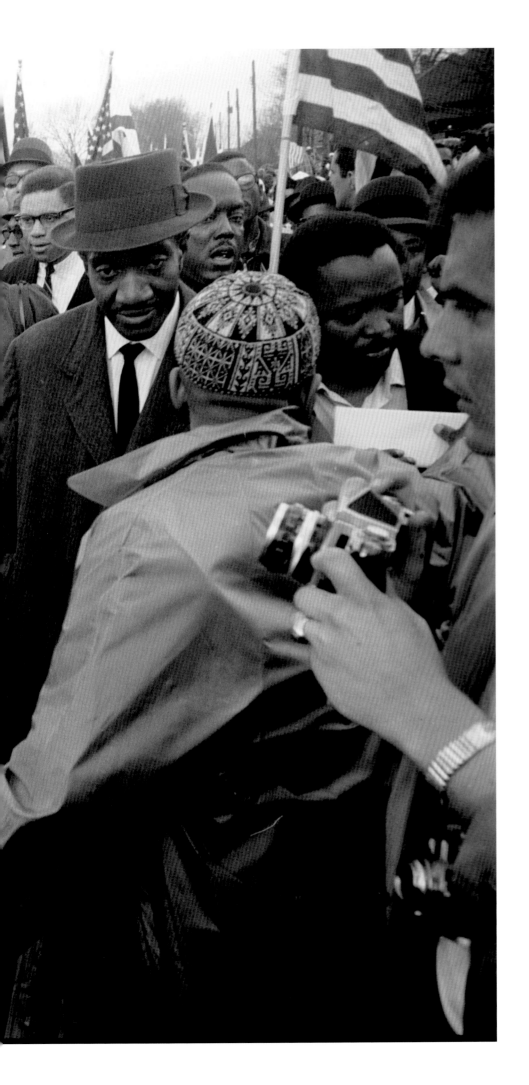

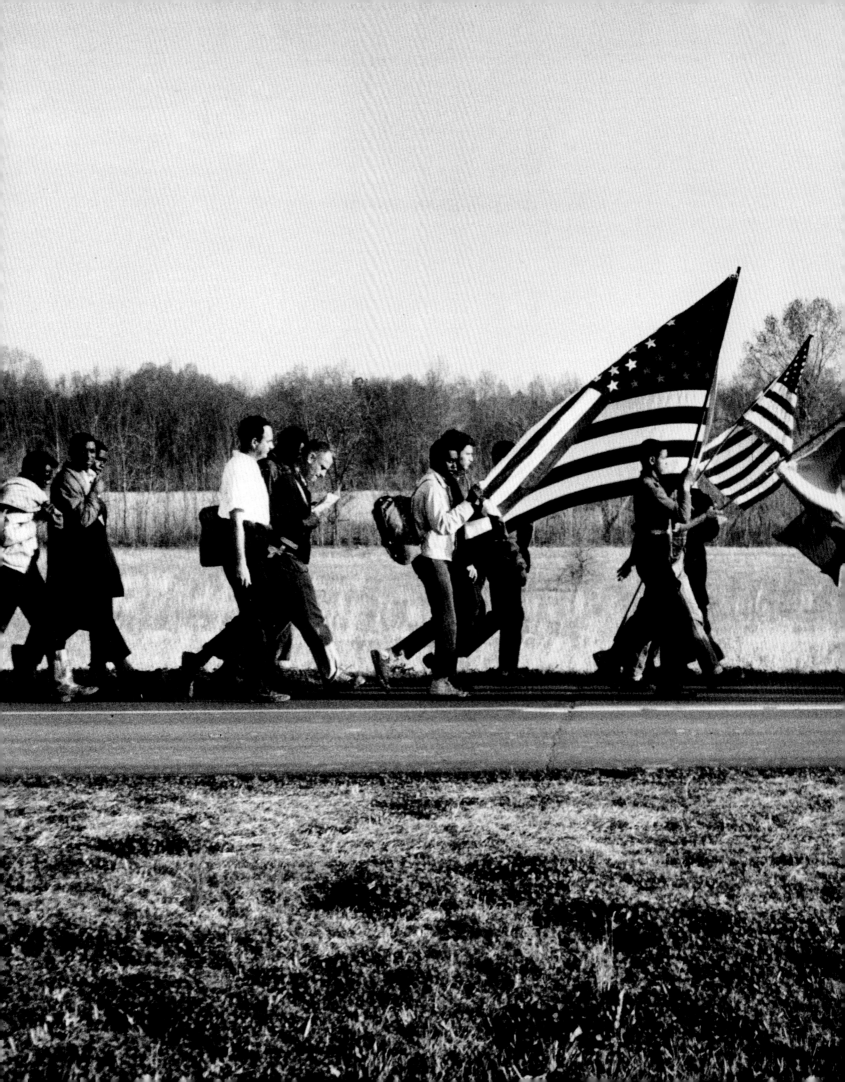

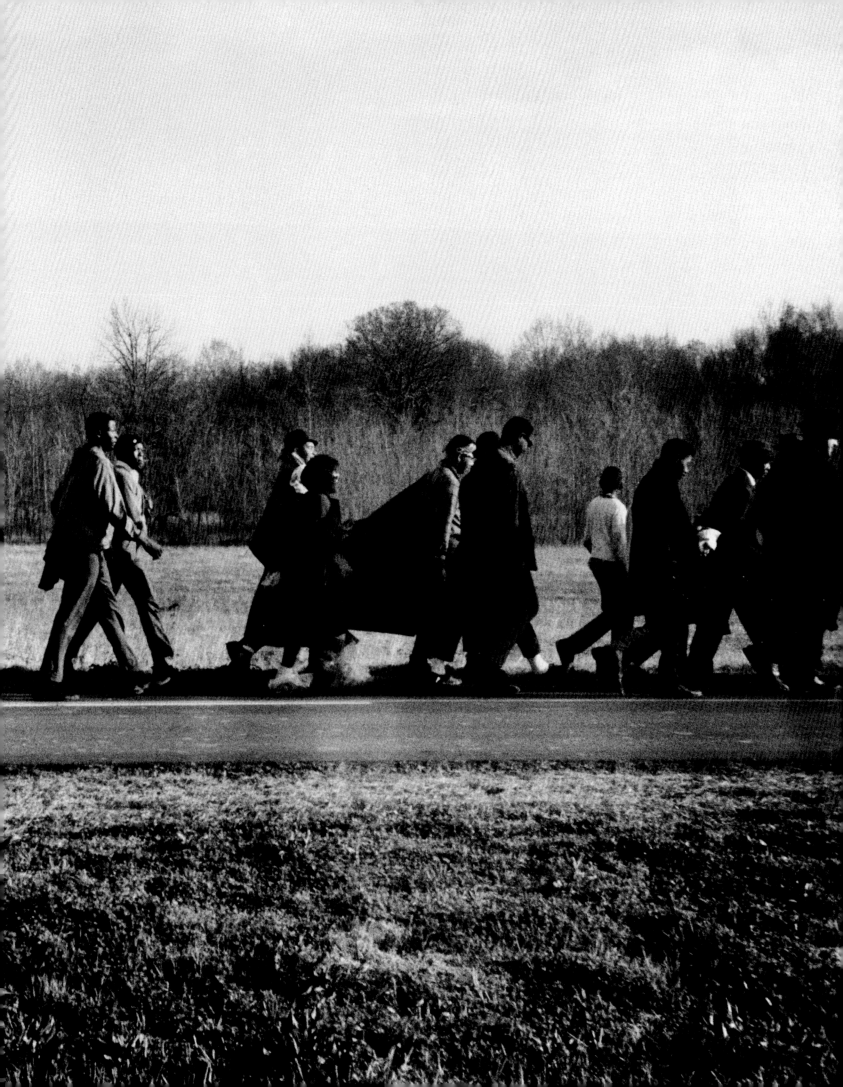

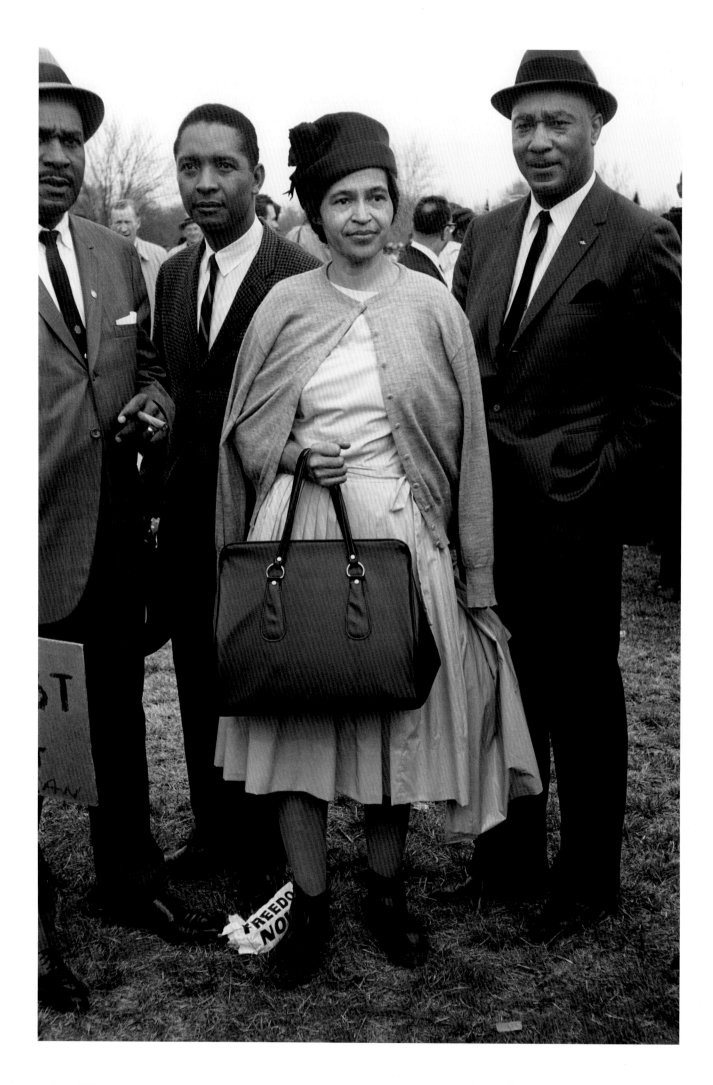

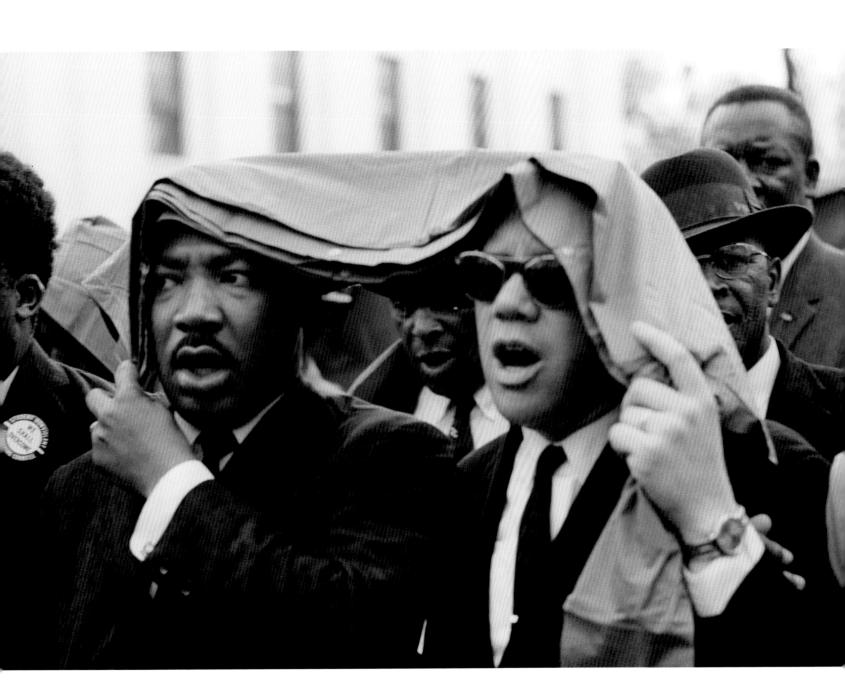

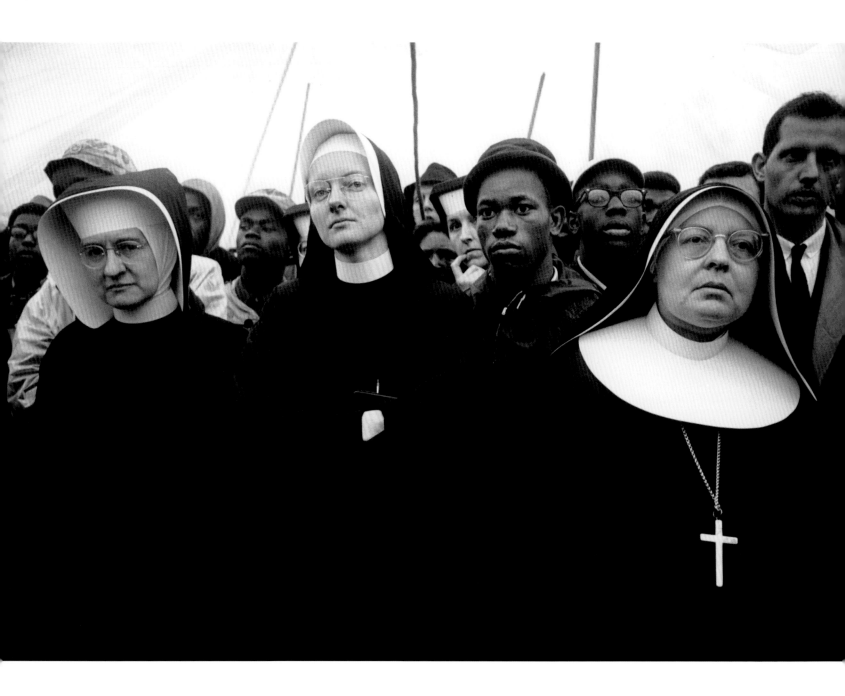

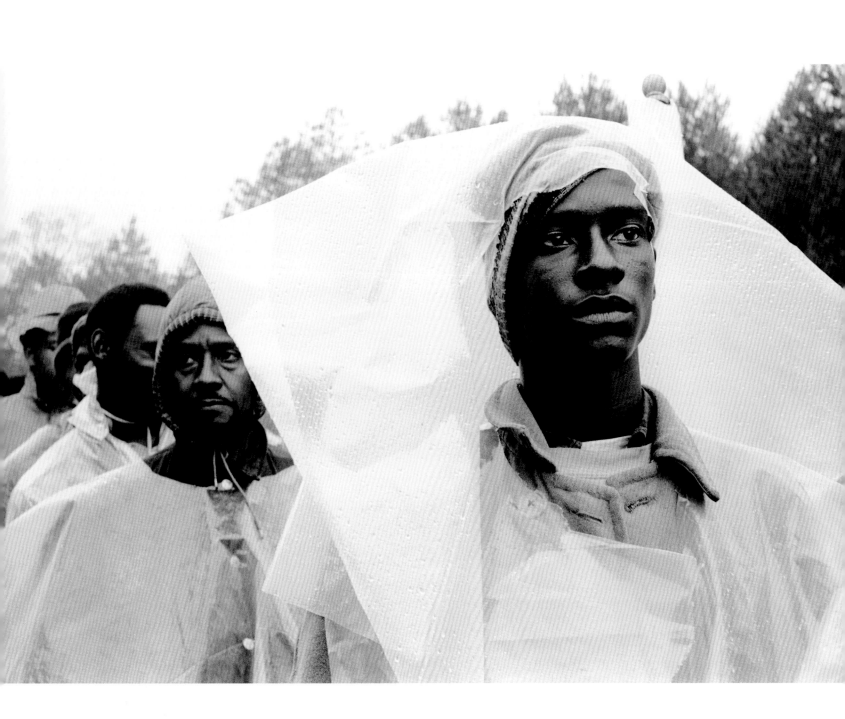

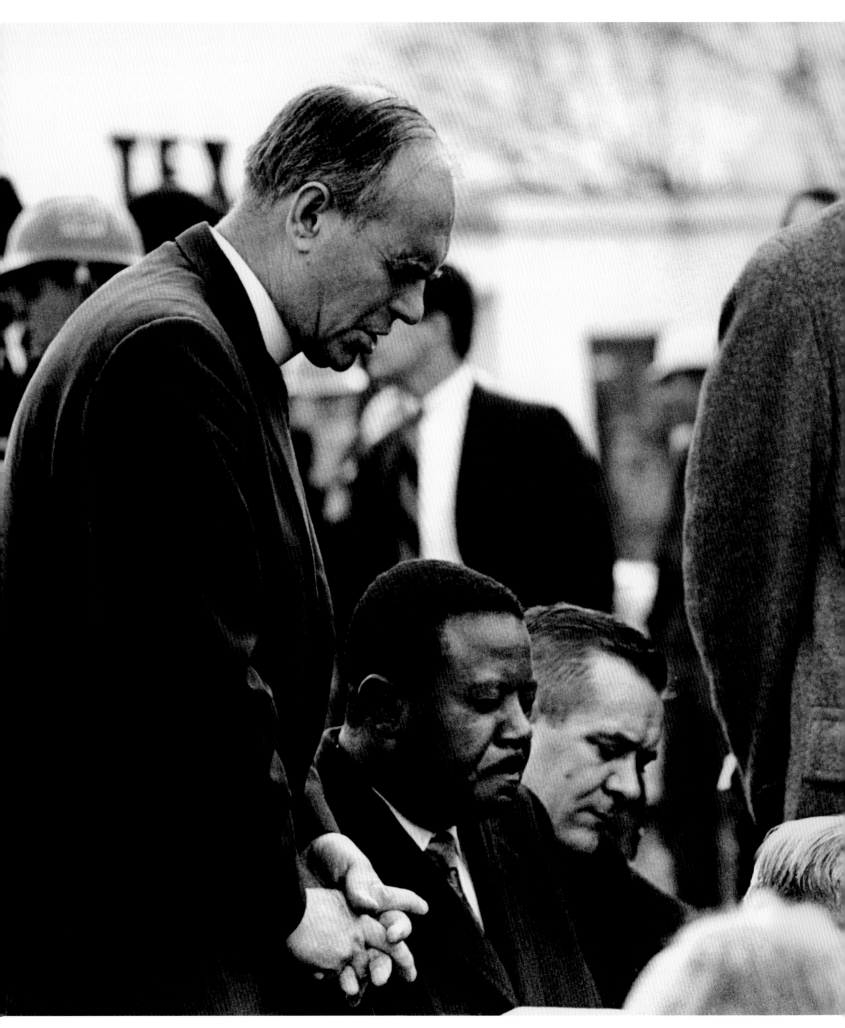

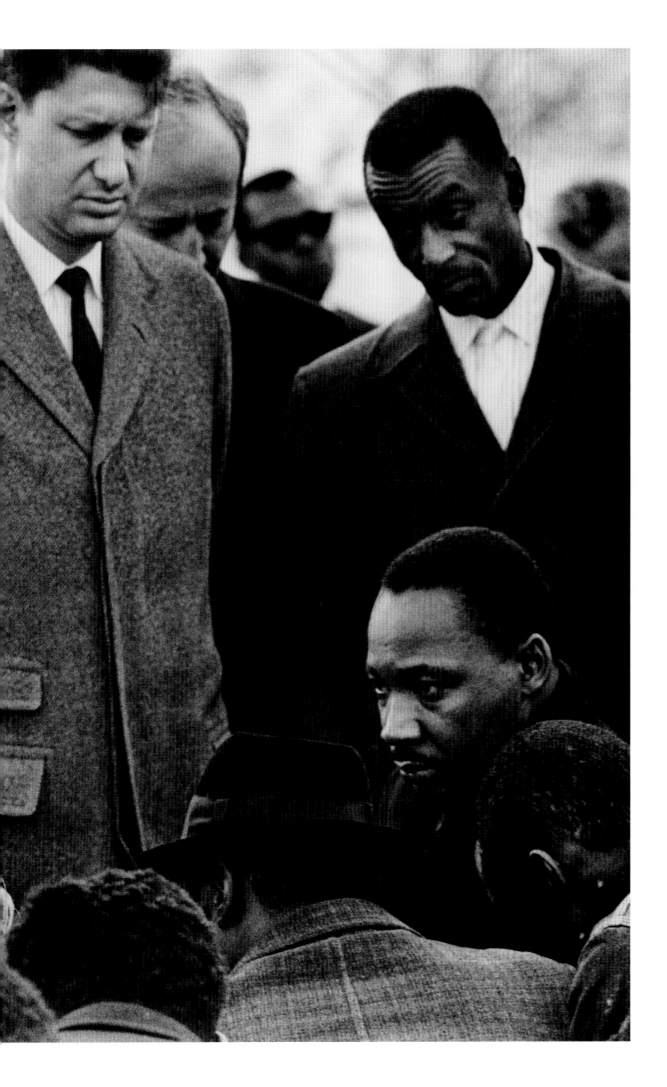

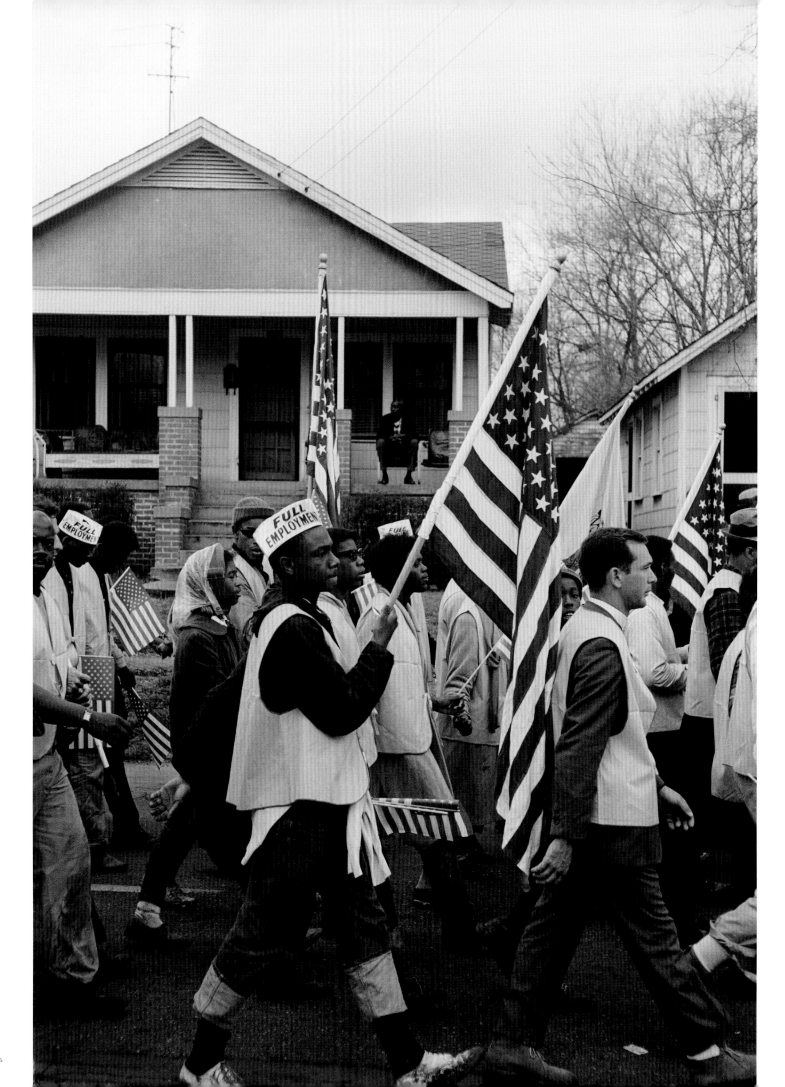

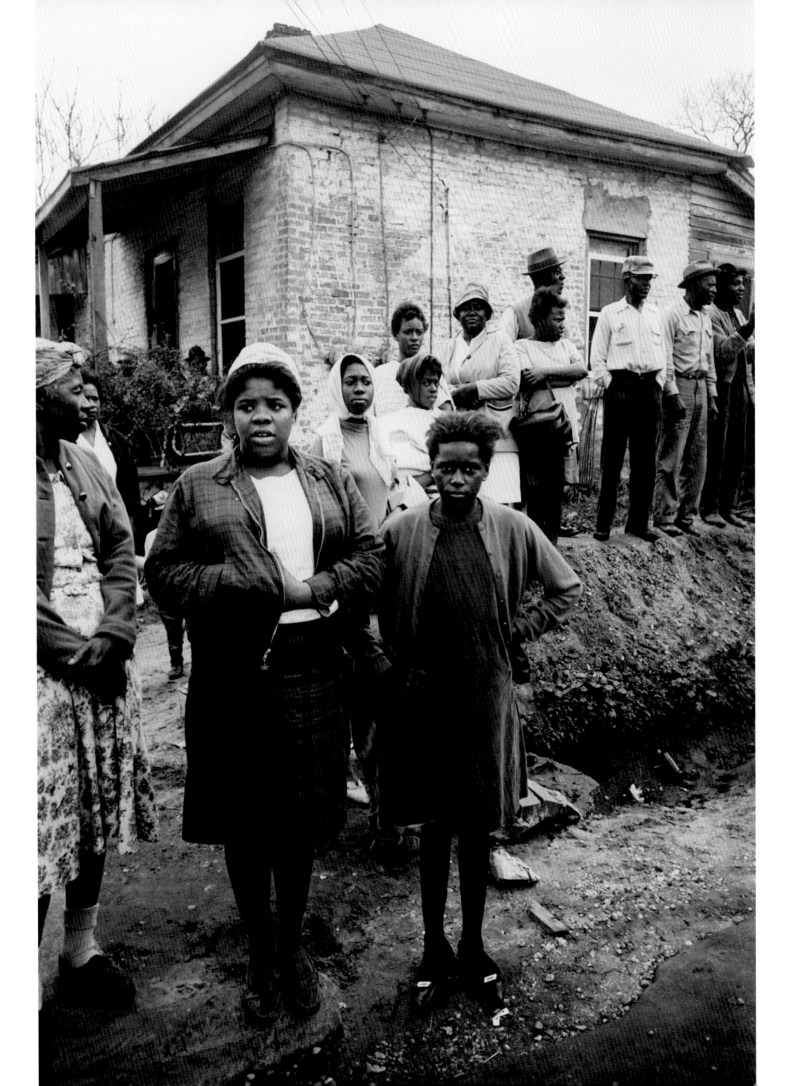

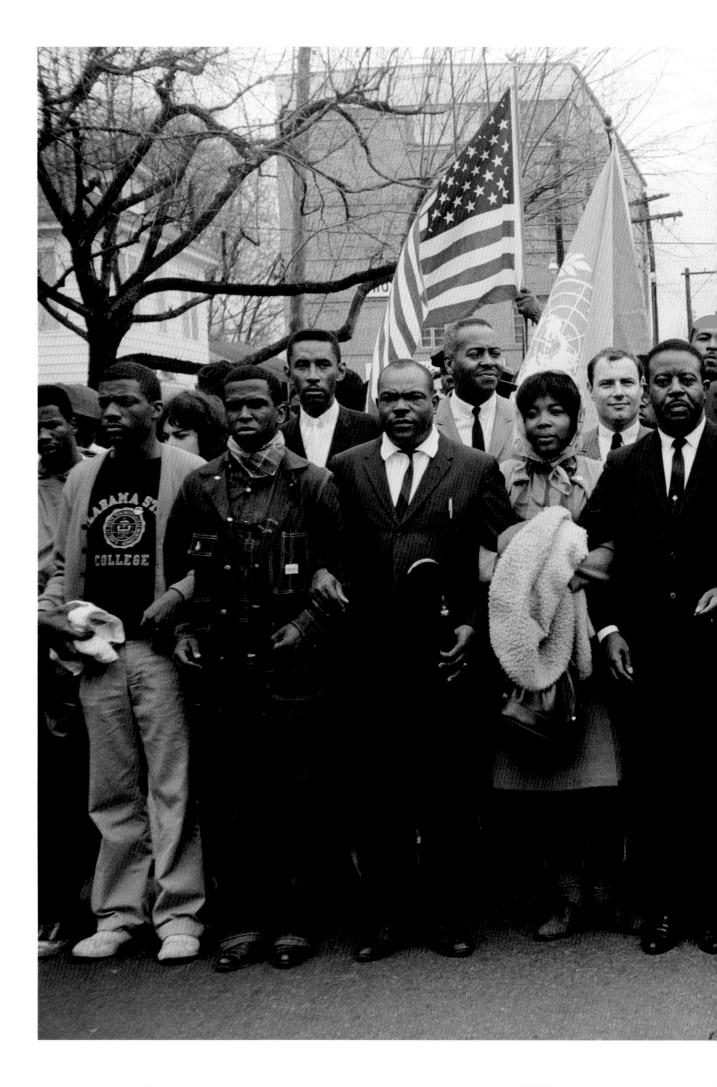

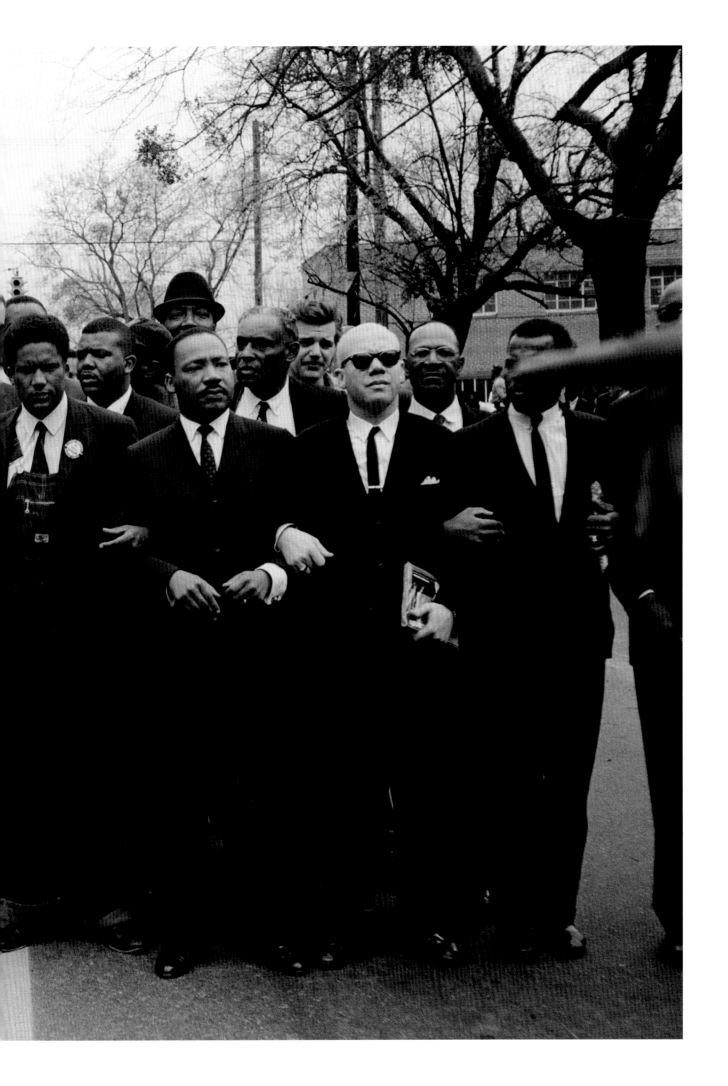

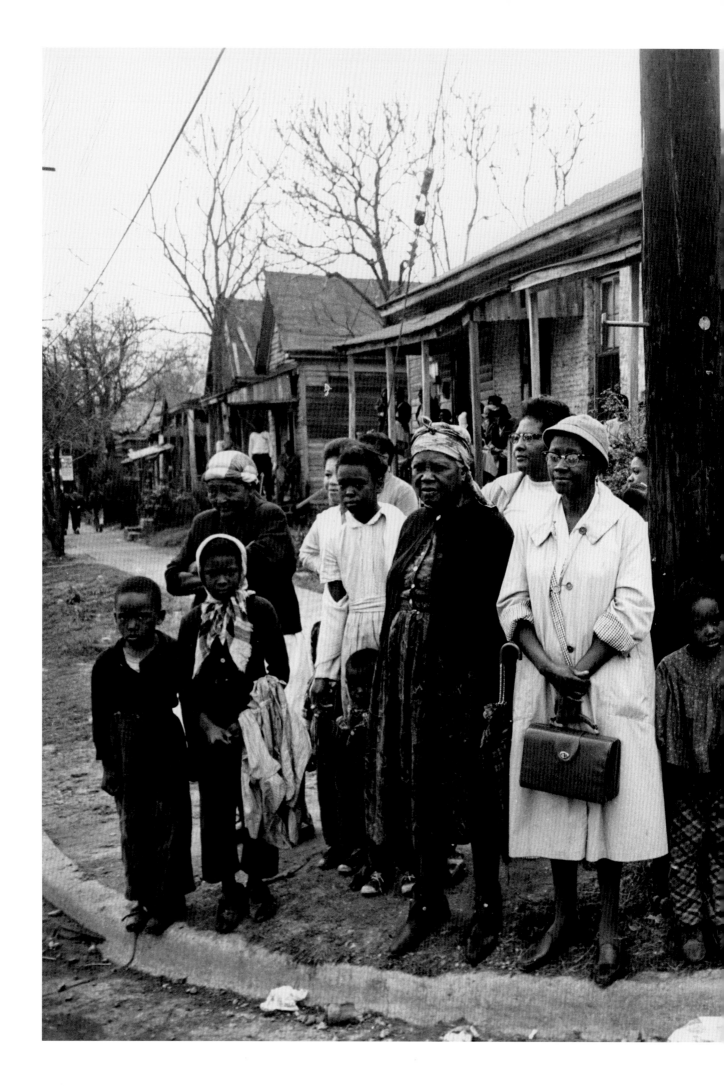

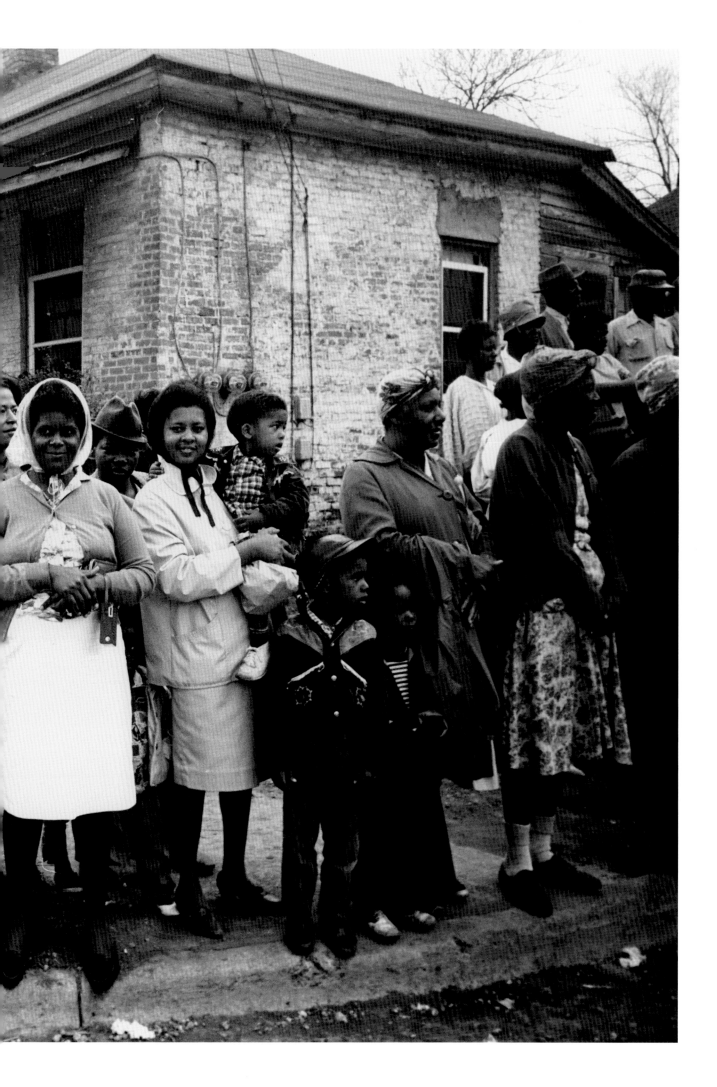

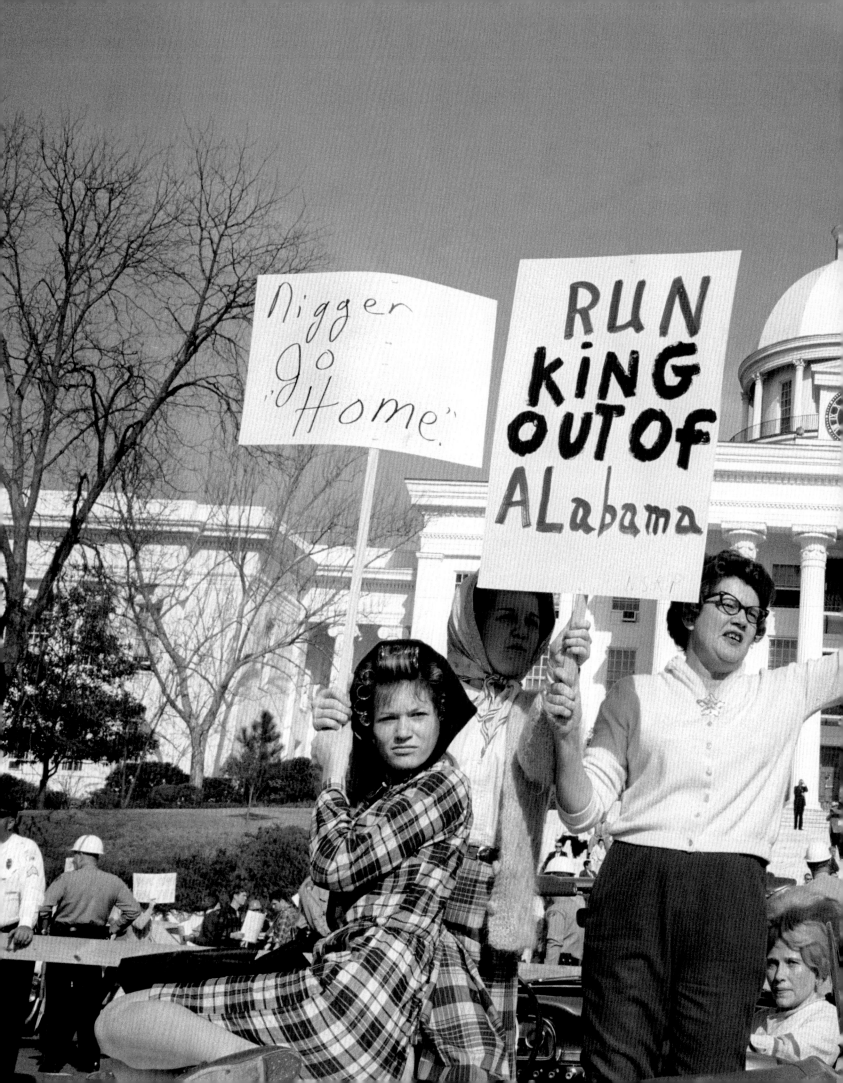

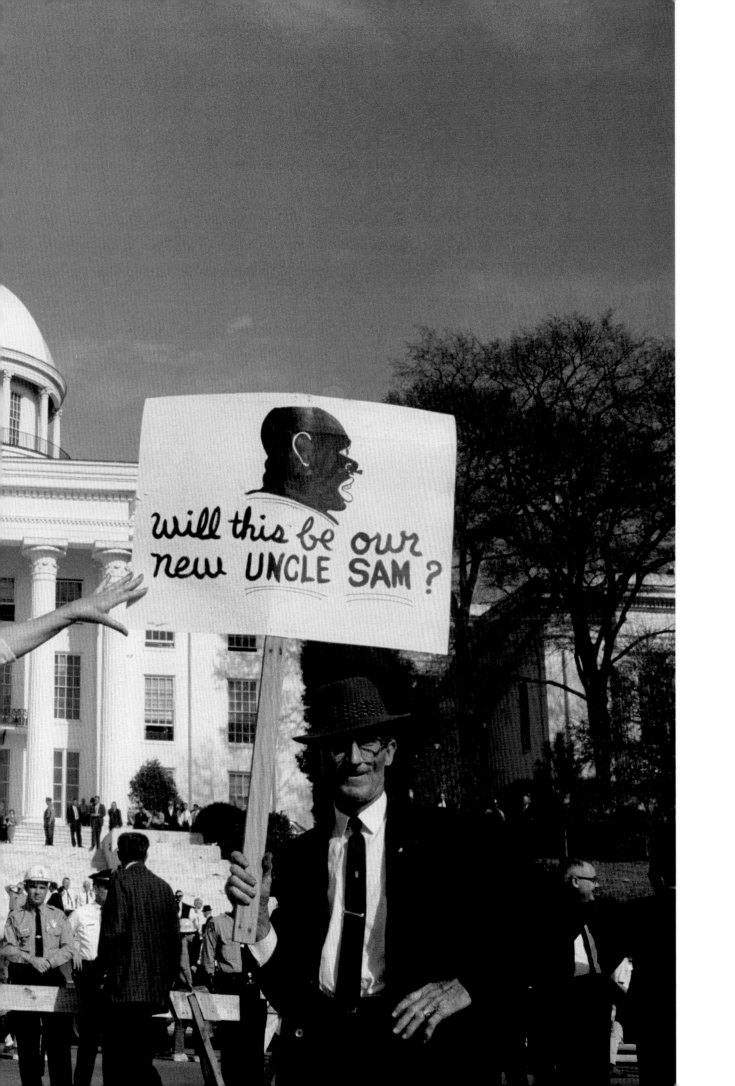

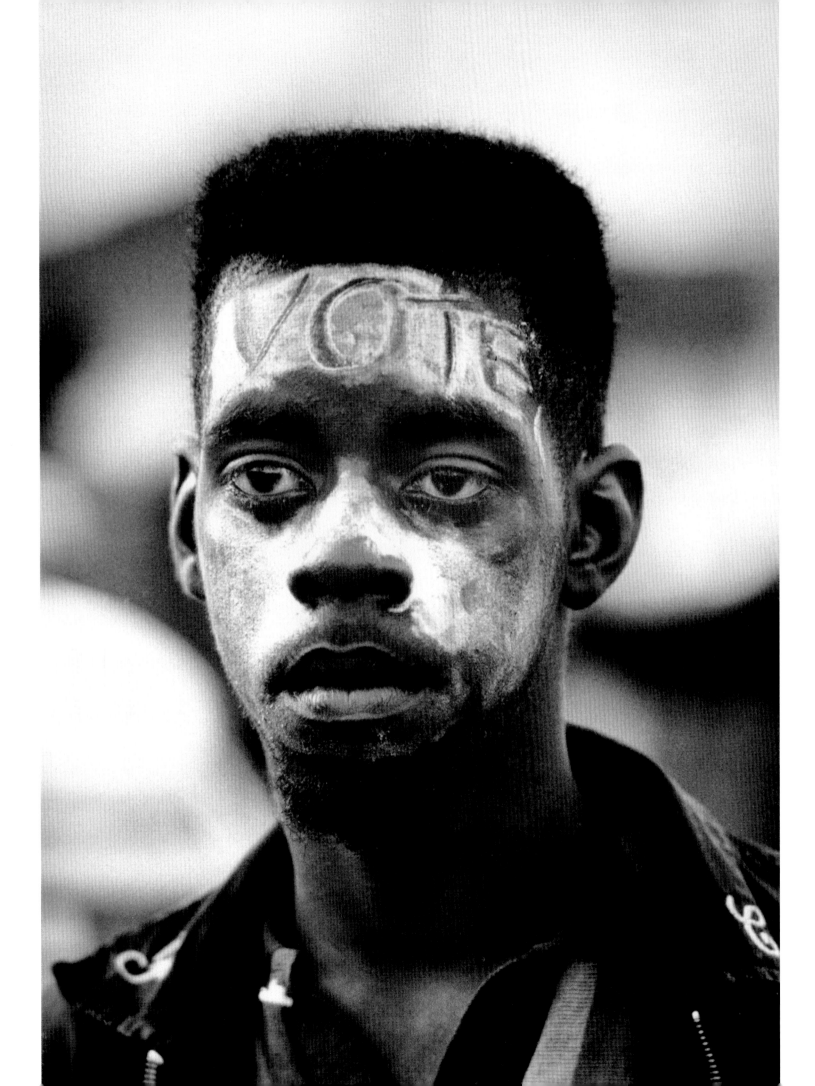

When it was learned that Martin Luther King Jr. had been shot in Memphis, *Life* magazine had me fly down there immediately. I went first to the rooming house across from the Lorraine Motel where King had been staying. The fatal shot had been fired from the rooming house's second-floor bathroom.

The consensus is that the assailant stood in the bathtub, steadying the barrel of his rifle on the window ledge. There was a greasy handprint on the wall above the tub, which I believe was left by the assailant. I photographed that handprint, and *Life* ran it as a full page in the magazine.

When I went over to the Lorraine Motel to see the room Dr. King had occupied, Hosea Williams, one of King's aides, was inside with two other photographers. I knocked on the door. One of the photographers blurted out, "Don't let that little motherfucker in," but Williams opened the door for me. Years later, one of the photographers told me they had been collecting Dr. King's blood.

Dr. King's briefcase, dirty shirts, and coffee cups were scattered on a ledge near the TV. When the ghostly image of King appeared on the television, I photographed the room. It gave me an eerie feeling. The physical body of Martin Luther King Jr. was forever gone, leaving a few small material remnants behind: a wrinkled shirt, a book, a *Soul Force* magazine, an old Styrofoam coffee cup. Yet his spirit continued to linger on, floating out from the television set on the wall, from which King continued to speak.

The half-drunk coffee cup gave me a moment of pause. He had left his room planning to return. Thirty-eight years after photographing the aftermath of that fateful event, I returned to Memphis for the first time. My initial experience had been emotional, almost traumatic, but my return was anything but that. The boarding house rooms were gone. Walls had been torn down and only the shell of the building remained. Videos about the murder, murals, and James Earl Ray's white car now filled the interior of the bare brick structure. The entire bathroom I had photographed had been scooped out and extended past the building's exterior with a plastic wall, so that you could see right into it. I have no doubt that the bathtub was the same one I had seen before, but the uneven wall with the handprint I had photographed was gone, replaced by smooth, green, unblemished plasterboard. Those markings, once a true part of history, had vanished.

Dr. King's motel room had also been preserved, but to make the room visible to the tourists who now flock to the National Civil Rights Museum housed in the Lorraine Motel, the wall on which the television set had been mounted was also gone, replaced with a sheet of thick clear plastic. Visitors could peer into King's room, but no one will ever get to see that eerie image that is forever imbedded in my mind.

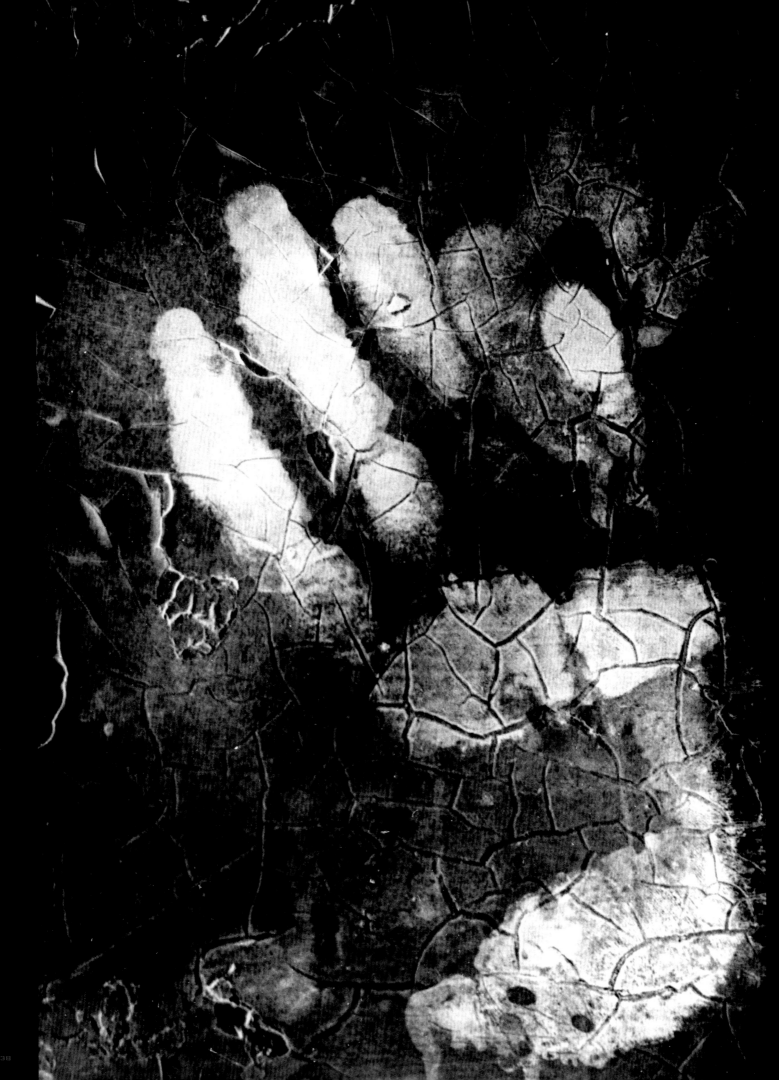

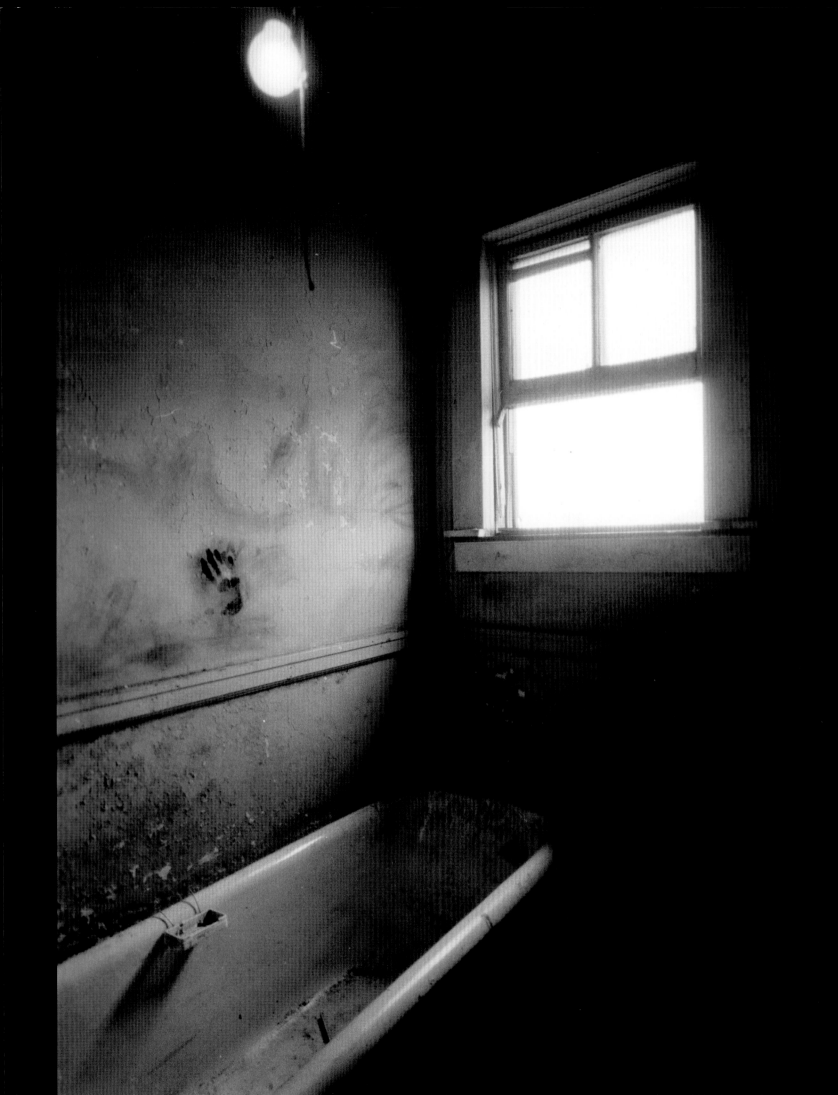

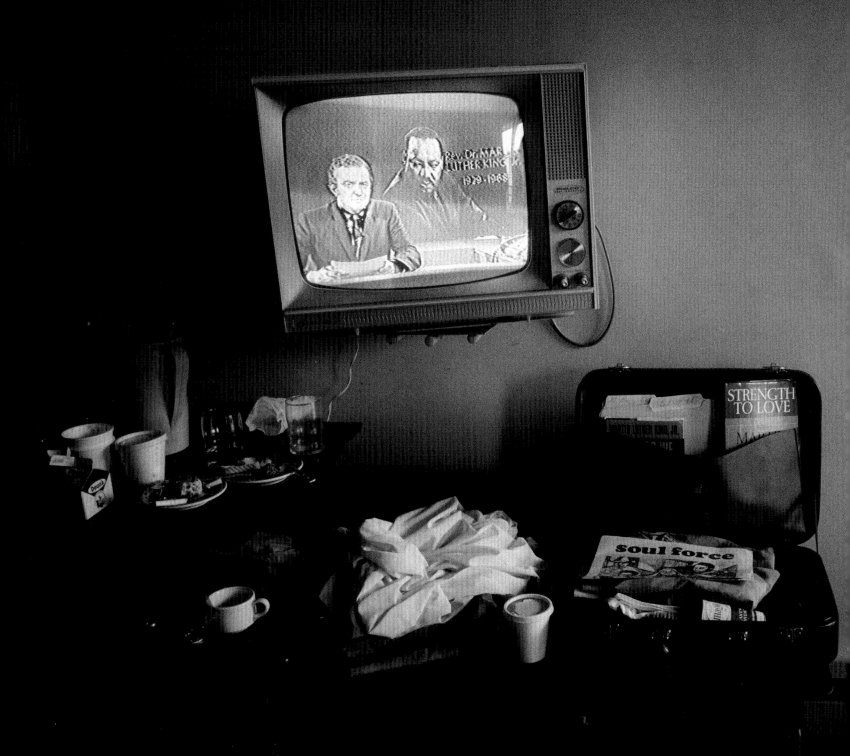

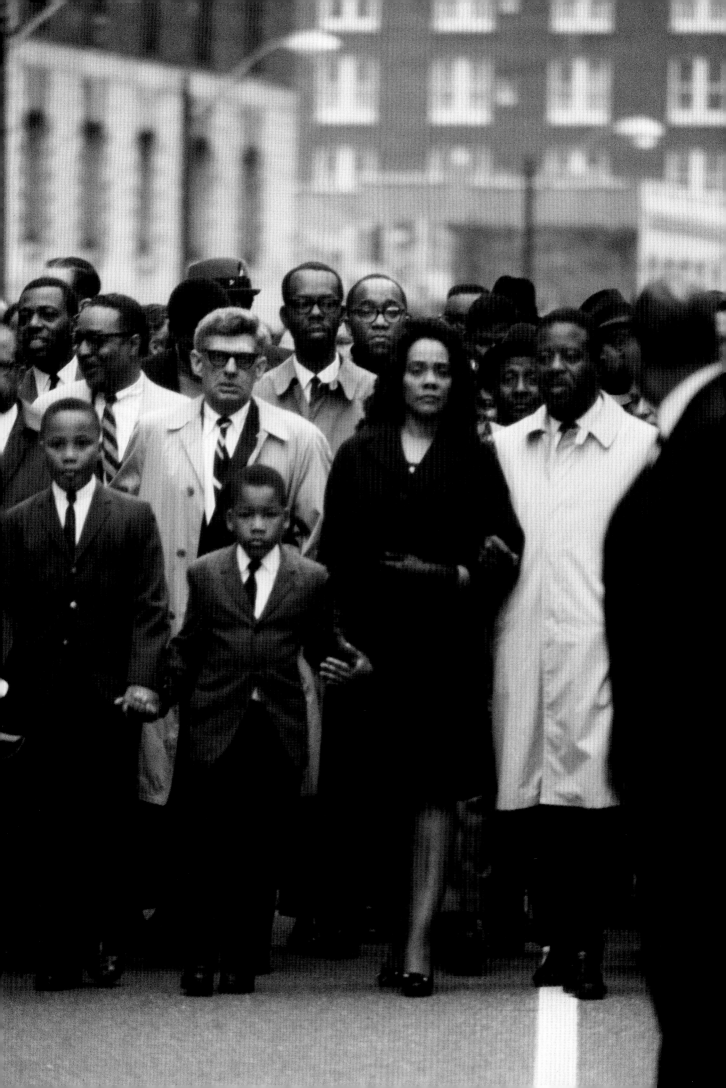

MUHAMMAD ALI

The photographs of Cassius Clay (Muhammad Ali) were taken for *Sports Illustrated* at his parents' house in Louisville, Kentucky in 1963. He had a great relationship with the kids in the neighborhood. His mother, Odessa, was a great cook and the family was very close. He had his hair cut in a local barbershop and delighted in looking at himself. The photo showing Ali with the boxing magazine was taken at Sugar Ray Robinson's office in New York.

ANDY WARHOL

The photographs of Andy Warhol were taken in New York and Los Angeles between 1963 and 1966. The photographs with the weights, the contact sheet, Andy with the camera, and the photo of the Warhol actors were all taken at the Factory. Andy under the silver cloud pillow was taken at the Ferus Gallery in Los Angeles in 1966, when the Velvet Underground came to do a concert at the Trip. Everyone stayed at Philip Law's old castle in the Hollywood Hills, where the rabbit and dog pictures were taken, as well as the group photographs of Nico and the Velvet Underground. Andy hanging the pictures of Joan Baez and James Brown was also in Los Angeles.

The "entourage" photo of Henry Geldzahler, Edie Sedgwick, Andy, and Gerard Malanga was taken at a New York party, as was the photograph of Andy and Geldzahler with Andy's silkscreen paintings in the background.

RAY CHARLES

The performance photographs of Ray Charles were taken at a New Jersey nightclub in 1965. The office photographs were shot at ABC Records in New York, in a meeting about the album *Together Again* with ABC executives. David Berger holds out his hand to Ray.

ROBERT F. KENNEDY

I started photographing Robert F. Kennedy in 1964 when he ran successfully for the Senate seat in New York. Through the Black Star photo agency, who continually found new assignments for me, I photographed Bobby and his family throughout his presidential campaign. I traveled with him to South America, where on a mountain overlooking Rio de Janeiro, he was showered with rose petals as a blessing. The family photographs were taken at Hickory Hill, his house in Maryland where a lot of football was played, and at the christening of Douglas Harriman Kennedy with W. Averell Harriman and George McBundy in attendance.

One day the Kennedy family posed for a family picture. Left to right, they are: Max, Christopher, Kerry, Courtney, Kathleen, Ethel holding Douglas, Bobby, Joe, Robert Jr., David, and Michael. Rory, the eleventh child, was born after Bobby's death.

Sadly, I photographed his last Christmas at Hickory Hill, where early in the morning all the kids rushed to get their gifts and one of Bobby's presents was a green beret. The campaign photograph where an older lady and some kids look up at Bobby with hope and expectation is one of my favorites.

JACQUELINE KENNEDY ONASSIS

Jacqueline Kennedy attended the arrival of the Shah of Iran and Empress Farah Diba at the Washington airport in 1963. Later at a lavish reception she appeared with her husband, President John F. Kennedy.

The photographs at the gala ball where she danced and talked with Ted Kennedy were taken in Boston circa 1968, several years after President Kennedy had been killed. The photographs with John Jr. and Caroline were taken at the dedication of the John F. Kennedy aircraft carrier in 1968. Robert McNamara stands in the background, to the left of Jacqueline. Ted Kennedy gave a dedication speech.

JAMES BALDWIN

I photographed James Baldwin in 1963 on assignment for *Life* magazine. We spent some time on the streets of Harlem. In New Orleans, I photographed Jimmy dancing with a CORE worker. He spoke to liberals there and was confronted by a girl who declared, "You are not my spokesman, Jim Baldwin." In Durham, North Carolina, he comforted an abandoned child at a neighbor's house. The photographs of Jo-Jo's Chicken House and the ice cream parlor with the "Colored Entrance Only" sign were both taken in New Orleans. In Jackson, Mississippi, I photographed Jimmy's visit with James Meredith.

TRUMAN CAPOTE

I took the photographs of Truman Capote for a *Life* magazine cover story in April 1967 in Holcomb, Kansas during the filming of the movie *In Cold Blood*. The writer Harper Lee accompanied Truman and wandered through town with him. He bought his famous cap in a local general men's store.

The filming took place at the Clutter house, where the real murders had happened. In one photo, Truman, Robert Blake, and Scott Wilson stand in front, and to the right you can see some movie paraphernalia in place on the side of the house. I also photographed Truman in the upstairs bedroom where the Clutter daughter was killed. In a scene from the movie, Robert Blake reenacts the killing of Mr. Clutter in the basement.

People from Holcomb threw a cocktail party for Truman, which many of the townspeople attended. The photos of him signing books with Harper Lee and resting in bed were both taken in Truman's hotel room.

BARBRA STREISAND

I first worked with Barbra Streisand in New York and Los Angeles in 1967. Barbra was already interested in politics and was a big fan of Bella Abzug, for whom she did fundraising work.

The shot with the assistant cameraman holding the clapper board was for the very first take of Barbra's first movie, *Funny Girl*. The bathtub shot, I am quite confident, comes from the sequel film *Funny Lady*.

Barbra and Robert Redford made *The Way We Were* in 1972, and I did a series of publicity shots of them together. Also in that film, Barbra dressed up as Harpo Marx and Groucho came to the set. The photo with Ray Charles was during a television special, shot in London. The photos of Barbra in the African costume and of her empty chair were both taken in Kenya during the filming of *Up the Sandbox*.

SAMUEL BECKETT

I photographed Samuel Beckett in New York in 1964, during the making of *Film*, which he had written. It starred Buster Keaston and was directed by Alan Schneider. The outdoor pictures were taken under the Manhattan Bridge, and the rest in a New York film studio.

MARTIN LUTHER KING JR.

I first photographed Martin Luther King Jr. in 1963 in a Birmingham pulpit, after the church bombing that had killed four little girls. His passionate ability to move an audience with his moral voice immediately brought him to a position of leadership. Often he was accompanied by Reverend Ralph Abernathy, who appears with him.

Most of the photographs of Dr. King were taken in Selma, Alabama before and during the Selma march, in which Coretta Scott King walked at her husband's side. The long march towards Montgomery, Alabama brought together many diverse groups and people, including students from the North and South as well as nuns and clergy. Rosa Parks stood with a "Freedom Now" banner at her feet by the side of the road, where crowds stood cheering or silently watching all along the route. The photo of the people with the racist signs was taken in front of the Montgomery capitol building, where the Confederate flag was flying in the wind.

In 1968, when it was learned that Dr. King had been shot, *Life* sent me to Memphis, Tennessee. I photographed the bathroom of the rooming house from which the shot had been fired, and the Lorraine Motel room where King had been staying. The photograph of King's motel room after he was killed is one I keep looking back at today.

ACKNOWLEDGEMENTS

Let me first give thanks to David Friend, who believed in this book and struggled to get it published. To Daniel Power and Craig Cohen, who actually published it. To Yuko Uchikawa, who has had incredible patience and a sure hand in designing the constantly changing pages, and to Adhemar Dellagiustina Jr. of The Print Lab for his great scanning abilities. Thanks to David Fahey and James Gilbert for their continued support these many years, and to the editors of *Life*, who let me meet so many incredible people.

And of course, thanks to my children, Smith, Aba, Teddy, Taylor, and Elle; and my family support team, Susanne, Mike, and Fred Smith, and Peter Donoughue. This book is dedicated to my wife, Maura, but I must again acknowledge the continued support, good taste, and good judgment she has always showered upon me.

SCHAPIRO'S HEROES

Published in the United States by powerHouse Books,
a division of powerHouse Cultural Entertainment, Inc.
37 Main Street, New York, NY 11201-1021
telephone 212 604 9074, fax 212 366 5247
e-mail: schapirosheroes@powerHouseBooks.com
website: www.powerHouseBooks.com

First edition, 2007

Library of Congress Cataloging-in-Publication Data:

Schapiro, Steve.
 Schapiro's heroes / by Steve Schapiro ; introduction by David Friend.
 p. cm.
 ISBN 978-1-57687-378-6
 1. Portrait photography. I. Title.
 TR681.F3S345 2007
 779.2--dc22

 2007060138

Hardcover ISBN 978-1-57687-378-6

Separations, printing, and binding by Midas, Inc., China
Book design by Yuko Uchikawa

A complete catalog of powerHouse Books and Limited Editions is available upon request; please call, write, or visit our website.

10 9 8 7 6 5 4 3 2 1

Printed and bound in China

DATE DUE